# Aboriginal Australian Art

RONALD M. BERNDT (1916–1990) WAS emeritus (formerly Foundation) Professor of Anthropology at the University of Western Australia. His wife, Catherine Helen Berndt, a Senior Honorary Research Fellow in Anthropology at that university, continues to carry out research writing under grants from the Australian Research Council. Together they studied at the University of Sydney and later at the London School of Economics, University of London. Their field research in Aboriginal Australia spans almost four decades, mainly in the Western Desert, Arnhem Land, west-central Northern Territory, and the Kimberleys, among other areas. They have specialised in Aboriginal traditional life, and also in the changes that have taken place since they began their research together in 1941.

Among their many books and articles, separately or together, are *Art in Arnhem Land* (1951), *The World of the First Australians* (1964, 1988), *Man, Land and Myth in North Australia* (1970), *Australian Aboriginal Religion* (1974), *Love Songs of Arnhem Land* (1976), *The Aboriginal Australians: the First Pioneers* (1983), *End of an Era* (1987) and *The Speaking Land* (1989). Among their edited volumes are *Australian Aboriginal Art* (1964, 1968), *Aboriginal Man in Australia* (1965), *Australian Aboriginal Anthropology* (1970), *The Australian Aboriginal Heritage* (1973, 1978, with E.S. Phillips), *Aborigines and Change* (1977), *Aborigines of the West* (1979, 1980) and *Social Anthropology and Australian Aboriginal Studies* (1988, with R. Tonkinson).

Their academic degrees include Ph.D (London), Hon. D.Litt (University of Western Australia), and they were Foundation members of the Australian Institute of Aboriginal Studies, Members of the Order of Australia, and Fellows of the Academy of the Social Sciences in Australia.

Dr John E. Stanton, Curator of the Anthropology Research Museum in the University of Western Australia, (renamed the Berndt Museum of Anthropology in the Berndts' honour) studied at the universities of Auckland and Western Australia. He has carried out research in western New South Wales, the Western Desert and the Kimberleys. He is presently working on innovative Aboriginal art, the subject of *Images of Aboriginal Australia* (1988) and *Painting the Country* (1989). He is a member of the Australian Institute of Aboriginal Studies, the Museums Association of Australia and the Australian Institute for the Conservation of Cultural Material.

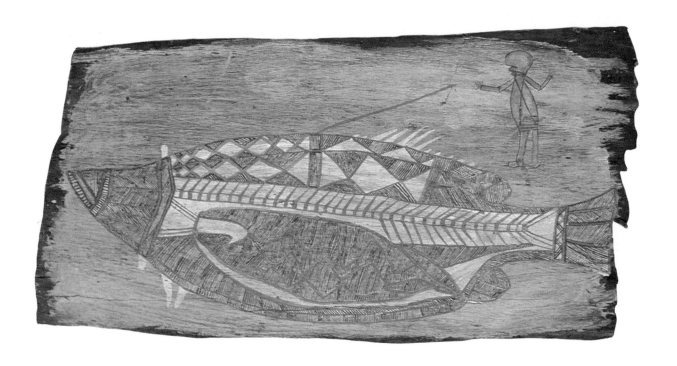

The spearing of the Dreaming Barramundi. Oenpelli, western Arnhem Land.

# Aboriginal Australian Art

Ronald M Berndt & Catherine H Berndt with John E Stanton

NEW HOLLAND

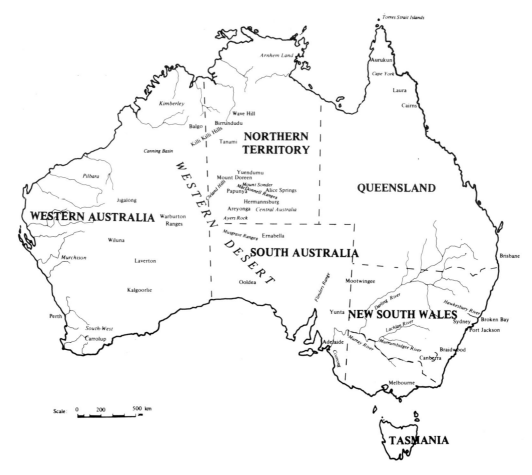

Scale: 0    200    500 km

Published in Australia in 1999 by
Reed New Holland, an imprint of
New Holland Publishers (Australia) Pty Ltd
Sydney • Auckland • London • Cape Town

14 Aquatic Drive
Frenchs Forest
NSW 2086 Australia

218 Lake Road
Northcote Auckland
New Zealand

24 Nutford Place
London W1H 6DQ
United Kingdom

80 McKenzie Street
Cape Town 8001
South Africa

First published in 1982 by Methuen Australia Pty Ltd
Reprinted 1988, 1992
Reprinted 1998, 1999 by Reed New Holland

Printed in Hong Kong by Dah Hua Printing
Press Co. Ltd

National Library of Australia
    Cataloguing-in-Publication Data:

Berndt, Ronald M. (Ronald Murray), 1916–1990
    Aboriginal Australian Art: a visual perspective.

    Bibliography.

    Includes index.

    1. Aborigines, Australian – Art. I. Berndt, Catherine H.
(Catherine Helen).

    II. Stanton, J.E. (John Edward), 1950– .III. Title.

709.0110994

ISBN 1 87633 402 9

# Contents

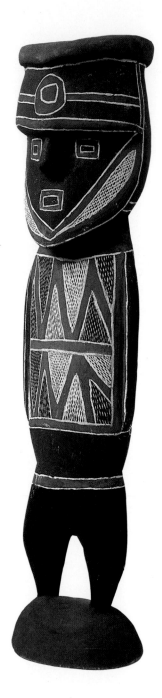

*DEDICATED TO*
*the Aboriginal artists who have contributed the works*
*of art illustrated in this book.*
*Any royalty moneys which accrue from the sale of this book*
*are to be put into a trust fund devoted to the purchase,*
*by the University of Western Australia Berndt Museum of*
*Anthropology, of works by Aboriginal artists.*

A Darwin policeman. Yirrkala, north-eastern Arnhem Land.

# *List of Plates*

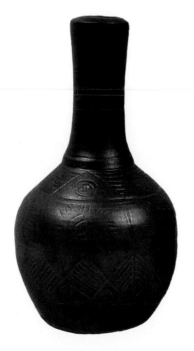

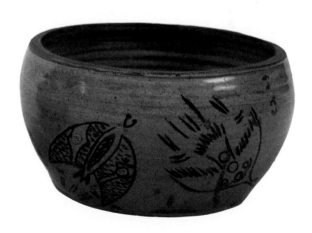

Two pieces of Tiwi pottery. Bathurst Island, Northern Territory.

THE AUTHORS OF THIS VOLUME express their appreciation to the Anthropology Museum Board of Management, the University of Western Australia, for permission to reproduce a wide range of materials held by it. Where specific objects are illustrated, these are noted as being in its collections, along with the names of various persons who through donation or loan, or through purchase, are associated with them. The Research Grants Committee of the Department of Anthropology, the University of Western Australia, has made possible the production of all these illustrations.

A number of persons also kindly supplied transparencies: Mr P. Bindon (Western Australian Museum), Plates 8, 9, 10, 11, 14, 15; Mr E. J. Brandl, deceased (through the Australian Institute of Aboriginal Studies), Plates 2, 4, 5; Mr R. Edwards (International Cultural Corporation of Australia), Plates 1, 3, 21, 22; Rev. D. L. McCaskill, Plates 19, 20; Mr P. J. Trezise, Plates 6, 7; Mr C. Roach (Australian Institute of Aboriginal Studies), Plates 94, 95; Mr N. Wallace, Plates 12, 13; Mr B. J. Wright (Western Australian Museum), Plates 16, 17, 18; and the Western Australian Art Gallery, Plates 52, 78A and B, 136. We take this opportunity to thank all of them. The original photographs of Plates 79 and 107-11 were taken in 1948 by Mr Woodward-Smith at the New Medical School, University of Sydney.

We have dedicated this book to the Aboriginal artists who have contributed the works of art illustrated here. Those,

# *Acknowledgements*

of the past and the present, who are represented here are as follows:

Arnhem Land: Groote Eylandt
  Nekaringa

Arnhem Land: north-eastern
  Djabu *mada*—Mama, Mudidjboi, Wonggu
  Dalwongu *mada*—Liagarang
  Djambarbingu *mada*—Banggalawi
  Djinang *mada*—Malangi
  Galbu *mada*—Gaguba, Midinari
  Gudji'miri *mada*—Dalnganda
  Gumaidj *mada*—Bununggu, Garmali, Munggaraui
  Magalranalmiri *mada*—Djimbaryun
  Manggalili *mada*—Banabana, Naradjin, Old Nanyin, Nanyin
  Maragulu *mada*—Dundiwuy
  Marangu *mada*—Gidbaboi
  Mararba *mada*—Mundugul
  Ngeimil *mada*—Lardjannga
  Riradjingu *mada*—Madaman, Mawulan, Wondjug
  Waramiri *mada*—Buramara, Madjuwi, Mambur (or Dick Marambar), Ngulberei, Wananyambi, Wuragi No. 2
  Wonguri *mada*—Magarwala

Arnhem Land: mid-west and north-east
  Gungurugoni language—Janbarri

Arnhem Land: western
  Gunwinggu language—Djamargula, Samuel Manggudja, Midjaumidjau, Jimmy Naguridjilmi, Neiimbura, Ngaiiwul, Dick Ngulei-ngulei, Joshua Wurungulngul
  Gunwinggu-Maung—Daniel Nalambir
  Maung language—Tom Namagarainmag, Old Wurungulngul
  Manger (Mangerdji) language—Nipper Maragar

Katherine
  Djauan language—Carpenter Paddy Djalgulg

Bathurst and Melville Islands
  Tiwi language—Peter Porkalari, Eddie Puruntatameri, Paddy Teeampi, John Bosco Tipiloura, H. Wonpa

Port Keats
  Indji

Central-Western Northern Territory
  Gugadja language—Badawun
  Ngari language—Djambu Lefthand
  Nyining language—Old Charlie Ralnga
  Wailbri (Walbiri) language—Munguldjungul

Papunya (Central Australia)
  Anmadjera language—Clifford Possum Tjapaltjarri, Billy Stockman
  Bindubi language—Walter Djambidjinba

Kimberley area: coast
  Nyigena language—Joe Nangan
  Ungarinyin language—Micky Bungguni
  Worora language—Alec
  — Big John Dodo, Lickie Nollier

Kimberley area: Balgo
  Gugadja language—Albert, Brandy Gunmanara, Mora 'Nagamara'

Hermannsburg (Central Australia)
  Cyril, Henoch, Lindsay, Rolf

Ooldea (South Australia)
  Andingari dialect—Mardidi, Mindinanga (a girl), Uninga, Wiriga (a woman)

Murchison district (Western Australia)
  Mambaroo

South-West of Western Australia
  Revel Ronald Cooper

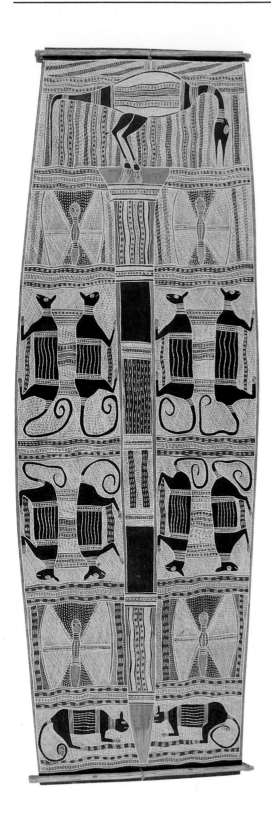

A *guwag* night bird on a wild plum tree, with possum.
Yirrkala, north-eastern Arnhem Land.

IN PRESENTING THIS BOOK, we have been guided by two aims. One is to place Aboriginal artistic endeavour firmly within its own socio-cultural context—recognizing the significance of changes that have been taking place in the matter of style over the last few decades and even longer. The other is to provide channels of communication into the wider Australian society, in the hope of encouraging more appreciation of Aboriginal art. In both cases, we are concerned with helping toward a better understanding of what Aborigines had in mind when they produced the works of art we illustrate here.

Traditional Aboriginal artists of the past, with a minimum of outside influence, have created masterpieces of considerable importance to the international world of art. In spite of the upheaval that has overturned Aboriginal societies throughout Australia, and the difficulties Aboriginal people have experienced in a variety of ways, great works are *still* being produced. One of our emphases is on the direct and indirect inspiration of Aboriginal religion in regard to all traditional forms of art, even in the domestic sphere. Our other emphasis underlines and demonstrates the qualities of Aboriginal imagination in adapting to new conditions, including an innovative approach to art. In that respect, we try to indicate the exciting trends that are evident today. It seems that Aboriginal art is at last escaping from the external pressures of commercialism, and that Aborigines are coming to recognize

# *Preface*

the great value and richness of their own cultural heritage; while acknowledging the force of economic necessity, they have decided that this must not be the final arbiter.

Most of the material illustrated here has not been published before. That does not apply so much to rock art, except for a few plates. Rock art provides a backdrop against which we can look at contemporary trends in particular areas. In our choice of examples, the bark paintings and sculpture of Arnhem Land predominate, as perhaps they should because of the masterpieces that have been produced there. We have attempted to balance these against outstanding work from other parts of Australia, most notably from the central-western part of the Northern Territory and from Papunya. But even for Arnhem Land, there are less familiar types of art: for instance, ochre-moulded heads, and brown paper drawings. In the sphere of more obvious innovation, where traditional Aboriginal styles have altered radically or where European influence is dominant, it is still easy to find artistic examples of great merit.

Finally, a short comment on the format of this book, and on the division of labour between the three persons whose names appear on the title page. The six chapters in the main text provide an overview of Aboriginal art in general terms. We have purposely avoided noting plate references here. Following them comes a fairly detailed list of annotations to all the plates, arranged so that the plates are correlated with the chapters and their subject matter. With the same intention, rather than cluttering the text with references to various writings associated with our discussion, a Bibliography is attached, which is particularly relevant to the section on 'Descriptive Annotations to the Plates'.

Professor R. M. Berndt was mainly responsible for the writing of this book, including the annotations; Dr Catherine H. Berndt edited and 'polished' it; Mr John Stanton was entirely responsible for preparing and assembling all the plates and maps, and organizing basic annotative materials. Collectively, the task has been a time-consuming one.

We hope that the beauty of the works of art illustrated here will appeal to readers, and stimulate their interest in this dimension of the Australian Aboriginal heritage, and in the Aboriginal people themselves.

R. M. Berndt
Department of Anthropology
University of Western Australia
January 1981

## CHAPTER ONE

# *Perspectives & Meaning*

WITHIN THE LAST TWO HUNDRED YEARS a new population has spread across the face of the Australian continent, almost replacing the indigenous inhabitants, and their culture too, including their rich and varied art forms. But Aboriginal art was not really accepted *as* art by the new settlers. Even now, it is often relegated to a particular category called 'primitive art'—not necessarily because it is simple or crude, but because Western European people were accustomed to regarding non-Europeans, or some of them, as being either 'primitive' or essentially different from themselves. In keeping with that view, they assumed that the aesthetic productions of most of the non-Western world were not equivalent to those available in the great centres of European art. 'Italian Primitives', for instance, in spite of the label, were not regarded as 'Primitive Art'.

There were exceptions. Art from other parts of the world had its own following in Europe and in north America. The wide-ranging field of 'Oriental' art (China, Japan, the Indian sub-continent, Korea, south-east Asia) appealed to a large number of committed connoisseurs, and not only to artists. Africa, with its Benin and Ifé bronzes, and Mexico and south America were a focus of interest for others. They were attracted by such factors as colour and line and texture and new techniques, or unfamiliar perspectives. The mixture of aesthetic and intellectual appeal led some of them to adopt a different perspective toward the culture or civilization that was the source of these products. The great traditions of Asia, for instance, were seen by some scholars as being on a par with European traditions, if not superior to them. And in approaches to non-European art forms, the dialogue between 'material' and 'spiritual' values has been a continuing theme.

Aboriginal Australian material had only a minor role in all this. It was outside the mainstream of discussion and artistic involvement. A handful of non-Aboriginal artists, especially within Australia, have sought inspiration from Aboriginal art. But what some of them, at least, were looking for was not so much the art itself as something else, something behind it. They were engaged in a search for the primordial mainsprings of life, or for the so-called mystic forces of a 'timeless land', forces mistakenly believed to be inherent in the supposedly simple forms of Aboriginal art.

Appreciation of Aboriginal art has been steadily growing over the years. Even so, it is a very limited appreciation. People in general are still a long way from understanding it—and from *enjoying* it in its own terms. Within the confines of its particular cultural styles, it is a sophisticated medium. And it has been responsible for the production of masterpieces of outstanding aesthetic quality. In this book we provide a selective panorama of Aboriginal art, in the hope of stimulating such appreciation and enjoyment and understanding of the contribution of Aborigines to the wider world of art.

One way of developing this kind of interest is through visual impact. A particular item catches a person's attention because it is similar to what that person is ordinarily responsive to aesthetically—or because it

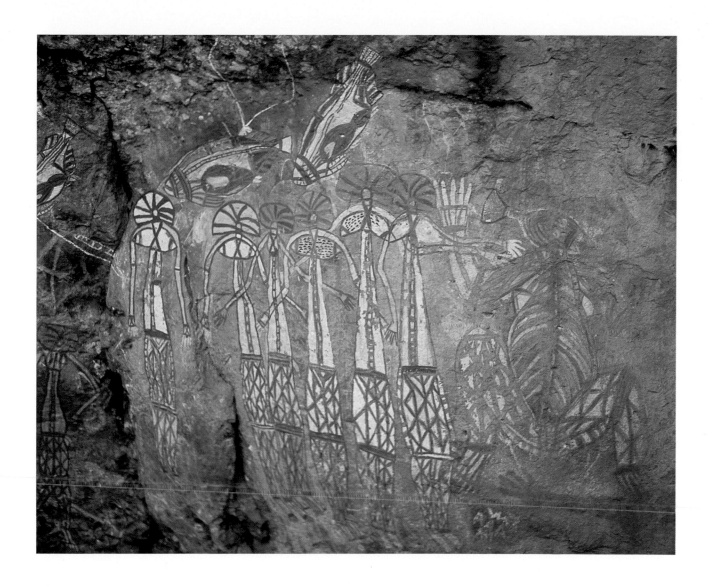

*Plate 1:* Dancing figures at Nourlangie Rock, western Arnhem Land.

is so different. This experience is highly subjective. It depends partly on a person's own cultural background and, in relation to Aboriginal art, on how receptive he or she is to differences. Or it may catch his imagination, a process that is not easily defined or described. Something about the painting or sculpture, or whatever it is, may trigger an emotion or an idea, or a new line of thought or action.

The second way poses more difficulties. It can lead to understanding, but not necessarily to appreciation. This is through what we can call 'intellectual application': trying to find out more about the art itself and the aspirations of the artists. That process has to involve getting to know about the cultural background and the meaning of the representation depicted.

These two ways of approaching Aboriginal art are essentially linked, but they actually lead to different results. In the first case, it is necessary to go a little beyond identifying what makes sense in one's own terms. But in this case, interpretation is limited to one's own personal experience. It is almost a kind of 'ego trip', and the fact that the object or design depicted *is* Aboriginal is more or less irrelevant. In the second case, we are led into another world of understanding and meaning which expands our own, creating bridges of illumination. All art is potentially communicatory. It has something to say to people who take the trouble to learn its language, or (as in the case of Aboriginal art) languages. It is that approach which we take here.

Although so many outsiders have had trouble in coming to terms with Aboriginal art, and continue to regard it as 'primitive' or simplistic even if they evade using those expressions, traditionally-oriented Aborigines were quite unconcerned about such opinions, and would have dismissed them as irrelevant. For them art was, and occasionally these days still is, part of everyday life. It was a living reality, never 'art for art's sake'.

This does not mean that Aboriginal artists did not appreciate graphic design, the curve of a line, the balance of figures, the beauty of nature around them, or the overall treatment of their work. Without doubt, as examples in this book demonstrate, care and loving treatment of subject matter were important and personally gratifying. Nevertheless, the production of a work of art was really of secondary consideration. It was art in the service of man (and woman), social man—a way of achieving or trying to achieve particular ends that were fairly well defined and understood within the artists' social milieu. In that sense, in every case, such representations had something to say, something to convey to those who were in a position to identify its imagery and symbolism, who knew its socio-cultural context.

In the realm of the aesthetic—and in this book we are concerned with only one of its dimensions— Aboriginal Australians undeniably excelled. They demonstrated a richness that contrasted sharply with their poverty in some other respects. Superficial simplicity and outward signs of physical hardship and deprivation have been obvious enough to anyone looking at the Aboriginal scene, in the past as in the present. Too often, however, those signs have been taken as representing the whole picture, obscuring or diverting attention from the complexity and beauty within.

# Art as a reflection of nature

Almost all living peoples have attempted to make graphic or three-dimensional statements about how they perceive the external world of nature. They have tried to encapsulate and to interpret both changing and seemingly unchanging features in their social and natural environments. In doing so they provide frames of reference which underline their relationship to those environments. Consciously and otherwise, they are expanding their own experience, and putting to varying use what they have set down or recorded.

Aborigines throughout Australia developed a particular way of coping with their environment. They brought it into their own social perspective, collectively humanizing its non-human ingredients. That enabled them to come to terms with it, placing it within a social context and imbuing it with meaning in relation to themselves: the unknown could be made known, the unfamiliar made familiar.

This mantle of meaning is especially important in regard to the visual arts. What Aborigines represented through the medium of painting on bark or stone, or through sculpture, had symbolic significance. On one hand, what they depicted was explicable in terms of itself. Irrespective of the cultural art style used in a given area, it could be identified as an example of a particular natural species, or natural phenomenon. On the other hand, it could also be identified as having additional or symbolic meanings, because a socio-cultural belief system had been superimposed upon the natural world as part of the carefully organized, comprehensible world of human beings. People saw themselves in association with various aspects of nature—often, but not always, in mythological terms. Their world was vibrant with natural, visible living things. But it was also vibrant with supernatural or mythic beings and their agents or intermediaries, expressed through such natural living creatures, including humans.

Such beings were the basic core of what is often called the Dreaming. This is a translation of the vernacular words used in some regions, and an overall interpretation of a number of others that have the same range of meaning. It points to a concept which symbolically expresses the eternal qualities of life—as a *general* concept, and as an issue of immediate significance to human beings. The Dreaming, existing from the beginning of time, is just as relevant in the present as it was in the past, and is vitally important for the future. This is not just a matter of emphasizing the social relevance of the-past-in-the-present. That is, or was, taken for granted. What it does underline is the essential similarity and the essential oneness of all living, natural things, of which human beings are part: all share a common life essence, a kind of basic identification with the natural environment and all it contains.

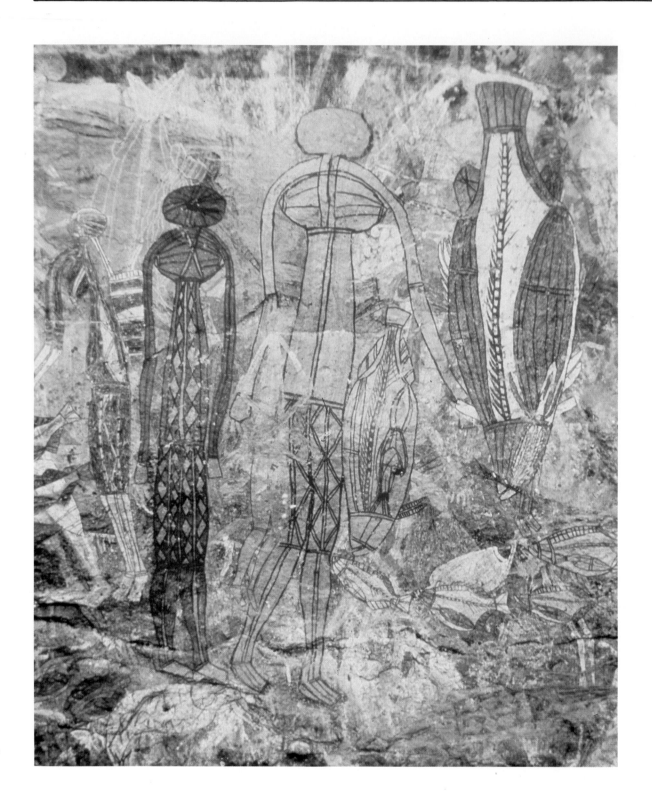

*Plate 2:* Paintings from Deaf Adder Creek, western Arnhem Land.

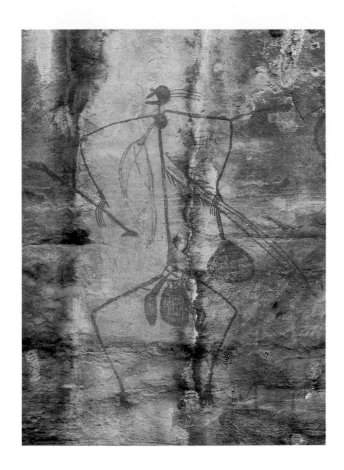

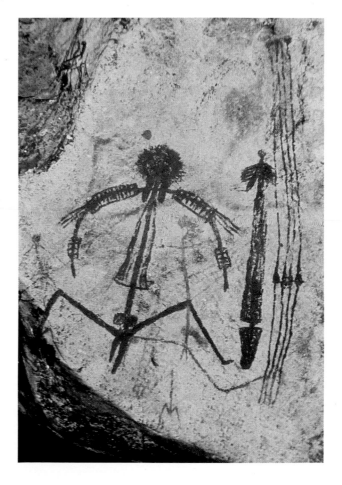

*Plate 3:* Mimi art at Oberi Rock, western Arnhem Land.

*Plate 4:* A squatting Mimi at Red Lily Lagoon, western Arnhem Land.

# A spirit-based art

In a sense, nature was harnessed through myth and ritual, because that is the sphere in which are to be found, and identified, supernatural beings through whom are manifested the control and regulation of natural phenomena. Mythic beings themselves signified or symbolized the various forces or elements in nature—not necessarily all of them, and often only indirectly or in association with others, but they are key figures who provide linkages into the Dreaming as the real source of life. So, while people obtained a 'religious control' over nature or particular aspects of nature, it would be just as true to turn this around and to speak of the crucial control nature had over people. They were absolutely dependent on its resources. And to make that dependence more socially acceptable, less onerous, providing an assurance for the future, they had—standing between themselves and nature—the mythic beings themselves, as intermediaries.

These beings and their adventures in the Dreaming are the subject matter of myth, song and ritual. They are also manifested in tangible, material form. A wide range of representational art is made in the shape of mythic beings or things connected with them—things which stand for them, symbolize them, or evoke them. Their preparation is in itself a ritual act, often accompanied by singing directly relevant to them. The symbolic form of a particular being or creature is a vehicle for its spirit. The artist is a re-creator, responsible for re-activating the spiritual powers of Dreaming spirits, bringing them into direct relationship with man so that he can draw on their powers. Although we shall be looking at this aspect in Chapter Two, it is well to remember that in Aboriginal Australia the artist performed a crucial role, not so much as an artist *per se* but as a re-activator. Virtually everything he painted or carved or constructed was an act of creation, revivifying the spiritual, transforming it into a tangible, visible focus of ritual behaviour.

The situation was fairly complex. It was not simply a matter of an artist painting or carving *any* object of mythic significance. What he carved or painted had to be spiritually relevant to him, either because he was a member of a particular local descent group, or because of his conception or birth affiliation, or because he had been accepted as a full member of a particular ritual constellation. He had to be linked spiritually in a special way, through the Dreaming, with what he produced. Being born or conceived at a particular mythic site implied that part of the spiritual substance of the supernatural being in residence there had entered his foetus and animated him. It implied that he was a living representative of that being, a potential custodian of the rites and myths and songs associated with it. As an artist, he was in a position to re-create the images and objects in his own mythic background. Only in that way could the material representations become spiritually active.

# *A land-based art*

Aboriginal art, then, was acknowledged as having a purpose: it was intended to fulfil a specified function, not necessarily an aesthetic one, although that is significant too. The primary reason in all Aboriginal art was to re-create a specific condition, usually a mythic one, in order to achieve a state of affairs that was defined at the very beginning, in the creative era of the Dreaming, for the 'real' world of human beings now. This did not happen automatically. People had to observe the rules and requirements that went with it. One of these is the 'membership rule' mentioned in the last section.

Specific men, by virtue of their relationship to certain aspects of the Dreaming, and through their membership of a specific local descent group in whose territory particular mythic sites were located or in which the deathless spirit beings reposed, were responsible for producing tangible items (in the form of sculpture, carving, painting, etc.). These served as media through which the power or life-essence inherent in such beings could be transmitted in order to replenish the earth, to ensure the fertility of the land and of all living creatures, including human beings. This meant that some persons—not all, and most usually men—had special responsibility for the ritual tasks that were necessary to maintain the natural *status quo* of the environment on which they depended. Their responsibility extended only so far, and usually involved aspects that concerned their own territory: their ritual 'coverage' was strictly limited. However, every such group was only one of a number that spread across a larger territory. To ensure replenishment of the natural resources of the whole countryside, members of other local descent groups with differing mythological associations were involved in the same process. The ritual and artistic activities of different groups, within a language or 'tribal' span, were essentially complementary.

Rituals were cooperative undertakings in which people sought and received aid from others. A complex kin-oriented network stretched across the differing local descent groups, with their members depending on one another in preserving the continuity of life. Some mythology and its associated sites were localized, peculiar to specific areas. Other myth-sequences, with related sites, extended over wide stretches of country. They formed tracks or pathways that linked territories of several local descent groups and even, in some cases, extended beyond the language and cultural horizons of those groups whose members met together or recognized potential linkages. These tracks, commemorating the movement or travels of the spirit beings, often cut across the tracks of other mythic characters. Some characters joined company and travelled on together. Others simply met and then continued on their separate ways until eventually they 'made themselves' or 'turned into' a particular site—or were metamorphosed as rocks, waterholes, trees, paintings, or some such physiographic feature. Everywhere they moved across the land, and wherever they camped or wherever they performed some action, they left part of their spiritual essence.

Aboriginal art, as one would expect, was land-based. Almost every painting or piece of sculpture was an

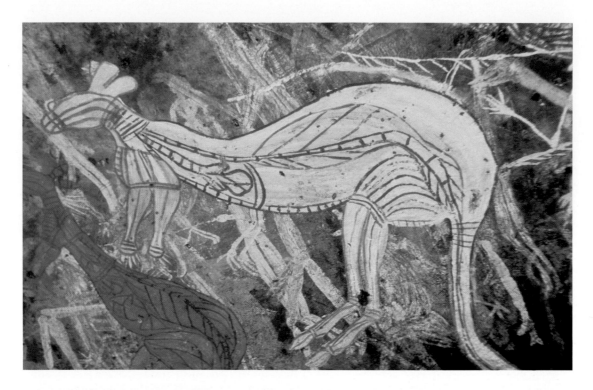

*Plate 5:* X-ray kangaroo and wallaby, western Arnhem Land.

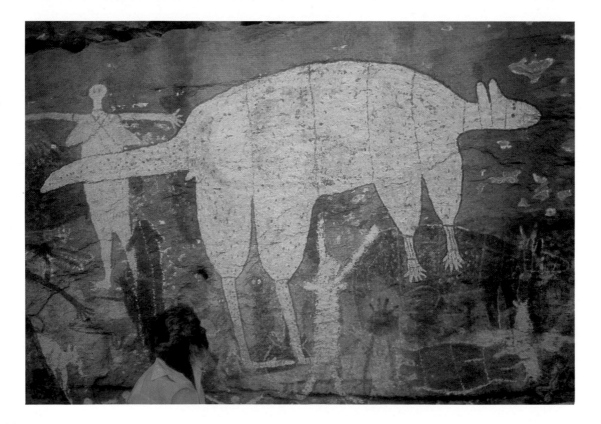

*Plate 6:* 'Quinkin' kangaroo, near Laura, Queensland.

*Plate 7:*
   'Quinkin' figure, Queensland.

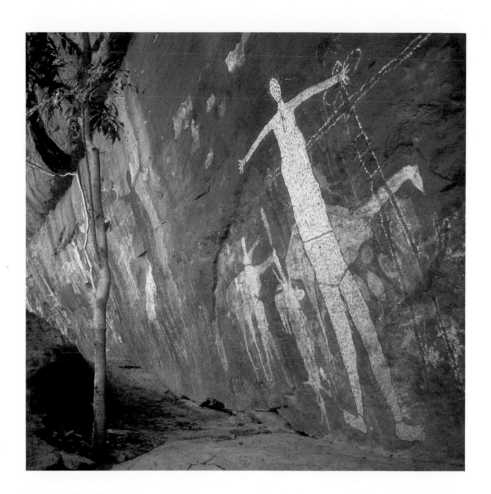

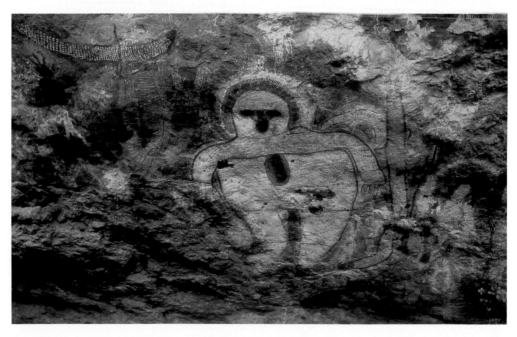

*Plate 8:* A typical Wandjina figure, Napier Range, Kimberley.

# Art as social

item in a charter relating to land, to ownership and possession of specific tracts of country. More than this, almost every painting and piece of sculpture was interpreted through a mythology in which Dreaming characters were the eternal actors. The land was vivified and made socially relevant through these Dreaming characters—in their own right, and also in the right of living Aborigines.

In a sense, the eternal beings lived and continue to live an independent life of their own. In another sense, they live spiritually through particular living persons and are dependent on them. These are two sides of the one coin, and closely interrelated. Traditionally, the tracks and pathways first made by the mythic beings were those over which Aborigines moved in their socio-economic pursuits. In their case, unlike the land over which the personages of the mythological era moved, the whole of the country was charted, and contained the named and identified physical creations of the Dreaming beings. The land, therefore, was dense with meaning—with song and story, and with their living spiritual representatives, manifested as features of that countryside. Most Aboriginal art was, then, a statement concerning land: not just any piece of land, but specific stretches of land substantiated through identified mythological associations. Simultaneously, it was a statement of personal and social ownership by virtue of the connection of a particular person or persons with those spirit beings.

One aspect which transformed nature into a social component was the shape-changing quality of many mythic creatures. They were in either human or some other physical form, with the power to change from one to the other as occasion demanded. A character could be manifested through a particular creature (bird, animal, reptile, insect, and so on), or could 'turn into' that creature at physical death—to live on spiritually in that creature and/or at a site associated with him/her/it or into which he/she/it was metamorphosed. In some instances, as we have noted, a mythic being 'made himself (or herself) into a painting' leaving his/her imprint on a wall of a rock shelter. In such a case, it is said to have been there from the beginning of time, and was (is) re-touched or the painting refurbished only in a ritual context.

The fact that so many mythic beings were shape-changing (remember, not all of them were) underlines two crucial aspects. (1) Because a particular being could assume the shape of a certain creature, a goanna for instance, the assumption was that both had the same life-essence. Consequently, all goannas today continue to have that spiritual association with their creator; and, likewise, the mythic being is manifested through all of them. (2) A particular mythic being is responsible for particular human beings. All persons conceived or born at, or otherwise associated with, the actual place where a mythic event took place (where the mythic being 'turned' himself or performed a particular act of creation or otherwise) are spiritually linked with him/her. They are one of his manifestations. In such cases, the creature representing or

symbolizing the relevant mythic being is the vehicle or intermediary which signals or heralds the conception or birth of a person. By virtue of this event an intimate association exists between that creature and the person concerned. Through this procedure, the mythic and natural worlds are regularized and brought within the social world of people. Or we can view it as a procedure through which people are incorporated into nature and into myth. In fact, it is really one intimate and socially defined world where everything that is the concern of man is patterned in social terms.

We have seen, in relation to land, that the power of particular mythic beings can be manifested only through particular persons associated with them. A person's descent, birth or conception defines that association and conveys with it the right to produce particular material representations. Others may help, because of their linkage through their mothers or mothers' brothers, or other close relatives. However, ownership and rights—in regard to a specific design or image, a segment of a certain myth or ritual, in the relevant land, in the sites where mythic transformation took place, and indeed in the mythic character himself or herself, and so on—these rights were and are not questioned, and are vested in the person or persons who are spiritual 'counterparts' of that mythic being (or beings). These social facts have important implications when we come to consider art and the position of the artist in Aboriginal Australia.

Traditionally, the definition of an 'artist' was not the same as in Western European society. He (less often, she) was not professionalized. He was confined to working in patterns and designs and conforming to a subject matter specifically relevant to his own social group and, by extension, to particular other kin-based groups. Anyone in the appropriate group could do these things—*if* they were fully initiated and had the required religious knowledge. However, there were always some men who were more competent artistically, and better able to interpret the range of materials relevant to their group or groups. Some demonstrated an early aptitude for such work and were taught by older artists. All were, essentially, 'potential artists', although some were more consistent in their interest and more widely acclaimed as being proficient in what they did.

An artist's presentation of subject matter was predetermined, because it was mostly intended for specific ritual occasions. In such circumstances, specific requirements had to be met. The object produced had to be in an acceptable traditional form and be recognized as such. Only in that way could it be potentially effective. The extent to which innovation was permissible varied from one area to another. It was more pronounced in north-eastern and western Arnhem Land and Bathurst and Melville Islands than in, for example, the Western Desert. Nevertheless, although it was crucial everywhere for any production to be socially acceptable, a certain amount of individual treatment was socially acceptable too. Some artists inevitably left the imprint of their own artistic accomplishment, to the extent that it is possible to distinguish an 'individual accent' in a number of great masterpieces.

Aesthetically, it is not always easy to pick out a masterpiece as contrasted with a work of lesser quality. As far as Aborigines are concerned, the evaluation of a specific work would rest on both its subject matter and its ritual importance. Questions relating to graphic representation, balance and overall treatment would also be taken into account. The real clue, however, to a judgement about its beauty would be found in the appropriateness of cultural style and in familiarity of design. In all cases there were approved, traditional ways in which particular subjects, mythological or otherwise, should be treated. Beauty was epitomized, in conforming to or within a particular local art style.

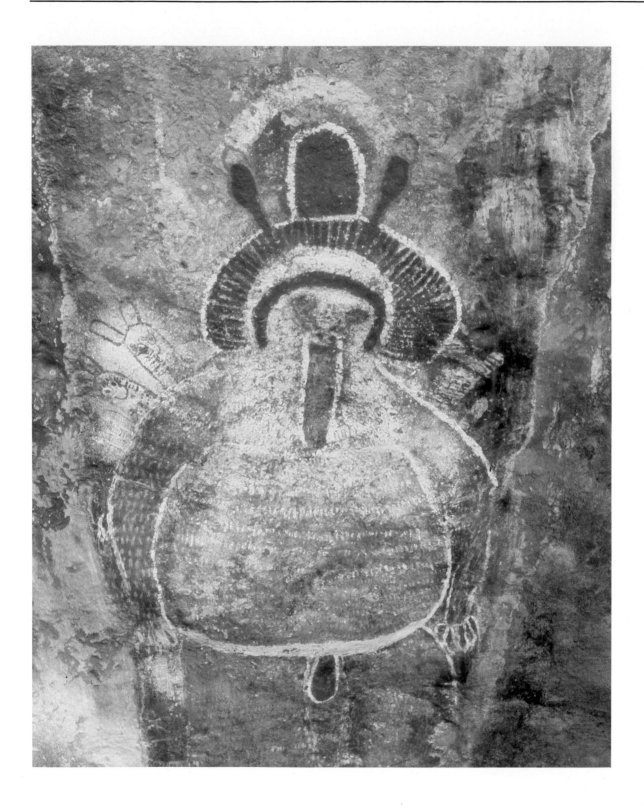

*Plate 9:* A Crocodile Wandjina, Oscar Ranges, Kimberley.

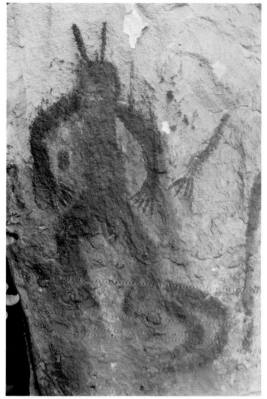

*Plate 10:*
  A Lightning figure, Trent River, Kimberley.

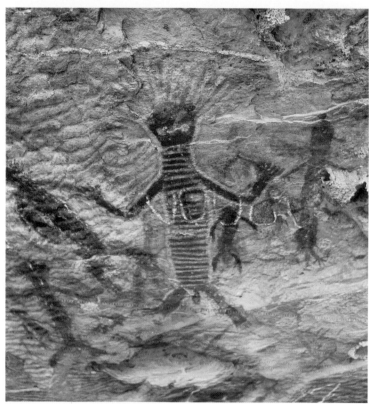

*Plate 11:*
  Red ochre figures, Carr Boyd Range, Kimberley.

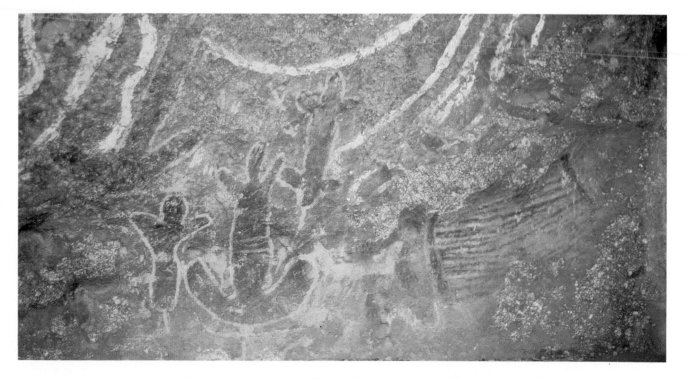

*Plate 12:* Wall paintings south-west of Ayers Rock, Central Australia.

# Art and style

*That* was considered to be the right way of doing things; and any too-obvious variations were likely to meet with criticism—or a more drastic response if they fell right outside the normal range of acceptability.

This situation is changing in some areas, for both artists and their productions, as alien contact intensifies. Other avenues have become available for deploying their work, the social setting has been widened and altered, and so have the rules. Traditionally, an artist carved and painted mostly, as we have said, for ritual purposes. To do this was sufficient satisfaction in itself, although he would usually receive some form of compensation for his work. After use, the object was dismantled or left to deteriorate under ordinary weather conditions: some that were left standing at a camping site might remain more or less intact for a couple of seasons or so. The only exceptions were some ritual objects, such as long wooden incised boards, stone *tjurunga* and so on.

External demands for Aboriginal art have changed the role of the artist. He may now devote a considerable amount of time to such activity, and consequently earn a reasonable living from it. But to do this, he must take into account alien demands which do not necessarily coincide with his own, or with those of other members of his community. As we shall see later, many Aboriginal groups have adapted themselves to meet the new situation; and this has often meant a deterioration of traditional aesthetic standards. In some cases, in contrast, it has enabled genuine innovative procedures to be developed, in terms of design and technique.

The question of style is of fundamental consideration here. Traditionally, Aboriginal Australia was not socially or culturally uniform. Not only were there many different languages (which were not mutually intelligible), but there were also dialectal variations. Depending on how such units are defined, there were about 500 distinctively identified larger social entities (sometimes called 'tribes'), with their own territories. The members of any one of these saw themselves as being different in a number of significant ways from neighbouring groups. Traditionally, the members of such a large-scale unit were self-supporting. They were organized into smaller, closely linked functional units which provided overlapping, 'hinge' populations on their boundaries, and their culture was considered to be more or less unique to themselves. While they interacted for certain limited purposes with their neighbours, for religion and trade, they did not travel great distances and rarely out of the region they regarded as their own 'tribal' territory or country. They preferred to remain within the region that was familiar to them, the land with which they were mythologically associated.

It is in relation to this picture that the matter of artistic style must be considered. In one sense, each culture could be said to have expressed itself artistically in a more or less unique fashion. In another sense, the cultural configuration in certain regions shows marked internal similarities, despite local variations and contrasts. Western Desert art style is an example. What is usually called Western Desert culture spans a very large region indeed, and it is characterized by

one broad language-type but a number of dialects. Traditionally its population comprised many small, territorially based but more widely interacting social-dialectal units. Overall, this more or less common culture extended from Ernabella in the far north-west of South Australia, and part of Central Australia; north from the transcontinental railway in South and Western Australia (the Great Victoria Desert) through Laverton, Warburton Range, Wiluna and Jigalong, including the Gibson Desert, the Great Sandy Desert and the Canning Basin to Balgo, south of Halls Creek in east Kimberley. Throughout this region, the simplicity and beauty of curve and line, circles and concentric circles, which in some northern areas are expanded into a multitude of geometric designs, expresses virtually the pinnacle of abstract Aboriginal art.

All Aboriginal art traditionally rested on the need for explanation; and Desert art, even more than other Aboriginal art forms, depended on accompanying oral communication. Highly abstract designs had to be interpreted, and the degree of interpretation depended on the religious sophistication of the communicator. Some recurrent symbols can be identified over fairly wide areas: circles, curves and meandering lines, various tracks of creatures and so on. But it was not possible, from one area to the next, to interpret any one overall design, in its combination of symbols, without aid from the design's owners. Even where abstract figures predominate, naturalistic ones may be present too. The Western Desert was undoubtedly the largest art region of Aboriginal Australia; and without too much difficulty, it could be expanded further to include Hermannsburg, Ayers Rock, Yuendumu and Tanami. There were and are other large art areas, although none as extensive spatially as the Western Desert. North-eastern Arnhem Land is one. Another is the Wandjina tradition of the north-western Kimberley coast; and, now no longer a living traditional culture,

the Narrinyeri bloc covering the lower River Murray, the Lakes area and the Coorong in South Australia.

When considering style, we must take into account the mature and vivid prehistoric art of which examples still remain throughout the continent. Some are very old indeed. In some parts of the north they co-exist with living Aboriginal art, or ancient paintings are overlaid with more recent ones. This is most obvious in western Arnhem Land, where the galleries of paintings are probably the most extensive in Australia. The same old-and-new contrast appears in the Wandjina paintings of the Kimberleys; they represent the most striking of rock art, remarkable for their beauty and variety. There are thousands of outstanding art sites scattered throughout the country. Many contain irreplaceable masterpieces, such as the Quinkin figures of Cape York. Additionally, there are constellations of rock sites including finely incised and engraved figures. Probably the most significant are those in the Yule River area of the Pilbara, Western Australia, many wrought with great delicacy, and distinctive as art forms. And to mention just a few, there are the Cleland Hills examples in Central Australia, with their incised faces on cliff walls; those from the Flinders Range-Yunta area in South Australia; and the pecked intaglios at Mootwingee in western New South Wales, and the Hawkesbury River, Sydney district, among many others.

One intriguing issue is the apparent continuity of some art styles over very long periods of time. This is most conspicuous where a prehistoric art complex exists spatially within the context of a living traditional art, as in western Arnhem Land and the Western Desert, and along the north-west Kimberley coast. The continuity of style in art forms depicted on the rock facings of shelters and caves is especially evident in the last two areas. In the western Arnhem Land galleries, the situation is slightly different. While the subject matter of Mimi art (see later) continues to be

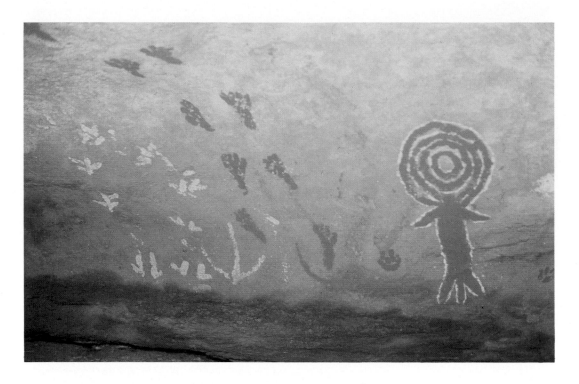

*Plate 13:* Cave paintings with stylized human figure, Western Desert.

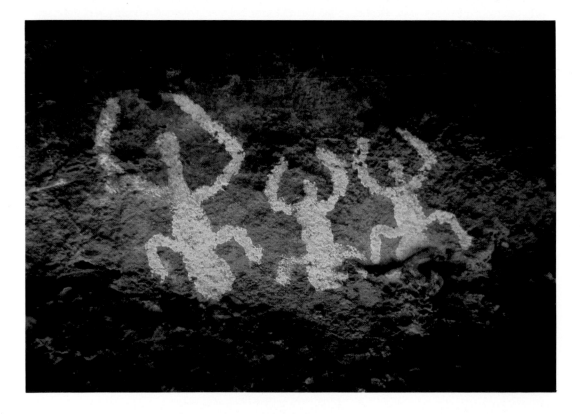

*Plate 14:* Dancing men, near Braidwood, New South Wales.

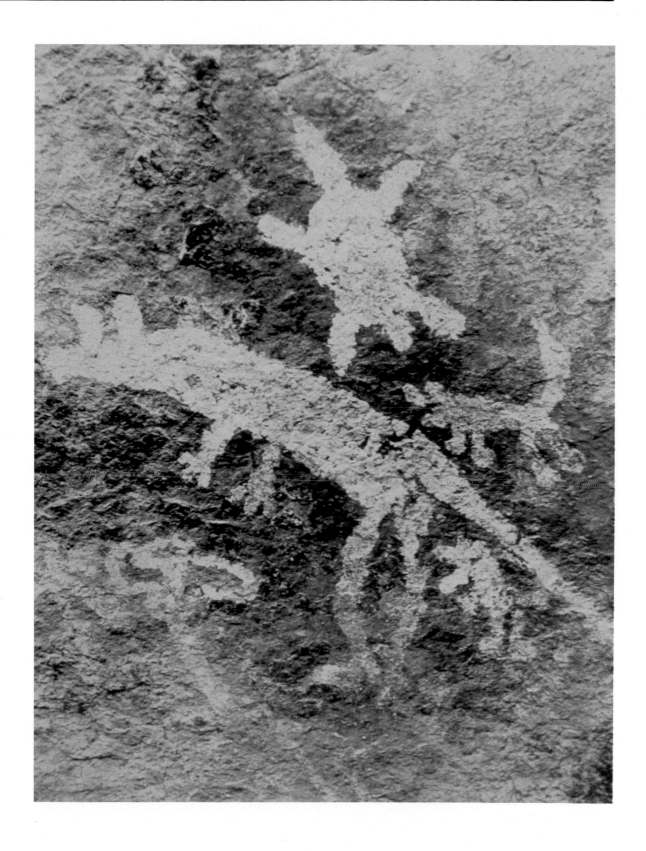

*Plate 15:* A dog and her pups, near Canberra.

significant there, the stylistic way of portraying these figures differs from earlier forms. The fact that the earlier examples are now called Mimi does not necessarily mean that they were regarded as being Mimi in the past. On the other hand, the unique x-ray art of this region appears to represent a continuing feature. At the same time, changes in representation are obvious.

Comparisons between prehistoric and contemporary art forms are, or course, invidious. Without knowing the context and meaning of the earlier ones, it is impossible to extrapolate into the past from the present. However, while contemporary Aboriginal interpretation of older work is often plausible, this is not the same thing as knowing what that work meant to people in the past. Continuity of style in particular cultural areas is, nevertheless, persuasive; and at the local level it is supported by the concept of the Dreaming, which itself emphasizes continuity in terms of the relevance of past events and values in the present. Moreover, religious ritual stipulated that emblemic figures and designs had to be, should be, produced in the way or ways in which they were originally made at the beginning of time. No one would suppose that such emblems as are made today or in near-traditional times resembled exactly those produced in earlier periods. Nevertheless, the assumption is that they should be alike—for various reasons, but mainly because of identification (in regard to certain characteristics which had to be portrayed) and because their efficacy would be impaired if they deviated too widely from socially acceptable forms. In sum, it seems reasonable to infer that the continuing influence of early art forms was significant in contemporary (non-innovative) artistic endeavour, over and above questions of individual interpretation.

There is a further influence which has some bearing on local cultural styles. We could call it the topographic influence. We have already emphasized that Aborigines were closely attached to their land and to everything within that land. It is, therefore, not surprising to find this relationship reflected in their art. A great deal of Aboriginal art contained designs representing segments of country—especially in north-eastern Arnhem Land and the Western Desert.

In north-eastern Arnhem Land, many of the bark paintings on mythological subjects depict these in relation to specific stretches of land. Similarly, those concerning *mada-mala* (dialectal unit-clan) emblems are abstract records of particular territories. The same theme was, and is, repeated in body painting, in the designs placed on sculpture, on secret-sacred poles, in ground structures, and the like. In the Western Desert, virtually all religious art was essentially topographical and mythological—although on occasion other subject matter may be superimposed.

The point here is that, although stylistically the ways of depicting country differed from one cultural constellation to another, the very fact that this was significant in so many different contexts meant that it had some bearing on the development of style. To put the matter simply, the collective choice rested on landscape rather than on portraiture. With Aboriginal Australia, ignoring some exceptions, it was landscape (or land) *and* myth which predominated. Portraiture did not develop and was not encouraged, except in a generalized and conventionalized manner. Mythic characters, for instance, were identified not so much by their facial characteristics as by the symbols shown in connection with them.

A further influencing factor had to do with the materials available and the techniques that were customarily used. The basic colours were red, white, yellow and black (ochres and charcoal), pipeclay and manganese, rubbed on flat stones and moistened with water. On the north coast of Arnhem Land orchid

tubers were used as an adhesive, their juices being mixed with the liquid ochre. Brushes of human hair, burred sticks and twigs, and even fingers were used for painting. Stone tools (axes, wedges, knives, scrapers, adzes etc.) were commonly used to remove slabs of stringy bark from trees and to trim their edges, and to produce wood carvings, or for incising. Sheets of bark had to be specially prepared, the outer bark removed to lighten them and facilitate the drying process and to ensure a flat inner surface. The wood clamps now used on two sides of a bark painting so that it remains flat were not used traditionally. Most wood carvings or sculptures were incised, or painted with ochred designs. Additionally, human hair, feathered twine and feathers served as decorations. The technical equipment of artists was limited, although what they had was most efficiently employed. Even so, it had a bearing on local cultural styles.

Over and above the issue of materials and techniques, was the way artists themselves painted or carved. Apart from permanent or static areas such as the walls and ceilings of caves and rock shelters, when people stood to paint or erected platforms for the purpose where the rock walls were high (as in western Arnhem Land), they nearly always worked sitting on the ground. With a sheet of bark placed flat on the ground or propped up against his legs, an artist could move it around without changing his position, or he could move around it as he developed his theme. Topographic representations were often shown as if the artist was looking down on the country, rather than seeing it from ground level. Again, there was the custom of depicting figures of importance (mythic beings, humans or natural species as the case may be, and depending on the context) as being larger than others of lesser significance. Such conventions, although they varied through the continent, are significant for understanding beliefs and values, and wider similarities in style.

The regional patterning of art styles in Aboriginal Australia poses some still unanswered questions. Anyone who becomes familiar with the diversity of Aboriginal art can distinguish fairly easily the 'typical' work of western from north-eastern Arnhem Land, or both of these from Groote Eylandt, Port Keats, Melville and Bathurst Islands, the Western Desert, the Wandjina of the north-west Kimberleys and so on. Looking at the illustrations in this volume should help in identifying and comparing these. However, there are a couple of points to remember.

Some regions include two or more well-accepted aesthetic approaches. We have mentioned two in western Arnhem Land: the distinctive x-ray art, and the scenes of stick-thin little Mimi characters; as well, there are complex curvilinear-figure forms, and also directly representational paintings and objects. Whether these can all be categorized together as manifestations of one style, or a regional combination of styles, is a matter of opinion. In the case of the Western Desert, abstract art co-exists with 'natural' representational art. While we continue to speak of the Western Desert cultural bloc as being roughly similar, it is necessary to recognize the proliferation of abstract geometric designs in the north-west sector of that region.

Another point here is what has been called 'cultural diffusion'. Interaction between neighbouring groups involved the spread of material things, and discussion of such things. Incised pearlshell pendants and pubic coverings with traditional geometrical patterns found their way by means of trade and gift-exchange from one group to another across thousands of kilometres, and were eagerly sought by both men and women. The same was, and is, the case with secret-sacred boards and other objects.

'Style' is more than a matter of lines and shapes and colours arranged in specified ways. From one angle, it expresses the values underlying what people who share a particular culture regard as aesthetically

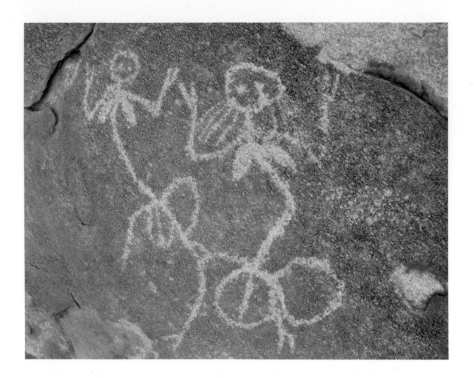

*Plate 16:* Dancing women at Yule River, Pilbara, Western Australia.

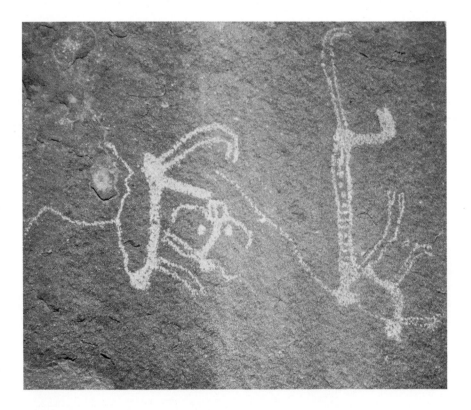

*Plate 17:* Two couples at Woodstock, Pilbara, Western Australia.

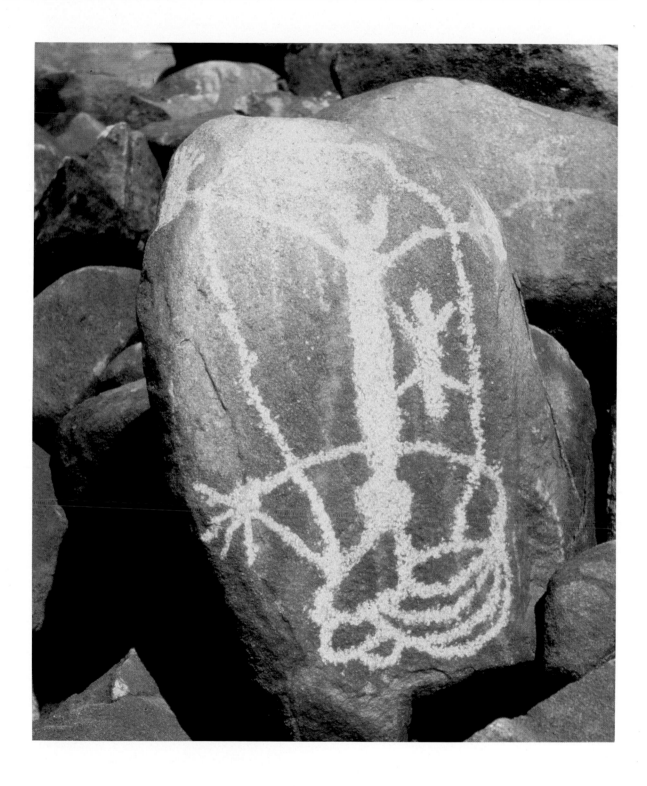

*Plate 18:* Woman and child, near Roebourne, Western Australia.

# *Art and communication*

pleasing. From another, at a superficial non-symbolic level, it provides visible items easily identifiable by such people. Traditionally, mythology set the guidelines, indicating what should be done by the artist. Visual art was not something which existed, or was produced, apart from its socio-cultural context. It was integrated into the total system. A bark painting or a piece of sculpture was not regarded as solely a visual experience, separable from everything else. It had to do with mythology, with song, and with dance. It had its social milieu and belonged within a broader setting. When we speak about 'style', it is important to recognize that this was not something which belonged to visual art alone. It made its presence felt in all aspects of social living, and was/is reflective of the social organization and structure of a particular society. It concerned the way people organized themselves in relation to one another.

*Art* is really a matter of design and of planning, of organizing available space in a meaningful way; and *style* is the way it is organized. In these circumstances, it is reasonable to suggest that style has a direct association with the organization and structure of a particular people. It was an expression of the ethos of a people.

To some extent we have already discussed this aspect. Essentially it concerns the 'language of art', as a form of non-verbal communication. The major point here is that all Aboriginal art has something to say, but does not necessarily convey the same meaning to all people within a particular culture. It is something which must be learnt. At the same time, it may not be *available* for learning to all sections of a given community.

For example, all 'open art' (or public art, whether or not it is religious) depicted through a recognizable style should be immediately identifiable within the artist's community.

A large north-eastern Arnhem Land mortuary bone-receptacle is shaped to signify, in a conventionalized fashion, a particular creature or some aspect of the natural environment, and on its ochred trunk are painted *mada-mala* (dialectal unit-clan) emblemic patterns. The shape, the particular social unit to which emblems refer, together with any representations of various creatures, would certainly be recognized at first glance by every adult in that area. Along with this they would recognize, if they did not already know, the social affiliations of the deceased person whose bones it contained. They would also identify (again, if they did not already know) the affiliations, if not the actual names, of the men, or likely man, who had made this object, as well as those who would be involved in the ritual associated with the erection of the receptacle. Broadly, too, all local observers (both men and women) would almost certainly know the name or names of the mythic being or beings associated with the emblemic designs. However, unless that design was

also spiritually linked in some way with a person's own social groupings, he or she would be less likely to identify instantly, without asking, the topographical and situational contexts of those beings. Further, that sort of *detailed* information could be 'read' into the design only if the person (most usually a man) had already acquired it during religious revelations on that specific subject. The symbolic implications of the designs are another matter, and their religious significance would require considerable knowledge on the part of an observer.

With secret-sacred sculpture, wood-carving and painting, identification depends on the acquisition of information gradually attained through ritual. Access to this is based on sex, age and social affiliation.

In the Western Desert, abstract designs are incised on long wooden secret-sacred boards and bullroarers, on hair skewers worn in the buns of newly initiated men, on spearthrowers, and on shields. Particular sets of designs may be used for all of these, whether they are secret-sacred or open-sacred or used simply for decoration. One design (the same one) may be interpreted differently by different people depending on their sex and age, or on their degree of religious sophistication. What is important here is the social context in which the design is used and, significantly, on what object it appears.

Traditionally, then, Aboriginal art was designed to communicate ideas to specific persons or groups of persons. Whatever local style was involved, it served as a vehicle through which a vision of the natural world could be conveyed—a world, however, seen through a mythological screen. A particular production encapsulated an aspect of nature at one period in time, or rather at a particular time or season of the year. It was not so much the 'actuality' of a situation with which an artist was concerned. Rather it was the essence, an attempt to obtain the essential elements which constituted a particular idea. This need to perpetuate such an idea was vital to Aboriginal social living: it was crucial to the process of making the mythological cloak, which shrouded nature, real and purposeful. In other words, an artist who depicted an aspect of nature was engaged in transforming it mythically, projecting its spiritual essence into the service of human beings.

This conscious procedure of encapsulation on one hand and, on the other, selection of specific features in combination with mythic interpretation, provided a stimulus to the growth and development of abstract (or symbolic) art. It also underlines the intellectual quality or aspirations of Aboriginal art, because in all cases meaning is paramount.

For example, in a ground structure or rock painting from the Western Desert concentric circles signify waterholes; shallow u-designs are places where persons (mythic persons) sat, the 'u' being the mark made by the buttocks in sitting; there are the track marks of various creatures, various 'shapes' which refer to foliage, trees, water courses, burnt-out country, and so on. The essential ingredients are drawn or painted. *In toto* it concerns a particular named place. It is a topographic representation of that place from the vantage point of its shaping (that is, its formation) by a mythic being, and from the perspective of the present time—*any* time. The mythic being may be shown *in situ*; or, if not shown, his/her presence is latent: this

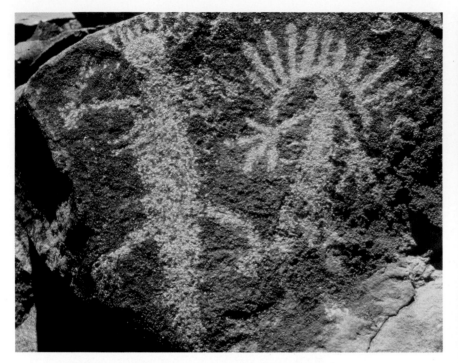

*Plate 19:* Figures near the Ashburton River, Western Australia.

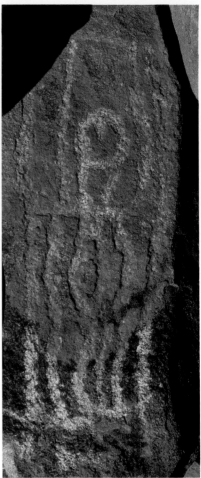

*Plate 20:*
An abstract incised pattern at
Waldburg Range, Western Australia.

*Plate 21:* A Cleland Hills face, Central Australia.

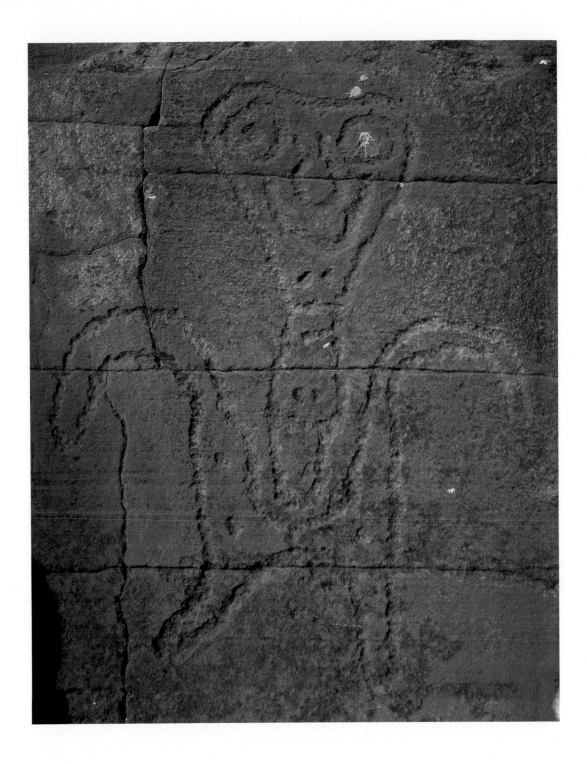

*Plate 22:* A Cleland Hills figure, Central Australia.

is the place where he/she left part of his/her spiritual substance or was metamorphosed for ever. The mythic interpretation of this revelation provides the place, and its replication in the form of drawings or paintings, with a timeless quality. What is there, in regard to its permanent features and the changing seasonal growth of its natural species within and around it, will *always* be there by virtue of its place within the Dreaming. In short, it is a statement of personal and social assurance, expressing faith in the future.

While mythic beings are symbolic of certain aspects of nature and are indeed manifested through those aspects, the one often standing for the other, their depiction in an art form emphasizes the spiritual linkage between the Dreaming and nature. But, as we have seen, it goes further than this. By portraying a section or aspect of the total environment within its mythological perspective, the artist not only reproduces an enduring feature. Also, he provides a medium through which the power of the Dreaming may be brought to bear on the affairs of human beings: for instance, in giving efficacy to ritual. In the case of an artist creating or re-creating an image of a mythic being, he is constructing a vehicle which, under special circumstances, may be 'possessed' by that being. Those circumstances must be reproduced in accordance with traditional social and stylistic dictates. In all such cases, art is much more than an attempt to set down graphically an artist's personal experiences, or his own view of his surroundings or of the 'passing scene'.

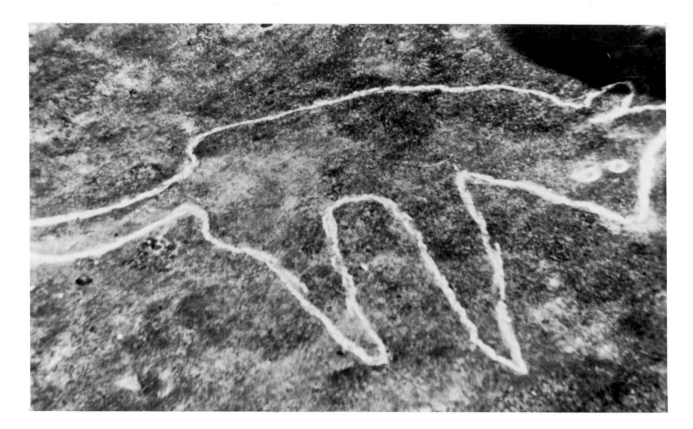

*Plate 23:* Engraving of a dog at Woy Woy, New South Wales.

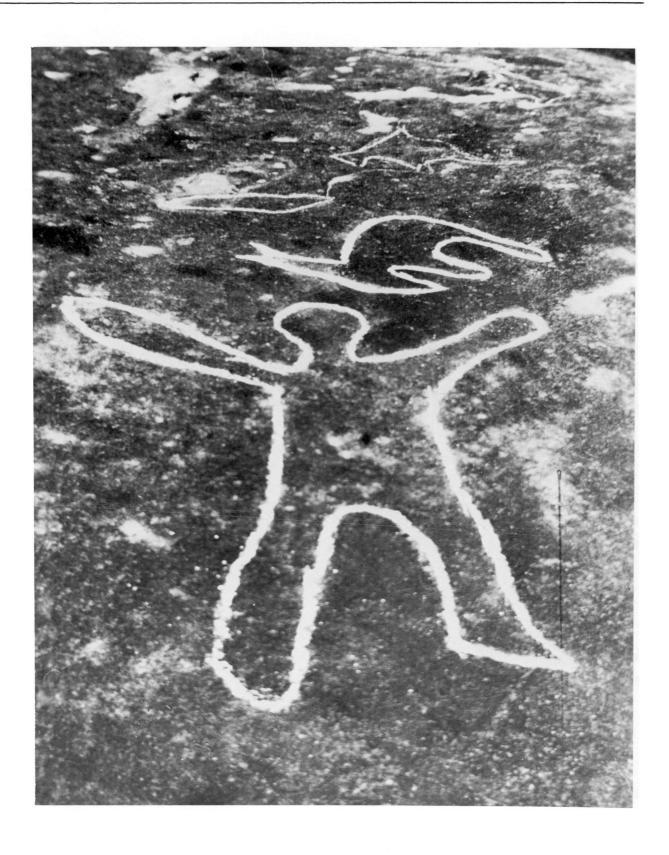

*Plate 24:* A human figure at Woy Woy, New South Wales.

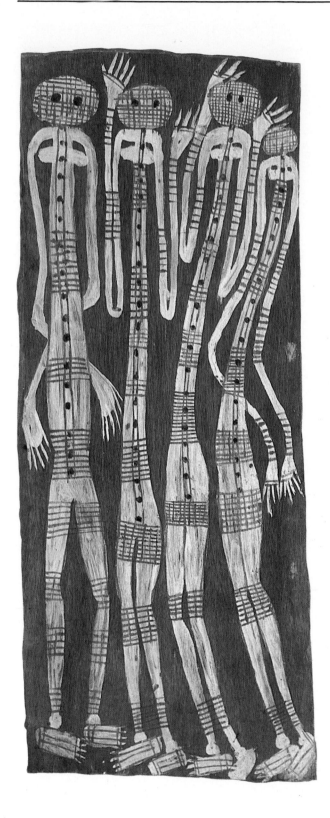

*Plate 25:*
   Dancing women. Croker Island, western Arnhem Land.

# CHAPTER TWO

# *Living Traditional Art*

REMEMBER THAT NOT ALL ABORIGINAL ART directly concerned religious topics, although much of it did. Some dealt with ordinary subject matter with no mythological relevance. Some focused on things seen during the course of hunting and food collecting or domestic living—particular natural species, or social occasions such as fights or 'play-about' dances, or just creatures or people at rest. There were also conventionalized representations of human beings, prepared for purposes of sorcery or love magic. Many traditionally constructed bark huts in Arnhem Land had on their walls rough sketches of a variety of subjects which in themselves had no direct religious connotation. Some of them were mere doodling, which would not ordinarily have been regarded as falling within the frame of artistic expression. This was apparently true in the past in the case of some cave or rock paintings, as it is now when the walls of introduced-type houses are sometimes covered with all sorts of graffiti. It is not our intention here to separate out such endeavours from what can be regarded as 'true' art.

Traditional Aboriginal art was—and is, where it is still of social significance and not simply a commercial exercise—defined primarily in terms of its particular style and its topographic-mythological relevance, whether or not it had/has a direct relationship with specific ritual. However, it was also recognized that a working definition was much wider. For example, in north-eastern Arnhem Land, Baiini or pre-Macassan (that is, pre-Indonesian) as well as Macassan contact was the subject of stories, myths, and songs, many of which were also expressed in ritual performance. As we mentioned, various objects were made which commemorated their visits to the north Australian coast. A great deal of this kind of experience has been integrated with local traditional culture. The Baiini are historical, human characters, but from the perspective of local Aborigines today they are seen almost as belonging to the Dreaming. Bark paintings commemorate some aspects of Macassan life: praus in full sail, utensils they brought with them, maps or charts showing praus and Macassans at Melville Bay and Port Bradshaw, and Macassar itself, which some Aborigines, prior to 1910, visited with their trading partners. Here and there on the walls of cave and rock shelters are paintings of a different kind of alien contact. Ships, cattle, horses, men with guns, and other such exotic sights attracted the attention of local artists, but without the song and ceremonial connotations of the Macassan experience.

So, not all the paintings on the cave walls were of a religious or magico-religious nature, or for sorcery (black magic) purposes, but some were concerned with past events in the human era. In the Oenpelli region of western Arnhem Land, for example, both religious myths and recent-past stories involving human beings were told in conjunction with preparation or retouching or showing of appropriate graphic illustrations. Key situations within such stories were translated visually on to rock walls or sheets of bark, to emphasize that the story was 'true', and to give the listeners an extra dimension of understanding. In the Western Desert, when a small group was listening to stories around an evening camp fire, or resting in the shade on a hot afternoon, the story-teller would illustrate the action by using little leaves or sticks as the main characters, or by making a series of marks

# A religious tradition

and designs in the sand, quickly erased and replaced as one event succeeded another.

For this reason, we include a series of brown paper drawings from north-eastern Arnhem Land, and from Ooldea on the lower southern fringe of the Western Desert. These provide some interesting contrasts to the more 'traditional' modes of expression. In both cases, they are stylistically the same as other material of this kind expressed through different media—on bark for the Arnhem Land material, stone or wood for the Western Desert. However, because a different 'canvas' medium is used, and an introduced crayon or pencil marker, some changes are discernible even though the traditional conventions are retained. We do not regard these as being innovative. Some of the most outstanding items in *that* respect come from the central-west of the Northern Territory. They also provide stylistic variations within a specific cultural context. They were drawn for a particular purpose; and while we could perhaps designate some of them as being innovative, we prefer to deal with them in this chapter. Many are of religious significance or purport to illustrate traditional scenes; stylistically, they are of direct Aboriginal inspiration.

Within the frame of religion, depicting mytho-topographic scenes deeply concerned with the Dreaming, are the now-famous Papunya paintings. Originally they were constructed on the ground during secret-sacred ritual, in designs using ochres, featherdown and blood. Now, such designs have been transferred to chipwood boards, masonite and canvas. They retain their basic traditional style, but with innovative overtones: their meanings remain unchanged.

Religion is not very far away from any of the productions of traditional Aboriginal art. Everything associated with the Dreaming—and it is hard to find anything that is not—*is* religious. The Dreaming embraced virtually every aspect of Aboriginal activity. We need to bear in mind that Aboriginal religion was not a mystical system designed to insulate people from the realities that faced them in gaining a livelihood or in interacting with others. It was based on a deep faith in the supportive ability and energy of deities (that is, the mythic and spirit beings) who were both directly and indirectly responsible for maintaining the *status quo* of all living things—human beings as well as natural species, and the environmental forces of nature. In them resided the life-essence that was variously channelled to ensure an animate and productive world. It ensured the interlocking of the spiritual and the material, the tangible and intangible. These were believed to co-exist as essential ingredients of everything within the Aboriginal perspective. They combined both finite and infinite principles.

The deities in their supportive role did not (could not) work alone. They needed the services of human beings in order to release their 'power' or life-force to bring about a desired state of affairs. Essentially, this was viewed as a cooperative undertaking between deities and people. In conception and birth, a particular event alerted both mythic being and man to the transference of part of its life-force (its spirit) which animated the foetus of an unborn child. Retouching a painting relating to a mythic being at his own site, together with singing or other ritual actions, was

enough to guarantee the spiritual and material replenishment of the natural species associated with him. The ritual performance of the Kunapipi (Gunabibi), which in north-eastern Arnhem Land involves the two Wawalag Sisters in mythic interaction with Yulunggul the Rock Python, is symbolically a re-enactment of the great myth at the onset of the monsoonal season, to create the necessary conditions for the yearly appearance of the monsoon. On the death of any person, the performance of mortuary ritual provided conditions which enabled him or her to pass from the world of humans to the spirit world in order to prepare for subsequent rebirth. Many examples along these lines, in local variations, emphasized the complementary nature, although differing roles, of deities and man.

Let us underline this point: that mythic beings are believed to be spiritually alive and available in the present, but ritual is a necessary pre-requisite in order to activate their relationships with people. The appropriate rites, varying between mythic characters as well as between regions, are based on the pattern traditionally circumscribed for those characters. Often the actual procedures were stipulated by the characters themselves. For a ritual performance to be successful, the conditions must be congenial to them—must fit their instructions or directions. The ritual must re-create, or re-enact, the mythic scenes in which they participated in the Dreaming. That re-creation was accomplished by producing tangible objects which symbolized not only the deity himself or herself but other associated things and creatures. The objects provided both the atmosphere and conditions for ritual. For this reason, we can say that Aboriginal religion was and still is the inspiration for Aboriginal visual art. The objects used were a necessary part of the ritual singing, music, dancing and decoration of human participants: visual art belonged to this broader setting, and was integrated within it.

So we could also turn our statement around and say that the visual arts were an inspiration for Aboriginal religion. It is clear that, from an Aboriginal viewpoint, ritual objects were much more than simply objects in themselves. They too, by virtue of their re-creation by an artist, contained the spiritual substance of relevant mythic beings, or served as temporary vehicles for those beings. Where stone *tjurunga* of the Aranda are concerned—or the long incised boards of the Western Desert, the *maraiin* emblems of western Arnhem Land, or the *rangga* posts of north-eastern Arnhem Land, etc.—these objects represent the symbolic bodies (or parts thereof) of particular mythic beings and are treated as being so; they are rubbed with ochre and touched with reverence. The surface of such objects is incised with designs relevant to the particular country of such beings and to their Dreaming actions. The designs are their body decorations, similar to the decorations painted on the bodies of human ritual participants. This is why the objects are made: to convey or transform the mythic being into a human social context where his/her power could be brought to bear on human affairs, conceived to be also the affairs of mythic beings; and in doing so to ensure, through mythic intervention, the continuation of life as Aborigines know it, or knew it. And of that life, the socio-economic was of primary concern. In a sense, ritual art was not merely instrumental, but utilitarian. So, for that matter, was Aboriginal religion. Aborigines saw religion as being a pattern or guide for survival, as being complementary to the imperative, more mundane tasks of hunting and foraging. Aboriginal art too was both spiritual and practical. The work of an artist was subjugated to social needs and ends; but these were his needs also, furthering his own interests.

# Painting

No archaeological evidence is available of paintings on bark or wood. There is, as we have already seen, no scarcity of early paintings on the walls and ceilings of caves and rock shelters. It is therefore reasonable to suggest that Aborigines painted on any clear surface which came to hand, especially as many still do so on human bodies, on the walls of bark huts and so on. Painting on sheets of bark has been reported for many different areas of Aboriginal Australia. Some of the earlier ones, as from Tasmania, are no longer in existence. Others are reported to have been produced in Victoria, and at least two of these have survived; and some were painted in south-eastern Australia.

Bark painting as we know it today seems to have been localized in northern coastal regions, particularly in Arnhem Land. At the same time, there is a tradition of painting on bark in the northern Kimberleys, within the Wandjina art area. Its subject matter is not confined to the famous Wandjina spirits: it includes a range of other spirit characters, as well as various sea and land creatures. As early as 1834 there were reports of ochre paintings on bark shelters at Melville and, presumably, Bathurst Islands. Apart from the paintings on *bugamani* (*pukamani*) mortuary posts and other ritual paraphernalia in that area, bark bags were painted with varying designs.

Bark paintings from the vicinity of what is now western Arnhem Land have been known to the outside world since 1878. These early specimens came from Port Essington on the Cobourg Peninsula, as did others collected by Foelsche (1882), Carrington (1888) and Basedow (1907). The main 'classic' collection was obtained by Baldwin Spencer (1914, 1928) from around Oenpelli, source of the large collection assembled by R. and C. Berndt in 1947 and especially in 1949-50, and those collected by C. P. Mountford in 1948. Art distinguished as being in the style, or styles of western Arnhem Land has come also from the Katherine and Adelaide rivers area and from Beswick, which probably represented its south-western extremity. The traditional eastern extremity was marked by the Liverpool River, which today at Maningrida provides a blending of 'generalized' western and north-eastern Arnhem Land styles, although distinctive examples of each are seen there.

There are marked differences in style between the paintings produced for Baldwin Spencer in 1912 and those of the late 1940s and early '50s. In the early part of the century, Gunwinggu speakers were not as numerous and dominant along the East Alligator River as they were thirty to forty years later. Stylistically, the art of people belonging to the 'old' or indigenous language groups along the River, and the Kakadu (or Gagudju) toward the South and West Alligator rivers, belonged to a different art tradition from the Gunwinggu. Some of that 'old' tradition still survived in the early 1950s, but not for very long after that. Gunwinggu art was essentially assimilative, retaining basic themes of the older form but putting its own imprint on its productions. The Maung of the Goulburn Islands rarely painted on bark. By the mid-'40s and earlier the Gunwinggu were well represented there, and bark painting was being produced.

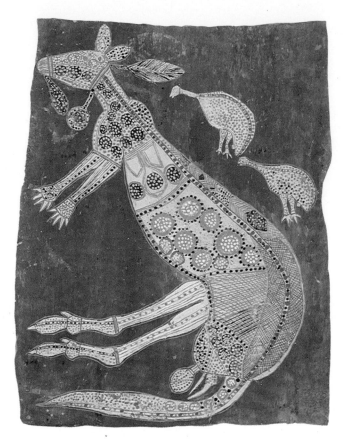

*Plate 26:*
    The mythic kangaroo, Nadulmi.
    Oenpelli, western Arnhem Land.

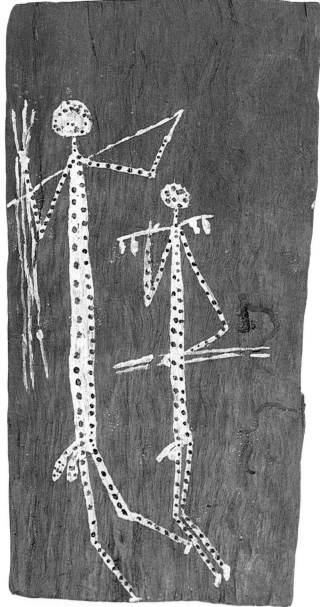

*Plate 27:* Two hunters. Oenpelli, western Arnhem Land.

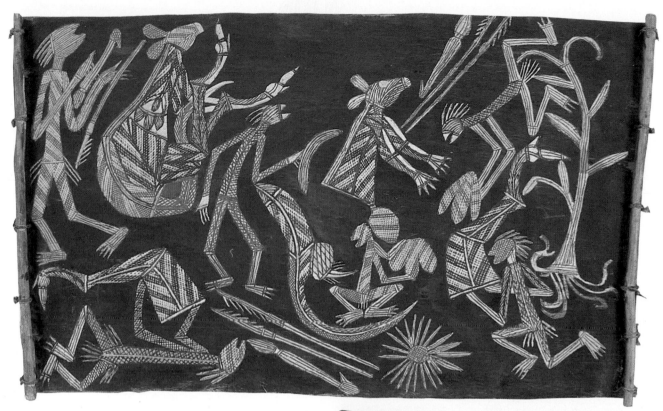

*Plate 28:* Mimi spirits dismembering a kangaroo.
Oenpelli, western Arnhem Land.

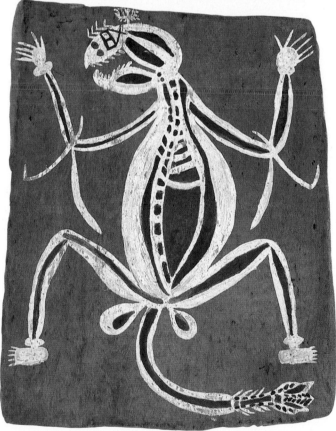

*Plate 29:* Aranga. Oenpelli, western Arnhem Land.

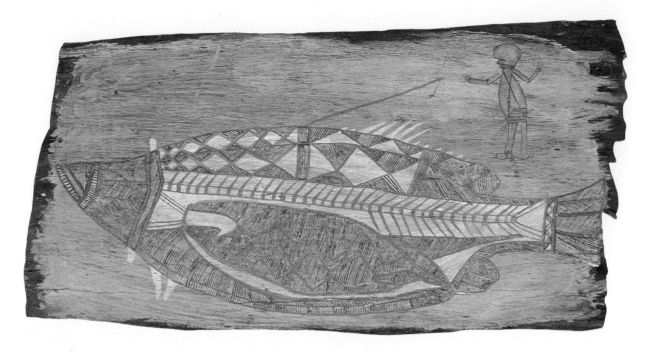

*Plate 30:* The spearing of the Dreaming Barramundi. Oenpelli, western Arnhem Land.

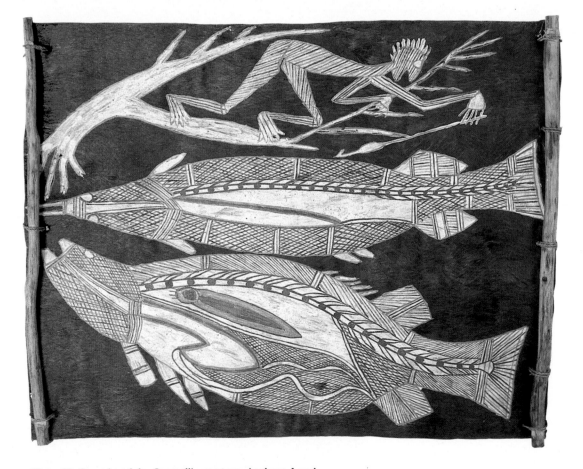

*Plate 31:* Spearing fish. Oenpelli, western Arnhem Land.

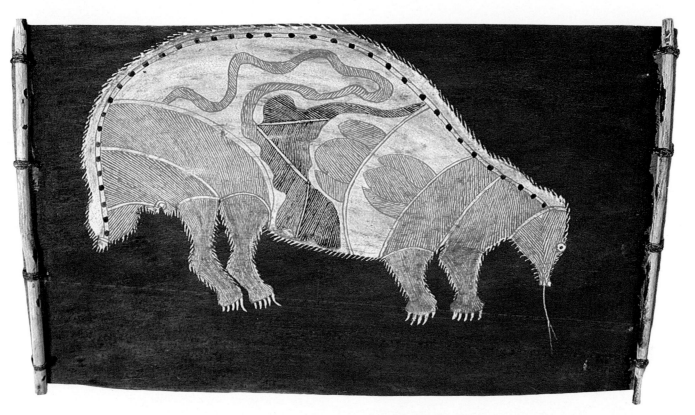

*Plate 32:* Echidna, x-ray style. Oenpelli, western Arnhem Land.

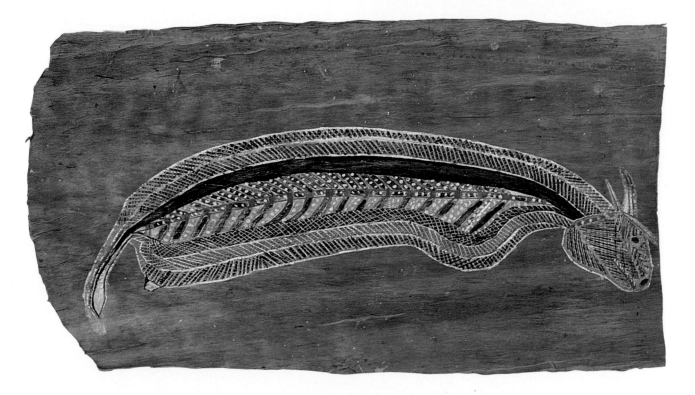

*Plate 33:* Ngalyod, the Rainbow Snake. Oenpelli, western Arnhem Land.

*Plate 34:*
    Emerging from the belly of Ngalyod,
    the Rainbow Snake. Oenpelli,
    western Arnhem Land.

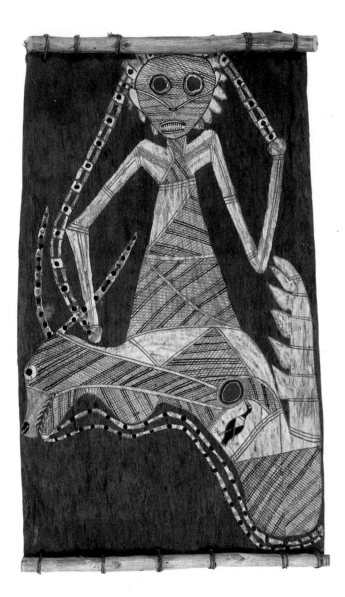

While subtle differences existed in the past and were observable up to the late '50s, we can now speak of a generalized western Arnhem Land art style, recognizing variations within that range. The art which comes from this region can fairly easily be distinguished. The most striking features are the x-ray and Mimi paintings we mentioned before, the depiction of sorcery and love magic subjects, and the treatment of space. On this last point, remember that the artist is limited to a canvas-size determined by the dimensions of his stringy bark sheet. As with most bark painters in western and eastern Arnhem Land, the design the artist has in mind is outlined broadly on the red-ochred surface. Even some of the great artists erase parts of their initial sketches in the process of planning what they want to portray.

In western Arnhem Land, careful attention is paid to balance, and to providing space around the figures so that they 'stand out' and are not lost in a multitude of background design. It is the figure which is important, either by itself or in relation to other figures. This device emphasizes action, as contrasted with static representation. The image is enhanced through the control of space, as well as through the use of curves, roundness and dots. Subject matter varies widely, although spirit and human beings and various creatures predominate. While aspects of the countryside are depicted, especially where mythic metamorphosis is concerned, this is in terms of landscape rather than topography. X-ray figures (of animals and humans, as well as of mythic beings) show internal organs and skeletal structure—some detailed, others only in part, or suggested. In this style, the intention of the artist is to show the whole being, not simply its external

*Plate 35:* A mythic woman within a
termite mound. Oenpelli,
western Arnhem Land.

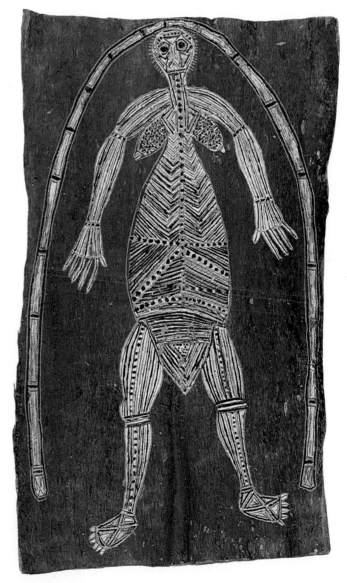

manifestation. Some artists say that, without the internal aspects of man and creatures, 'we show only their shell; we want to show them living'.

The very dissimilar Mimi art almost certainly belonged to the 'old' western Arnhem Land tradition. There are many examples on the walls of local rock shelters. However, Mimi art of the late '40s and early '50s is not the same stylistically as the earlier forms—which were simple linear figures of great variety, spirited in execution and of considerable beauty. The later examples retain echoes of this quality but, with some exceptions, they are rather stilted. There are many stories about the matchstick-thin Mimi spirits. A few human travellers are said to have met and talked to them, in their home territory high in the rocky escarpment. In recent years the name Mimi has come to include a number of other spirits which previously had different names and characteristics. The well-known Ngalyod or Rainbow Snake has also gradually changed shape over the years, not so much stylistically as representationally. This important mythic personage, in her (his) guise of being a good or bad mother, is concerned with seasonal fertility and the shaping of the landscape, and sponsors religious ritual. She appears in many mythological accounts, as well as in 'historical' stories.

Sorcery painting in and around western Arnhem Land is quite distinctive, and seems to owe its origin although not its style to similar themes in the rock painting of the area. The earlier forms may belong to the broad category of Mimi art, because some of them resemble the composite sorcery figures obtained at Oenpelli in the late 1940s and early 1950s. Basically the figure of the prospective victim is painted with a

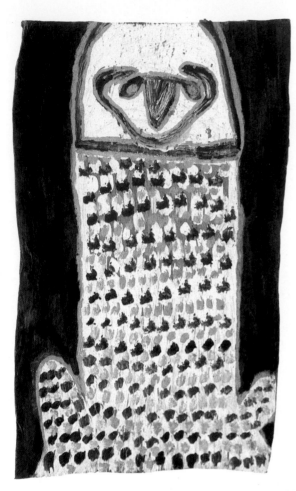

*Plate 36:* The metamorphosis of Nimbuwa.
Oenpelli, western Arnhem Land.

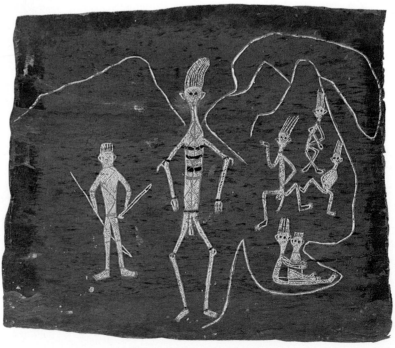

*Plate 37:* Mimi kill a human being. Goulburn
Island, western Arnhem Land.

*Plate 38:* The Frog who spoke. Goulburn Island, western Arnhem Land.

*Plate 39:* Rock kangaroo. Katherine, Northern Territory.

*Plate 40:* Stingray. Katherine, Northern Territory.

*Plate 41:* Two crayfish. Katherine, Northern Territory.

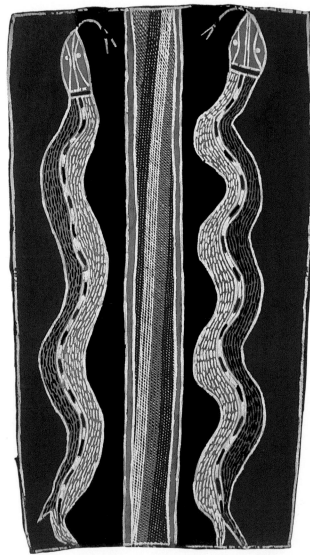

*Plate 42:*
  Glyde River, with two grass snakes.
  Milingimbi, north-central Arnhem Land.

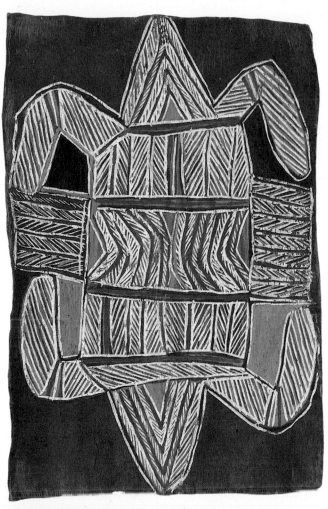

*Plate 43:* A turtle. Yirrkala, north-eastern Arnhem Land.

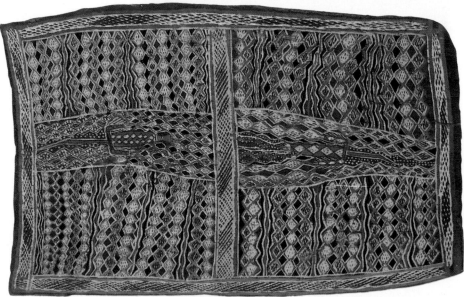

*Plate 44:* Dreaming country at Guludi. Yirrkala, north-eastern Arnhem Land.

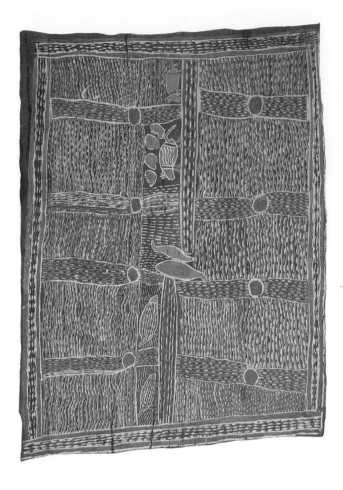

*Plate 45:*
  Dreaming country at Djaragbi.
  Yirrkala, north-eastern Arnhem Land.

human body, the head of some creature (often the mythic Ngalyod), distorted genitals, and protruding stingray 'nails' or spines. This form of art seems to have disappeared almost entirely from the repertoire of contemporary Gunwinggu artists.

An additional style is also present. It is manifested through what is known as *maraiin* art. This is focused on particular designs which occasionally appear on bark but are more often seen on ritual emblems and on the bodies of participants. The *maraiin*, as a ritual constellation, originally came from east of Milingimbi in the north-eastern Arnhem Land cultural bloc. The patterns are highly stylized and abstract, covering the whole of the available surface of a sheet of bark. The design is made up of criss-crossing lines with dots, rather like the traditional body painting of north-eastern Arnhem Landers. In their case this referred to clan and dialectal unit (*mada-mala*) territories and had mythological implications: earlier examples rarely included naturalistic representations of humans and natural species.

North-eastern Arnhem Land art is distinguished by its own basic style. Certain aspects of it, as we shall see, are said to have been influenced by batik designs of cloth brought to the coast by Indonesian trepangers. However, these have been Aboriginalized and retain their own traditional flavour. Probably the first bark paintings from this region were collected by the anthropologist W. Lloyd Warner in 1926-29 at Milingimbi and by a missionary, Rev. W. S. Chaseling, between 1936 and 1939 at Yirrkala and Caledon Bay. A major collection obtained by R. and C. Berndt in 1946-47 has been added to over the years. C. P.

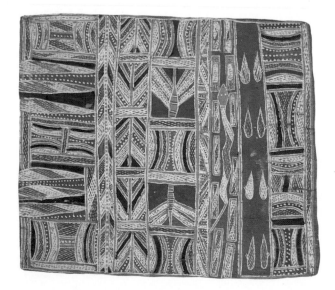

*Plate 46:*
  At Muruwul, home of the Yulunggul Python.
  Yirrkala, north-eastern Arnhem Land.

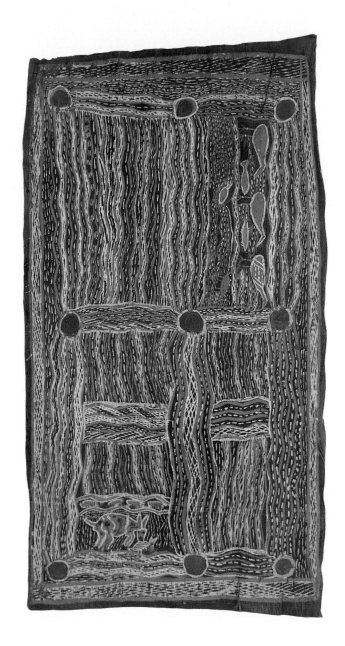

Mountford collected a series in 1948. These earlier ones did not vary fundamentally in style, but recently there have been some fairly radical developments.

In contrast to western Arnhem Land, a north-eastern Arnhem Land artist likes to fill in the whole surface of his sheet of bark. There are exceptions, less obvious in the past than in the present: but generally he tries to use all of the available space. Perhaps to emphasize his control over that space (though this is an inference, not given as an explicit reason), the artist usually, not always, defines his own boundaries on his canvas: he provides an ochre-line 'frame', edging the rectangular bark sheet in a way that is common in body painting. One marked characteristic is the division of the painting into compartments or panels, which often represent (in the emblemic patterning of a clan dialectal unit) topographic changes, or mythic sequences, or time changes in the incidents depicted. This has almost a cartoon effect. The topographic examples are most striking. Contrasts between sea-coast and inland-bush imitate natural divisions, with the intergrading of creeks and rivers, etc. While the Gunwinggu speakers of western Arnhem Land were never very far from the coast, they had basically an inland perspective. The north-easterners, on the other hand, whose territories embraced both the coast and inland areas without direct access to the sea, were oriented much more in the direction of the sea.

This and the nature of the social organization of north-eastern Arnhem Land had a strong influence on their art. For instance, diagrammatically a patchwork of named *mada-mala* (dialectal unit-clan) spread across the whole of this region, from a little beyond

*Plate 47:*
Dreaming country at Me'yun.
Yirrkala, north-eastern Arnhem Land.

*Plate 48:*
Country at Ngalawi, with the Dreaming
Crocodile. Yirrkala, north-eastern Arnhem Land.

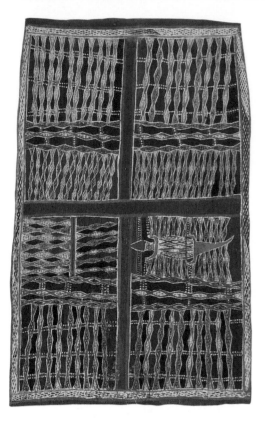

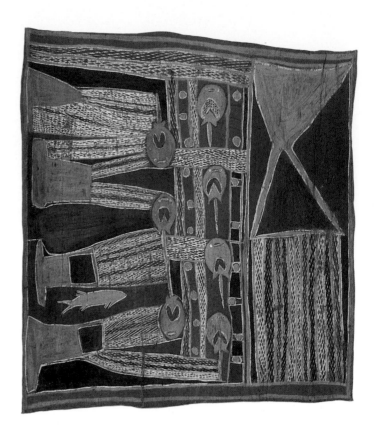

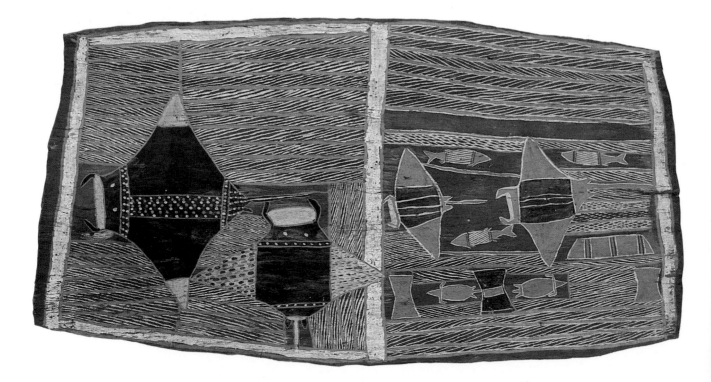

Milingimbi in the west to Blue Mud Bay in the south-east. There are a large number of these, each associated with a dialect (*mada*, 'tongue') of the common language, and with a specific piece of land (expressed through the concept of the *mala*, or clan). They were based on patrilineal descent (membership through father and father's father), and were exogamous (people had to marry outside their own *mada-mala* groupings). Each, too, had its own emblemic patterns to express and display its own specific religious identity. In this region the whole social organization was divided between two moieties: *dua*, and *yiridja*. While *mada-mala* affiliation within the same moiety was close, their designs were distinct and could easily be identified as belonging to one *mada-mala* pair as contrasted with another. Such designs were religious, specifying places within *mada-mala* territories associated with the great mythological cycles. In the creative era of the Dreaming, as in other parts of the continent, mythic characters moved across the land, creating and shaping its features. Members of a particular *mada-mala* territory are responsible for that section of their country through which the mythic travellers passed. Of course, they are responsible too for local mythic characters. Their part of the mythology, manifested in emblem form, is distinctive when compared with others.

Unlike the arrangement in western Arnhem Land barks, the background around the figures is filled in with cross-hatching. This gives the impression of a repetitive design, but nevertheless has meaning. Action is suggested through flow and sequence of events rather than through injecting movement into the figures themselves; naturalism is muted, and symbolism enhanced. In spite of these prescriptions, the mark of individual artists is apparent and there are opportunities for them, even in dealing with traditional mythological subjects, to record items of personal experience and involvement.

In both regions, traditionally, bark paintings were used in religious contexts. In western Arnhem Land, for instance, they were often arranged in rows on a ritual ground and novices taken to view each in turn, at the same time being told their meaning. In north-eastern Arnhem Land, they were often kept in special storehouses away from the main camps, along with such material as ritual posts (*rangga*). They too would be shown to initiates on appropriate occasions and the meaning of their symbolism explained. This was especially the case in *ngurlmag* rituals, one of the three ritual complexes associated with the Wawalag mythology. As a further example in a fairly recent context (1958), sacred patterns on bark were kept and occasionally propped up for inspection in and around the Elcho Island Memorial. And in both regions such paintings were openly displayed on sheets of bark used in building huts. Hubert Wilkins saw some examples on the Goyder River in 1924.

Two points that came up before need to be kept in mind here.

One is that paintings were used to illustrate stories, and also to give credibility to what was being said. The visual impact provided a kind of veracity, a sense of reality and a contemporary relevance to such accounts: 'This is how it looked, this is how it was!'

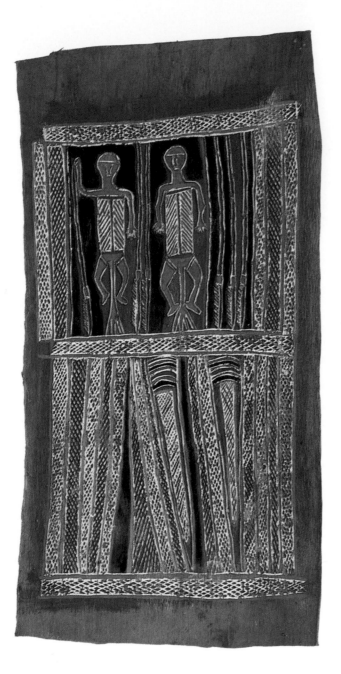

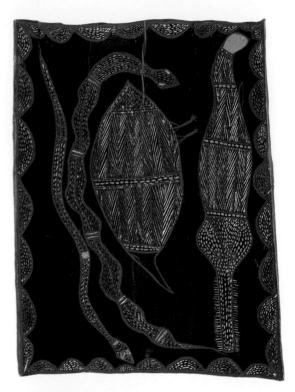

*Plate 52:*
  Mythic creatures.
  Groote Eylandt,
  Arnhem Land.

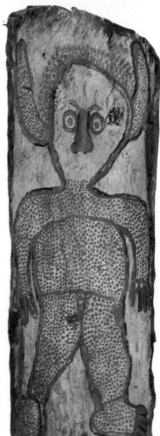

*Plate 51:*
  Bodngu, Thunder Men. Yirrkala,
  north-eastern Arnhem Land.

*Plate 53:*
  The trickster
  spirit, *agula*.
  Kimberley.

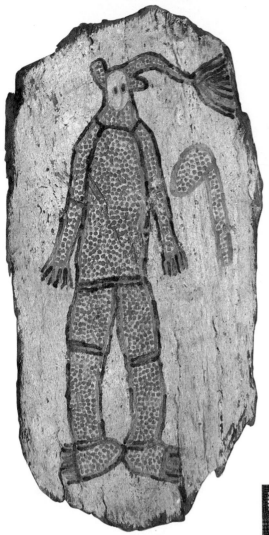

*Plate 54:*
A *naranara* spirit. Kimberley.

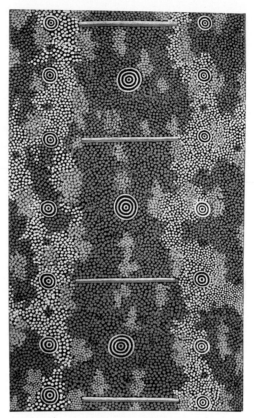

*Plate 55:*
The myth of Manukitji, the bush Plum.
Papunya, Central Australia.

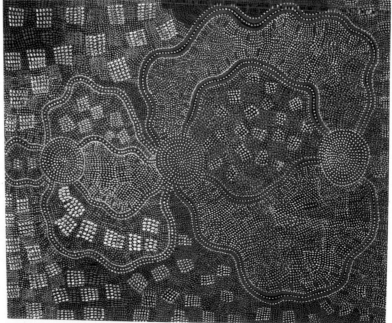

*Plate 56:* The myth of the two Possum Men. Papunya, Central Australia.

The second is that although an artist was not employed solely on such an artistic activity, he received compensation for what he did. This was particularly the case with north-eastern Arnhem Land emblemic barks. Conventionally, if a man was invited to view someone else's sacred patterning or to have it painted on his chest or on his spear blade, he could not refuse. The only condition was that he or the subject matter, or both, had to be related in a specific way to the artist. That is, it had to be one of the sacred patterns of the viewer's mother's clan, or his mother's mother's brother's clan, and so on. For that privilege, he would be obliged to pay the artist with food or, in turn, reveal one of his own clan patterns in a similar way. If someone else's clan pattern were painted on his spear blade, all creatures speared by it would automatically become sacred (*mareiin*), and the property of men of the clan to whom the pattern belonged.

It was not until the early 1950s that external demands lent added impetus to the production of bark paintings. Except for the large collections made by Mountford and ourselves, there is no way in which we can gauge how many were actually produced before, say, the mid-1940s. Our own view is that the output was never large, that most of it was ritually specific, and that what was painted did not survive for long. In fact, such paintings were not intended to last beyond the time of their immediate use. In a semi-tropical climate, with an abundance of termites and other hazards, they are not easy to preserve without special safeguards. This was true, too, for the sketches on bark huts. With those on the walls of caves, the situation was different. Some of these were credited to non-human agents—that is, to mythic characters who 'turned' or transformed themselves, leaving their representations in the form of paintings.

These outside demands gradually brought about a proliferation of bark painting. At first there was not much discrimination regarding subject matter, religious or otherwise. As the market expanded and prices for individual works increased, it was possible for artists to make a living on that basis. Professionalization brought in its train the stereotyping of designs and subject matter, and stylistic changes, with more care being taken to trim the edges of bark sheets and even the addition of stick clamps to retain the bark's flatness.

Bark paintings as separate items for particular purposes were traditionally used on Groote Eylandt. It is not clear whether this was so on Melville and Bathurst Islands, although the people there painted designs on bark huts and bags. However, Mountford (1958) collected a fairly large number in 1954. Virtually all of these reproduced traditional designs on mortuary posts and bark containers. At Port Keats, south-west of Darwin, the market for bark painting developed only in the mid-1950s; it was not indigenous, although the designs were adaptations of indigenous ones.

A more recent development which has roots set deeply in the traditional local background is the work produced by Papunya artists. (Papunya settlement lies west of Alice Springs.) People from several different groups are involved—Wailbri or Walbiri, Anmadjera, Waramunga, Ngalia, and Pintubi or 'Bindubu'. Their home territories are mainly in Central Australia as well as in northern areas above and below the Tanami track which runs diagonally north-west from Mt Doreen to Halls Creek. While there were linkages between these groups, the last two were part of the Western Desert cultural constellation and the first had close associations with it. One feature they all had in common was decorative ground structures, used in religious ritual and mytho-topographically based.

The main ingredients were ochre, blood and feather-down, carefully superimposed on grooves, shallow 'trenches', holes or hollows to represent the contours and physiographic features of specific stretches of country. Some covered quite large areas. They were secret-sacred, and the designs replicated those that were incised on sacred boards and also painted on the bodies of ritual participants. Only persons linked

through the Dreaming with the appropriate piece of territory and possessing the appropriate religious knowledge were in a position to re-create such ritual models. They were assisted by younger men who were themselves related in specific ways to that territory and were at the same time being instructed in religious matters. Each ground structure represented an identifiable area of country. The range of compositions was therefore extremely wide. It was limited only by the availability of persons legitimately entitled to make them and by the extent of their geographic knowledge and religious (mythological) insight. Further, any piece of country was susceptible to varying treatment, even though the basic topography had to be taken into account. Although the local style set guidelines and boundaries, this form of traditional art was by no means static and was amenable, at least to some extent, to innovative trends.

The transference of this art on to board and canvas, with the use of commercial paints, is a development of major significance. It began in 1970 with the encouragement of a teacher, G. Bardon. At first, pieces of cardboard and plywood were used, but gradually better materials became available and interest in this art form expanded. Now, examples are widely available on the Australian market. As far as the designs are concerned, perhaps we could speak of innovation, since new methods and techniques are being used. Traditional themes have been considerably elaborated, and colour contrasts used which were not possible traditionally, including the addition of background treatment. Nevertheless, the distinctive Desert style remains. Some of the paintings are made by individual artists, but many of the larger ones have been produced by several men working together. They are not 'mosaics', although they have been called that, any more than the religious ground paintings were. As with the bark paintings of Arnhem Land, they are painted while the board (or canvas) remains flat on the ground, the artist moving around it or moving his board accordingly.

One point here is the artist's use of what appears to be a 'fixed' set of symbols—concentric circles, connecting curves, u-designs, meandering lines and so on. These are stylistic devices, as we said before, so that while some may be consistently interpreted as standing for a particular feature—for example, a concentric circle standing for a rockhole or soak—they could just as well refer to a hill, a camp, or a fire, etc. Remember that interpretation of the design and of the stylistic devices within it rests on mythological knowledge and on familiarity with the features of the countryside being depicted.

Also, this new development does not take the place of (or replace) the ritual importance of ground paintings: both are contemporaneous. The ordinary paintings are secular projections of the secret-sacred, having the same mythological associations but placed within a different social context. This conforms with the use of the same patterns for a wide range of purposes, not confining them to the sphere of the secret-sacred—they may also be used on spearthrowers, shields, hair skewers and so on.

In recent years, painting on sheets of ready-made board has been introduced from the Papunya-Yuendumu areas to Balgo settlement, south of Halls Creek, in Western Australia near the Northern Territory border. Not enough of these have been collected or examined to make comparisons (with other areas, and with immediate local traditions) useful, although at first glance some seem quite close in style to Papunya art. At the Balgo airstrip now, an open shelter for travellers has a large wall covered with traditional designs of mythological significance. While it is physically accessible for all to see, it is nevertheless restricted as far as Aboriginal women are concerned. This colourful mural is much nearer in style to the original ground paintings and those on Western Desert rock walls, and does not have the decorative elaborations of the Papunya examples.

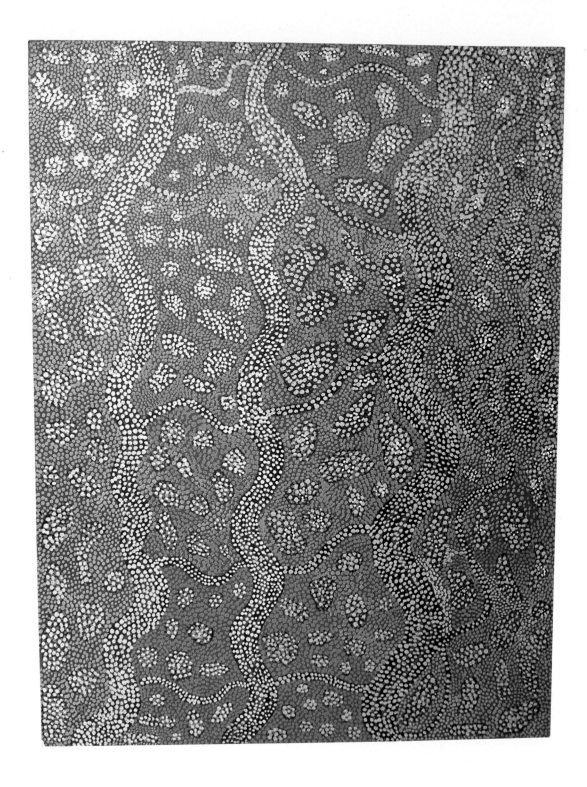

*Plate 57:* The myth of the Rain Dreaming. Papunya, Central Australia.

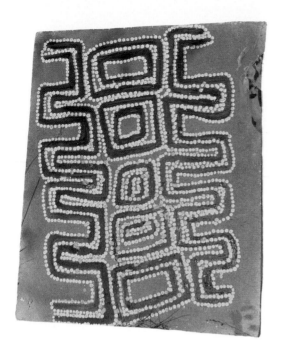

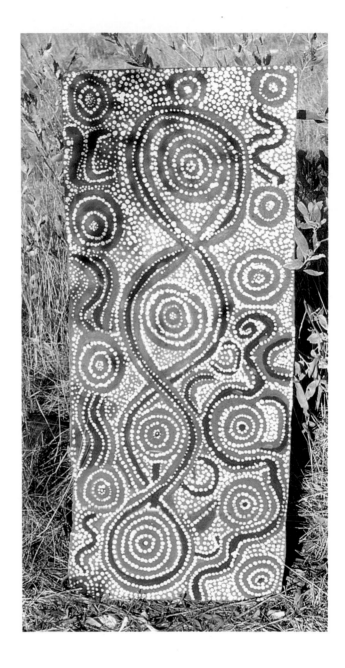

*Plate 58:*
   Place of the Fire Dreaming. Balgo, Kimberley.

*Plate 59:*
   Place of the Dreaming man, Djaldubi. Balgo, Kimberley.

# *Drawings*

Traditional Aboriginal paintings are produced by artists using 'wet' coloured ochres and applying them with brushes or an equivalent. In contrast, drawings are essentially an 'applied' medium where the artist uses crayons and pencils, mainly but not always on paper or similar material. Charcoal sketches in indigenous contexts approximate these; or when a traditional artist draws an outline of a proposed theme on a sheet of bark before beginning to paint. Rock art too includes figures that resemble drawings rather than paintings.

A number of early examples of drawings as such have been noted by Brough Smyth (1879) and Worsnop (1897), among others. Basedow (1925) illustrates some charcoal sketches, from Pigeon Hole on the Victoria River in the Northern Territory, which give every appearance of being 'indigenous'. These are similar to the realistic and often crude sketches which appear on the surfaces of bore (windmill) tanks on pastoral properties in the north; or, for that matter, the drawings or graffiti on the inner and outside walls of Aboriginal huts and houses built in European style. In addition, there are the drawings made by Aboriginal school children, past and present: their origins and themes are mixed.

The drawings illustrated here were specifically collected in the course of anthropological research. They are on sheets of brown paper and the artists have used lumber crayons and, occasionally, pencils that were supplied to them. Sometimes the colours have been restricted to the basic Aboriginal range, or additional ones have been introduced. Tindale and Mountford were the first research workers to make systematic use of this method in the Western Desert and Central Australia, in the late 1920s and up to the early 1940s. It was developed primarily to record local patterns and ways of depicting the socio-cultural and natural environment, where no other medium was available except rock walls, the ground or sand, or objects themselves, mostly sacred objects. The results have been quite outstanding. Many interesting and beautiful examples deal with mythological and topographic topics as well as everyday events. Many, too, resemble traditional Desert rock art, and bear comparison with Papunya art.

Those referred to here come from what were then traditionally-oriented communities. They were drawn by artists who had had no experience in handling crayons or pencils, and few opportunities to experiment in a new medium. The artists worked with the sheets flat on the ground in the same way as bark painters and Papunya artists do. Our three major collections came from Ooldea on the transcontinental railtrack in South Australia, the central-west of the Northern Territory, and north-eastern Arnhem Land. The Ooldea examples, from Bidjandjara (Pitjantjatjara)-speaking people in 1941, are very similar to those obtained by Tindale and Mountford. Stylistically they are of Desert type, in both topographic and figure representation.

The second set came from Birrundudu, in the Northern Territory but close to the Western Australian border, in 1944-45, when it was an out-station of Gordon Downs pastoral property in W.A. The artists were from the Nyining, Ngari, Gugadja, Woneiga and Wailbri (Walbiri) speaking groups whose original home-territories extended from north-west of Birrundudu, south-west and north-west of the Tanami track, including Sturt Creek and the area south-west into Balgo; and southeast and east from Birrundudu. Thus, there were cultural ties, as there still are today, with Papunya and Yuendumu on one hand and Balgo on the other—although at that time the recent art developments had not even been foreshadowed.

Birrundudu art demonstrates some remarkable stylistic variations which suggest a mixture of Desert and northern influences. For instance, country and

*Plate 60:*
   *Mamu* and *gordi* spirits. Ooldea,
   western South Australia.

*Plate 61:*
   A female *mamu* spirit.
   Ooldea, western South Australia.

*Plate 62:*
   A young man's perspective of his initiation.
   Ooldea, western South Australia.

*Plate 63:*
  The Dreaming site of
  the *bura* yams.
  Birrundudu, central-western
  Northern Territory.

*Plate 64:* The Dreaming site of Bandubada. Birrundudu, central-western Northern Territory.

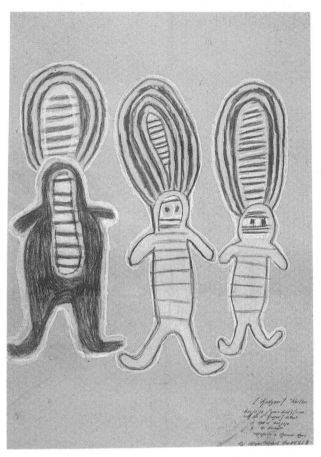

*Plate 65:*
Dancers in a religious ritual.
Birrundudu, central-western
Northern Territory.

physiographic features often appear as in typical Desert art—'in plan', looking down from above; but some examples are scenes of mythic characters climbing hills, with both the side and the top of a hill shown, to provide perspective and detail. (The only other area in which landscape art is treated in this way, or at least close to it, is western Arnhem Land.) 'Action' art is also common, as in drawings of participants in the great Gadjari fertility rituals (related to the northern Kunapipi). Some examples have a passing resemblance to Kimberley Wandjina art. Some show considerable vitality and movement in their representation of other ceremonial and ritual sequences. A high degree of realism is achieved in drawings of dancing women, and of a Rainbow Snake with Aboriginal 'doctor men' astride it. Although the artists use a variety of colours, they have blended them most skilfully.

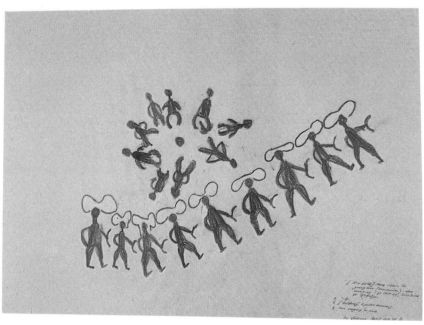

*Plate 66:* The *wanbada* dance. Birrundudu, central-western Northern Territory.

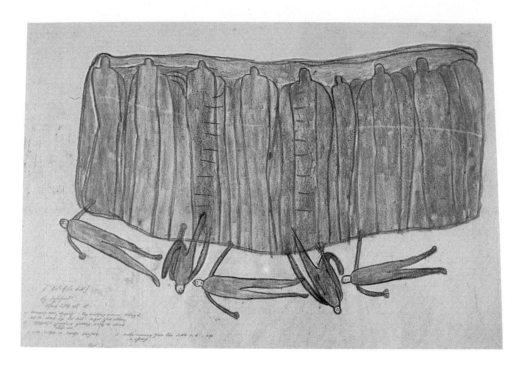

*Plate 67:*
  Climbing Killi Killi Hills. Birrundudu, central-western Northern Territory.

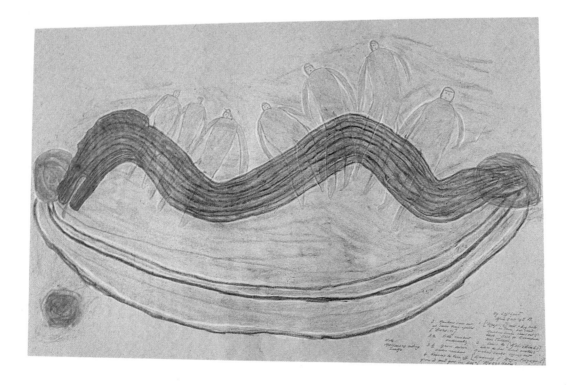

*Plate 68:*
  Aboriginal doctors riding the mythic Rainbow Snake.
  Birrundudu, central-western Northern Territory.

Plate 69:
Bremer Island; a mytho-topographic guide.
Yirrkala, north-eastern Arnhem Land.

Plate 70:
The pre-Macassan Baiini make a settlement at Bangubalang.
Yirrkala, north-eastern Arnhem Land.

In north-eastern Arnhem Land, the situation was different. There was really no reason why we should have collected brown paper drawings, as was so necessary at Birrundudu and in the Western Desert, because of the strong tradition of bark painting throughout Arnhem Land. However, at that time (1946-47) it seemed useful to have the bark paintings we obtained replicated on brown paper in terms of topic. In the circumstances of our fieldwork, storing and preservation of barks was difficult, and we were not sure whether we could move them without damage. In this area, then, while basic cultural styles are retained, the relative flexibility of drawing in the new medium opened up new vistas of representation. Especially, it provided opportunities to spell out the ramifications of mythological sequences.

As a medium for artistic expression, paper drawings have rarely been used in recent times, except in the context of schools. One outstanding exception is the work of Joe Nangan, sometimes called Butcher Joe, an elderly Nyigena man living in Broome. Over the years he has produced many pencil sketches illustrating local mythology and everyday Aboriginal life. They do not use traditional forms, and are almost European in style as well as in technique. Nevertheless, they are lively and effective supplements to his large repertoire of traditional myths and stories from his own tribal country.

*Plate 71:*
Duramungadu spirits at Arnhem Bay. Yirrkala, north-eastern Arnhem Land.

*Plate 72:* House-building at Badu, the *yiridja* moiety land of the dead. Yirrkala, north-eastern Arnhem Land.

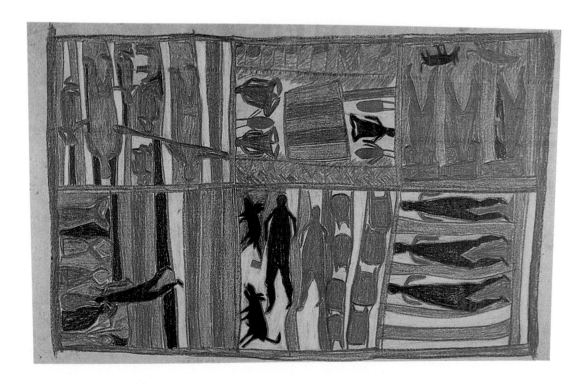

*Plate 73:* Collecting cycad fruit; and the killing by Nguriri. Yirrkala, north-eastern Arnhem Land.

# CHAPTER THREE

# *More About Living Traditional Art*

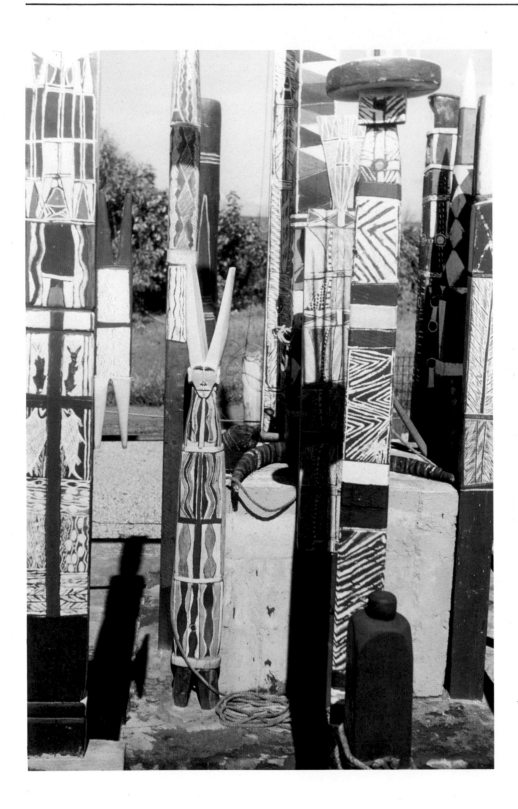

*Plate 74:*
Close-up view of the Elcho Island Memorial, 1958, north-eastern Arnhem Land.

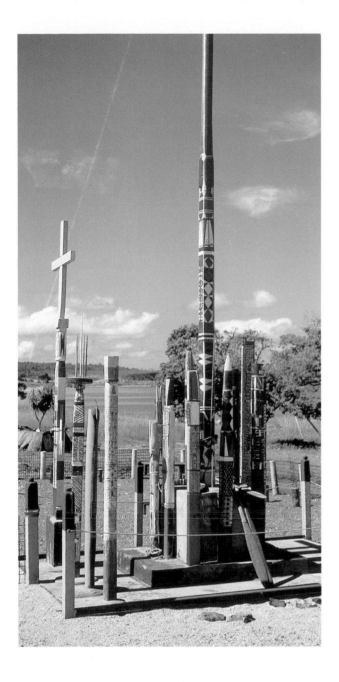

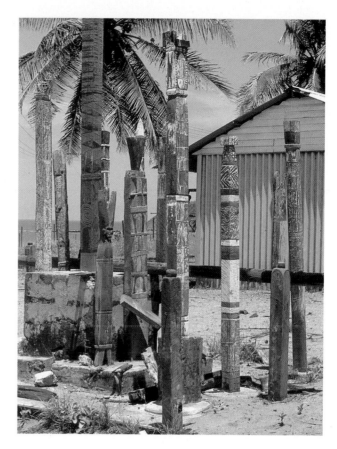

*Plate 75:*
The Elcho Island Memorial, 1958,
north-eastern Arnhem Land.

*Plate 76:*
Neglect of the Elcho Island Memorial,
north-eastern Arnhem Land.

# *Sculpture*

THREE-DIMENSIONAL SCULPTURE in wood was almost always religious, directly related to mythological constellations of the Dreaming. The subjects were mostly of the same broad kinds we have been talking about for two-dimensional art forms; mythic characters, or aspects associated with them, creatures, and so on. They were, and some still are, used in secret-sacred or public (camp) ritual or in mortuary procedures. Among the most important non-anthropomorphic examples are the long incised wooden boards and bullroarers of the Western Desert. The Aranda of Central Australia, a people who became almost world-famous through the work of Spencer and Gillen and of Strehlow, have long boards and poles too, but their most important *tjurunga* are made of stone. In western and north-eastern Arnhem Land a wide variety of creatures of Dreaming importance are carved for use in rituals. On the north-eastern side, long *rangga* poles carved to symbolize creatures and things connected with the great mythic deities bear ochre-painted designs and feathered-twine pendants. Some are bound with twine or human hair and may be tipped with a bunch of feathers.

The prototype of all Aboriginal wood sculpture probably lies in the beautifully-made secret-sacred emblems constructed of brush, saplings or spears. Sometimes they are combined with sacred boards, bound with twine or human hair, and decorated with ochre and featherdown designs and hanging tassels. Many different kinds, representing mythic beings and/or their attributes, were used in Western Desert and Central Australian religious rituals. They took a considerable amount of time to make, for a sequence which more often than not was over in a few minutes. But because the making of such an object was in itself a ritual act, preparing a temporary (and renewable) vehicle for a mythic being, the long preliminary task was just as important in its own way as the more dramatic sequel to it. Then, once the purpose had been achieved the structure was dismantled and usable parts retained (the feathers, human hair and twine): the rest was left on the ritual ground to disintegrate. The same is the case with the more elaborately sculptured wooden figures and mortuary posts. These, too, although left to rot after use, are in fact intended to last longer than the impermanent structures of the Western Desert and Central Australia. The more durable hardwood poles can serve as a basis for more transient decorations over several years of ritual use.

Sculpture in traditional Aboriginal Australia refers primarily to wood carving in the round. Carving in stone was rare, except for *tjurunga* and for very recent innovative examples. Most wood carving is confined to northern areas, such as Arnhem Land, Bathurst and Melville Islands, Cape York Peninsula and the north-west of Western Australia. As regards the last region, the practice probably derived from the Port Keats area, although Helmut Petri reported (in 1957) two remarkable heads from the Njangomada language group of the Pilbara district, Western Australia. One is in stone, the other in wood. Other examples have been noted for the Laragia (Larrakia) of Darwin and the Cox Peninsula, but none of these have survived.

The first Arnhem Land human figures to attract outside attention were collected by W. Lloyd Warner at Milingimbi in 1927-28, by D. Thomson at Caledon Bay

in the 1930s, and by W. S. Chaseling at Yirrkala, probably in 1938. However, evidence suggests they were seen by missionaries in the region at least a decade before. All of these early examples were highly conventionalized. Fairly large collections of such figures were made in 1946-47 by R. Berndt, and in 1948 by C. P. Mountford. Comparison with the early examples demonstrates a continuing stylistic tradition, modified and elaborated in certain directions. For instance, while the carved figures from Yirrkala in 1946-47 vary in treatment among themselves, there are more obvious contrasts between all of them and those collected by Mountford from the same area the following year. The most likely explanation is that those we collected were nearly all carved at leisure to the accompaniment of songs, and some had been used in actual rituals. Those obtained by Mountford were commissioned works on a commercial basis. However, figures collected after that period tend to show even greater differences and a high degree of innovative treatment.

Carved figures in human or quasi-human form were a traditional feature of north-eastern Arnhem Land, though there is no evidence of when or how they first developed. As a rule, they were highly conventionalized. In some respects they resembled the mortuary posts of Bathurst and Melville Islands (see below). Yet, in western Arnhem Land such figures seem to have been entirely absent, though some recent examples have appeared. It is not entirely certain when legs and arms and other 'naturalistic' features appeared on the north-eastern Arnhem Land figures. When we expressed interest and pleasure at the sight of the stylized figures that appeared in various contexts in 1946-47, some artists began to make more of these, to be given to us after they had served their various ritual and ceremonial purposes. A number of them had legs (the bottom of the post, shaped for inserting into the ground, was simply divided into two), and a few had arms, but not at our suggestion. It seems to us

most improbable that naturalistic figures in that sense were made prior to the mid-1930s, at the earliest.

The north-eastern Arnhem Land figures fall into two broad categories, according to their subject matter and purpose.

Those in the first category derive from what are collectively called *rangga*: secret-sacred poles, or posts, stylized or semi-naturalistic. To demonstrate the more or less direct relationship here, we include an illustration of the Elcho Island 'Memorial', erected in 1957. This is a cluster of *rangga* emblems belonging to various *mada-mala* in the Elcho Island-Yirrkala region. Each one is different in shape, design and overall conception. The painted designs on their trunks refer to aspects of the relevant mythology and specific stretches of country—that is, they refer to what the overall *rangga* represents. Usually, as we have said, such *rangga* are secret-sacred. In this case, they were 'brought out' into the open so that they could be publicly seen by everyone. The Memorial was a central focus in the Elcho Island Adjustment Movement, a syncretistic development that drew upon and emphasized traditional cultural features. All we need say here is that one of its aims was to bring together the many different *mada-mala* groups in the region in order to achieve social and political unity, taking introduced features into account, but looking toward greater Aboriginal involvement and self-determination in decision-making *vis-à-vis* other Australians. This Movement was very differently conceived from the essentially commercial venture manifested in the Papunya example, but they had one thing in common. In both cases, this involved transforming or transferring an essentially secret-sacred art form into an open-sacred *and* mundane setting. In both cases this was accomplished without harming the original form of the objects or paintings. In both cases, too, their secret-sacred *context* is retained.

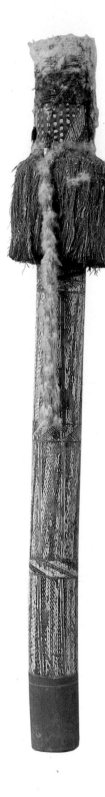

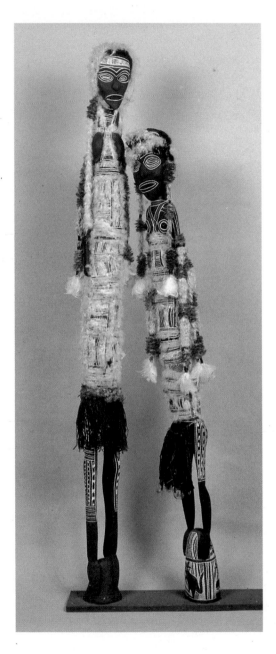

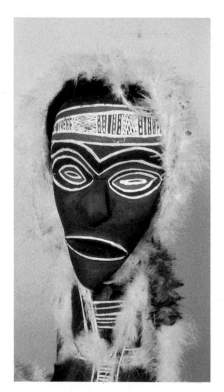

*Plate 77:*
    A *djuwei* Wawalag post.
Elcho Island, north-
eastern Arnhem Land.

*Plate 78A:*
    The elder and younger Wawalag Sisters.
Yirrkala, north-eastern Arnhem Land.

*Plate 78B:*
    A close-up view of the
elder Wawalag Sister
shown in Plate 78A.

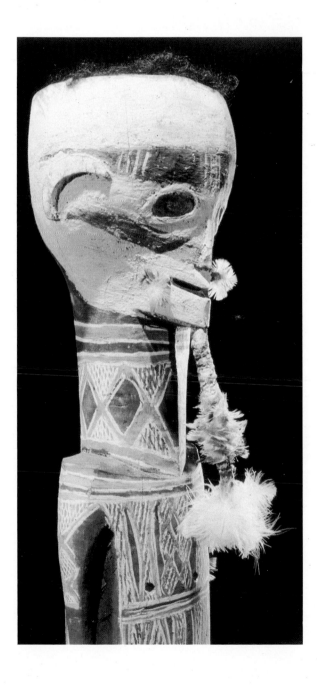

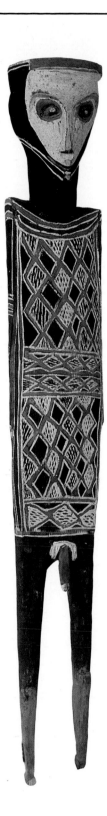

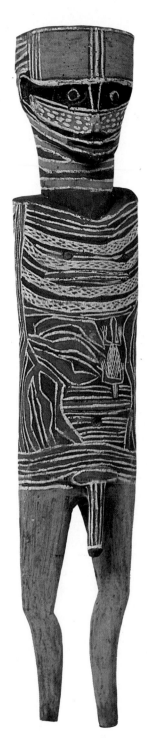

Plate 79:
The mythic Laindjung, after emerging from the sea. Yirrkala, north-eastern Arnhem Land.

Plate 80:
The mythic Banaidja. Yirrkala, north-eastern Arnhem Land.

Plate 81:
Bunbulama, the Paddle Maker for Bralgu, the *dua* moiety land of the dead. Yirrkala, north-eastern Arnhem Land.

# *Sacred figures*

The Elcho Island example is more or less unique. The open display of *rangga* was designed to demonstrate to everyone, including non-Aboriginal people, the richness of the local cultural heritage. As one of the leaders put it then, 'These are our most precious possessions'—and the question implied was, 'What are you going to do about it? How do you propose to respond?' At the same time, the *rangga* included in the Memorial constituted only a fraction of what was actually available in the region. Further, they did not lose their importance through being displayed publicly. However, over the years the Memorial has fallen on hard times (as a further illustration shows), since the Aborigines' political interests and ideas, and opportunities for achieving them, have branched out in other directions.

In the second broad category of north-eastern Arnhem Land figures, are those used primarily in mortuary and associated rituals. A clear-cut line cannot really be drawn between the two categories. Both may relate to mythological topics, especially where the lands of the dead are concerned—one land for each moiety, *dua* and *yiridja*. Also, all mortuary ritual is fundamentally religious. Nevertheless, one major contrast between them can be suggested. Items within this category usually, though not always, include reference to non-Aboriginal sources which have been traditionalized or Aboriginalized.

We look first at figures mostly derived from *rangga* and used on ceremonial and ritual occasions to which access is not necessarily restricted. The most traditional and stylized examples are the *djuwei*. A *djuwei* figure belongs to the *dua* moiety. It is a focal point in public circumcisional performances (called *djunggawon*), erected in the main camp, where participants dance around it.

The artist prepares a round post, of varying height, and removes all the bark from it except for an encircling section almost at the top; this he shreds and trims to represent hair. The rest of the post is smoothed and red-ochred. It represents the body of one of the *wongar* Dreaming Wawalag sisters who were swallowed by Yulunggul (Rock Python); or it may also represent Woial or Wudal, a Honey spirit character indirectly associated with the Wawalag. The bark hair is usually (in the case of the Wawalag) encircled with a feathered string chaplet and pendant, or (in the case of Woial) hung with pendants. The post itself is painted with designs from the Wawalag mythology. Apart from being a post with its fringe of shredded bark, there is nothing specific or visible to identify it as a human or human-type form—only the information that this is what it actually symbolizes. The painted designs provide clues to its mythic identity.

The Wawalag, and the Djanggau (or Djanggawul) cycle, are of the *dua* moiety. Along with the Laindjung-Banaidja cycle, of the opposite moiety (*yiridja*), they are the most important ritual constellation in north-eastern Arnhem Land, and the basis of the religious

system. A number of other mythologically-oriented cycles, some directly or indirectly linked with these three main ones, help to make up the total, quite complex, pattern.

The Wawalag sisters, travelling north across the bush country of Arnhem Land from the direction of the Roper River, came at last to an important waterhole, home of Yulunggul, the great Python. Near it they built a bark hut and one sister either gave birth to a child or menstruated. (There are various versions. This is a very compressed reference to their story.) The smell of the blood attracted the Snake, who emerged from his deep waterhole bringing a fierce storm—with dark clouds, wind, rain, thunder and lightning. The sisters tried to keep him, and the storm, at bay by dancing, each in turn; but finally he swallowed them and the child, or children, and later regurgitated them. This, along with subsequent events, symbolizes the onset of the northern monsoonal season. The *djunggawon* ritual commemorates this particular situation. Young novices are painted with designs identifying them with the Wawalag, and at the conclusion of their initiation sequence they are said to have been regurgitated, as the Wawalag and child-(ren) were. These two sisters also sponsor two other ritual sequences—the *kunapipi* and the *ngurlmag*. Woial's association with the Wawalag is sometimes close, sometimes distant. As with the Wawalag, his country was originally far inland toward the Roper River. He has 'boomerang legs' and, among other things, wears long baskets strung from his shoulders, full of honey and bees. He lets the bees out from time

to time to obtain honey, but they always return to their baskets. He is responsible for a *dua* moiety wind from the southern inland, sometimes called the 'honey wind'. *Djuwei* figures representing the Wawalag and Woial appear in more naturalistic carvings too, but those are not used in *djunggawon* ritual.

Another sister-pair in north-eastern Arnhem Land, the great Djanggau, were rarely portrayed in the past in carvings of naturalistic form. Their proper milieu was secret-sacred *rangga* posts and emblems. One example, however, which unfortunately cannot be illustrated here because of its secret *rangga* character, resembles a post figure with carved head and breasts. The two sisters and their brother, sometimes with a companion, and collectively called the Djanggau, came paddling to the north-east coast by bark canoe in the rays of the rising sun, from the mythical island of Bralgu (also identified as the *dua* moiety land of the dead). The sisters are sometimes called Daughters of the Sun. They travelled across the country from place to place, and finally out of this region toward the setting sun. They are responsible for creating and shaping much of the countryside, including fresh-water springs; and the two sisters gave birth to the first people there, establishing them in specific territories. Essentially, they are concerned with fertility in all its aspects. Their story is a complex one too, with some momentously dramatic episodes.

The great *yiridja* moiety character Laindjung takes physical shape in various stylized and naturalistic forms—although, again, the *rangga* posts associated with him are secret-sacred. A typical example of what

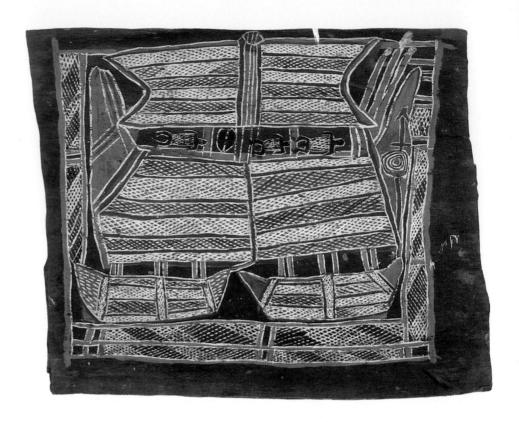

*Plate 82:*
  The spirit Burulu-burulu.
  Yirrkala, north-eastern Arnhem Land.

*Plate 83:*
  A Macassan prau in full sail. Yirrkala,
  north-eastern Arnhem Land.

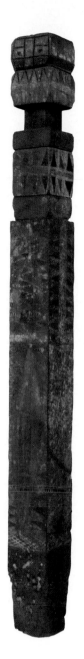

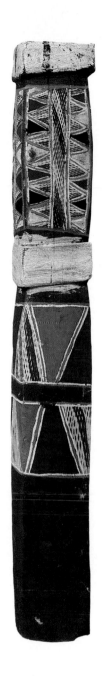

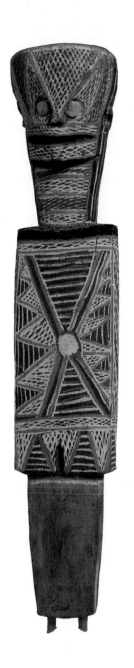

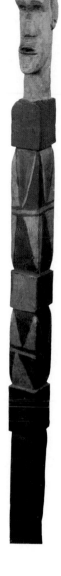

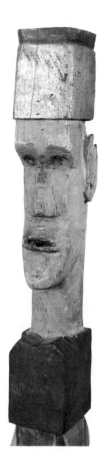

*Plate 84:*
  A *wuramu* post
figure. Milingimbi,
north-central
Arnhem Land.

*Plate 85:*
  A *wuramu* post.
Elcho Island,
north-eastern
Arnhem Land.

*Plate 86:*
  A Macassan woman,
in *wuramu* form.
Yirrkala, north-eastern
Arnhem Land.

*Plate 87A:*
  *Wuramu* image post
of a dead person.
Elcho Island, north-
eastern Arnhem Land.

*Plate 87B:*
  A close-up view of
the *wuramu* head
in Plate 87A.

# *Mortuary figures and posts*

can be regarded as the older style was placed on the Elcho Island Memorial. However, one of the earliest available near-naturalistic figures was made at Yirrkala in 1947. This is a remarkable and unique example of a carved and painted work. Laindjung and/or Banaidja (sometimes identified as Laindjung's son, although there are differing versions) also emerged in the early Dreaming era from the sea on the eastern coast, in his human-male manifestation (and not, as can also be the case in other contexts, as a Barramundi fish). His face was white from the sea foam, and his body bore variegated salt-water patterns; these marks, according to tradition, were the source of designs now used on sacred emblems by various *yiridja mada-mala*. Some myths tell that Laindjung 'turned himself' into a paperbark tree. He (or, he and his counterparts), now associated with a wide repertoire of mythology and song, moved across the countryside, and are associated with ritual sequences and with other *yiridja* moiety myths.

A number of other figures of male and female *wongar* (Dreaming) or *mogwoi* (spirit) characters, some localized, others more widely relevant, take shape in material representations, both stylized and natural-istic.

Figures more directly related to mortuary ritual, in our second north-eastern Arnhem Land category, and known by the term *wuramu*, are mainly in post form. In all the early examples we have seen, the post is angularly shaped, as contrasted with the rounded *djuwei*. Another point of contrast is that a *wuramu* has a clearly distinguished head and face with eyes, etc. Two examples from Milingimbi on the north-central Arnhem Land coast depict the traditional type, although some recently made ones are just as devoid of facial features as the *djuwei* are. However, some artists produce quite elaborate specimens, that exhibit outstanding sculptural qualities—and figures of this type have been in common use for many years.

The *wuramu* tradition is usually associated with song and ritual cycles centring on Macassan (Indonesian) contact along the north coast, which as far as is known extended for several hundreds of years until recent times. We noted before that the Baiini people were formerly said to have been the first non-Aboriginal visitors, but that was in the memory of older men and women who were still alive in the 1940s. These days they are often merged with the Macassans, or treated almost as Dreaming characters. Song cycles and accompanying ritual, shorter and less detailed than they used to be, are traditional 'packages' of infor-mation and comment on the visits of these Macassans, their trade with local Aborigines (primarily for trepang), their life on the Australian mainland and off-shore islands, and their praus that came with the

north-west monsoon and sailed back on the south-east tradewinds to their distant homes, sometimes accompanied by Aborigines. Many *yiridja* moiety people have personal names referring to things and places and characters mentioned in the songs: cloth, sails, knives, houses, rice, and so on. One of the local words for European, *balanda*, comes from 'Hollander', Dutchman; and Nona, Nonei, is a Baiini or Macassan woman.

*Wuramu* was sometimes translated as 'collection man'. From Aboriginal accounts, it seems to refer to customs officials at the port of Macassar (Mangkadjara, to the Aborigines) in what was then the Dutch East Indies. In the Aboriginal context, a man, or men, of the appropriate *mada-mala* pair prepares a wooden figure, carving and painting it and attaching long feathered strings, as arms, for a special role in a *yiridja* moiety delayed-mortuary ritual. At the proper time, but without warning, the men move quickly through the camps, carrying it with arms outstretched to collect any articles or food left lying around. This is intended to compensate the men responsible for making it; people are not supposed to do anything to save their possessions, though some try if the group is still a fair distance away. Finally, the *wuramu* post is stood upright in the ground near the camp of the dead person.

A few of these figures are, or were, identified as effigies of Macassan personages (prau captains, for instance), but others represent stereotypal Macassans and deceased Aborigines. In some of the large *yiridja* moiety mortuary rituals when sections of the Baiini-Macassan cycle are sung and dramatized, ornate masts are made and erected, along with flags. Although many of these features are of non-Aboriginal origin, they have been skilfully integrated into an Aboriginal traditional setting. Moreover, while *wuramu* is a generic term

used for this category of objects, and probably derived from a non-Aboriginal source, it is nevertheless highly likely that it was simply a matter of incorporation into what was already traditionally present. The prototype *wuramu* is a straight post without carved legs or arms, only feathered strings, and once set up in the ground it is left to rot there. In recent years, some have been made for external sale; and even some that were made in 1946-47 have carved legs, at that time regarded as an innovation. *Wuramu* have also been carved to represent Europeans—a Dutchman-image, for example, has survived, being given to us in 1947; so was an incised red-ochred head commemorating a Japanese who was speared on the eastern coast of Arnhem Land in 1932. Many *wuramu* are memorial 'portraits' carved in a conventionalized manner to depict a deceased Aboriginal (man, woman, sometimes a child); they are subjected to the same ritual procedures as the others and left standing near the huts or houses in an open camp setting.

We mentioned Bralgu as the nearest origin-point of the great Djanggau, and also the *dua* moiety land of the dead, the place to which spirits or souls of the newly dead of that moiety return after their final mortuary rites. On the *yiridja* side, among the guardians of the *yiridja* moiety land of the dead are Kultana (Guldana) or Ranyi-ranyi, or other names: a husband and wife pair originally located at the island of Modilnga somewhere north of the Wessel Islands—a conception later extended to include Badu, a local collective name for the Torres Strait Islands. The Kultana light large fires to attract and guide spirits of the dead. They are also responsible for sending cold winds, and the coconuts and canoes (some intact) and seed-pods that are occasionally washed up on north-eastern beaches at the end of the monsoon season. They have been carved as standing figures, painted with a design signifying rain streaming down their bodies.

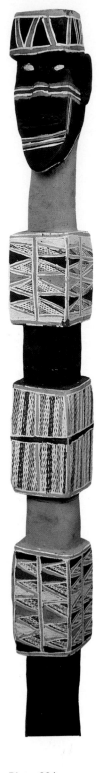

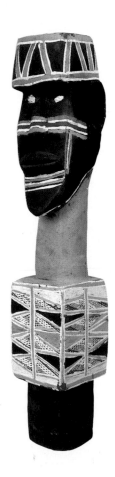

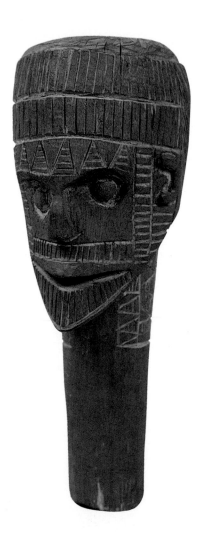

Plate 88A:
A *wuramu* image of Deimanga, a Macassan captain. Elcho Island, north-eastern Arnhem Land.

Plate 88B:
A close-up view of the head in Plate 88A.

Plate 89:
Head of Kimasima, a Japanese murdered on the north-eastern Arnhem Land coast.

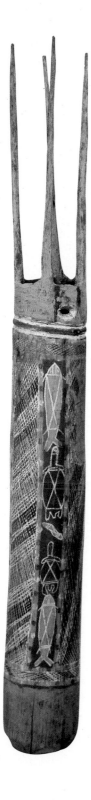

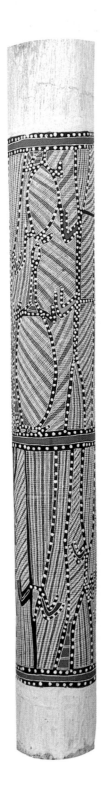

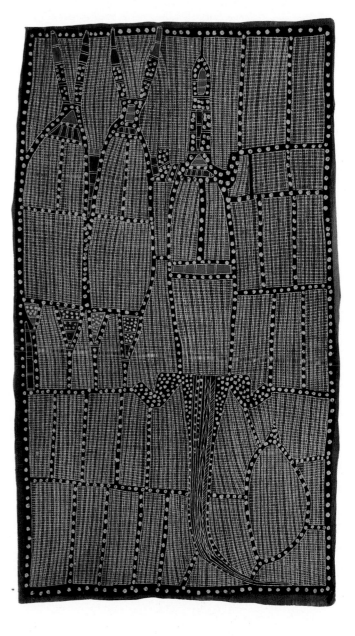

*Plate 90:*
  A hollow-log bone-
receptacle. Milingimbi,
north-central Arnhem Land.

*Plate 91A:*
  A bone-receptacle
from mid-northern
Arnhem Land.

*Plate 91B:*
  A bark painting associated with the
bone-receptacle shown in Plate 91A.

To some extent we can speak of a preoccupation with death ritual in north-eastern Arnhem Land—if we consider the matter superficially. In fact, the focus is more on life than on death: on transforming physical death into spiritual life and eventual rebirth. Mortuary rituals are much more elaborate than in Desert and Central Australian areas. *Wuramu* are only one small item in these. Large ground structures are prepared to represent the specific local territory of the dead person and his mythological associations. Although functionally and stylistically different, they bear some resemblance to the ground paintings of the Central area. But here they replicate the paintings on sheets of bark, on the bodies of novices and postulants, and on the *wuramu* themselves. There are also large hollow log bone-receptacles, carved at their apertures and with ridges to resemble or symbolize features of a particular creature associated with a dead person. In the case of a *dua* moiety person, the receptacle may represent a whale, sawfish, porpoise, *dua* moiety shark, wild honey, snake, stone, tree, etc.; in the case of a *yiridja* moiety person, a mast, *yiridja* moiety clouds, rain or wind and various other aspects concerned mythically with that moiety. These too were painted with emblemic designs.

In the associated ritual, the long hollow log (called *laragidj*) rests on forked sticks, and lengths of feathered string are strung out from its gaping 'mouth'. The bones of the dead person are collected from the corpse-disposal platform, cleaned and red-ochred and wrapped in paperbark, and brought to the ritual ground. There they are unwrapped and broken up. Each fragment is put carefully into the 'mouth' of the log, to the accompaniment of singing and invocations to the spirits and to the dead person's country. The physical remains of that person are being returned to their mythic agent or intermediary, within his/her own homeland. The soul or spirit, or the main aspect of

it (there are other, subsidiary manifestations, more like potentially malignant ghosts), has already departed to the land of the dead, urged on by the appropriate songs and rites arranged for that purpose. The hollow log, as a symbolic creature or thing, 'swallows' and absorbs the bones. It is then stood upright in the ground among the homes of the living and left to disintegrate, finally scattering its remains across the camp. Often in the past, although not recently, the skull was retained, to be worn by a widow or widower as a necklet slung across the shoulder. This too was red-ochred and painted with *mada-mala* designs which serve to identify the dead person. Often, too, the bones before being broken up, or some of them, were carried around in a bark 'coffin' or receptacle painted in a similar fashion; but this is rarely done now.

Such hollow logs and posts were common in traditional northern coastal areas, and not only in north-eastern Arnhem Land.

In western Arnhem Land, for instance, a mortuary rite was also part of an initiatory experience. This is interesting, because death was itself regarded as an initiation rite which transformed the dead person. There are two major forms of what are called *lorgun*, both painted with designs: one has a v-shaped 'mouth', the other has a plain 'mouth' but is hung with feathered strings. The dead person's bones are collected, then ritually unwrapped and red-ochred and placed within the *lorgun*, to the accompaniment of invocations associated with his or her home territory. In one of the procedures in the *lorgun* complex, all his belongings are burnt and their ashes covered with a mound of earth into which is stuck a small *wawal* post. This indicates that the mortuary rituals are completed and the soul or spirit can now go to its own waterhole or country—and, in one of its manifestations, to the local land of the dead.

The well-known mortuary posts of Bathurst and Melville Islands resemble these others in a number of ways, but visually their impact is quite distinctive, and so are their ritual and social contexts. Their vivid colouring when they are new includes much more, very brilliant yellow ochre, and their cluster-effect is reminiscent of the Elcho Island Memorial—or the other way round, in view of the time-sequence, though none of the Memorial's leaders reported having seen or been influenced by the Tiwi model. The Tiwi posts are not hollow receptacles like those in Arnhem Land: they are more closely related to the *wuramu* tradition. Early photographs by Spencer (1914), taken in 1911-12, suggest that their workmanship was less complex than it is today and much more conventionalized. The actual carving now is fairly elaborate and the trunk designs more boldly executed, and human-type figures have become commonplace. The term used for these posts, *bugamani (pukumani)*, has the wider connotation of a condition or state of being tabu. It is a significant key to an understanding of Tiwi culture. The body of a dead Tiwi person is buried. About two months later the preliminary rites begin and the grave posts are cut and carved. Various relatives of the dead person, and his wife or wives or her husband, are classified as *bugamani*: traditional rules specify what they must and must not do, what to avoid, and so on. They are contrasted with the 'workers' (who are not themselves *bugamani*) who actually make the posts. Presents are distributed among the workers in compensation for their efforts.

While the posts are being shaped and painted, a series of rites continues. Finally the covering bushes are removed from the grave and the posts are erected there. Men and women dance before them. This is one of the occasions when a dead person's husband or wife (or wives) and close relatives sing personal songs of grief composed by themselves. The rites are designed to propitiate and control the dangerous *mopaditi*, the soul spirit of the dead person, from harming any of its living associates. The posts that were, and are, traditionally placed at the grave are in marked contrast to those available for commercial purposes. Even though the local-use posts are more elaborate than they were, they retain the traditional patterning. The posts for commercial sale show a trend toward extreme innovation, especially in regard to human figures. Moreover, all the traditional posts were placed directly in the ground; the more recently made naturalistic human figures have legs and arms, and were not intended for that purpose. In either case, their style continues to be distinctively Tiwi. The carved and painted designs are still conventionalized, and have both topographic and mythological meanings, but many of them demonstrate a traditional-innovative individualism that is much less pronounced in other parts of Aboriginal Australia. The same trend is evident in other aspects of Tiwi culture—for example, in the *kulama* initiation ritual, and in the dancing and singing of individually composed and individually identified songs.

On the western side of Cape York Peninsula, from Aurukun, come some outstanding carvings. What is not clear is whether these existed traditionally in the form in which we see them today. Certainly their patterning is mirrored in the body painting of ritual participants. Nevertheless, it would seem that these naturalistic examples have been derived from conventionalized objects and emblems, as in the case of Bathurst and Melville Islands. These carved and sculptured figures, in human and animal form, are used in rituals by Wik-mungkan people and members of adjacent language groups. They are associated with mythic and spirit beings and with species-renewal centres. At such sites, members of particular clans perform their

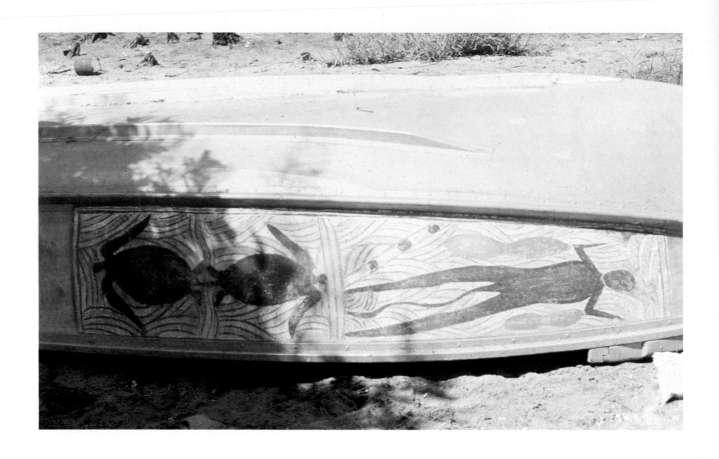

*Plate 92:* Dedication paintings on a modern dinghy. Yirrkala, north-eastern Arnhem Land.

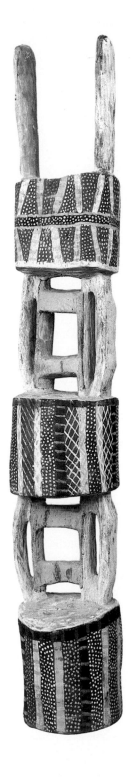

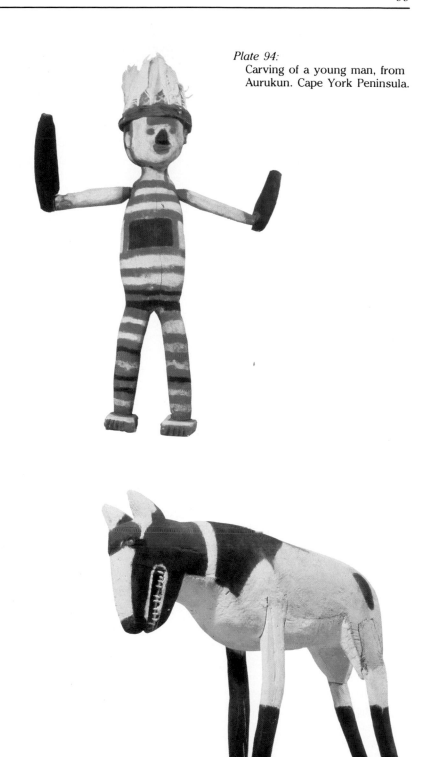

*Plate 94:*
Carving of a young man, from Aurukun. Cape York Peninsula.

*Plate 93:*
A *bugamani* grave post.
Bathurst Island, Northern Territory.

*Plate 95:*
A dingo, from Aurukun.
Cape York Peninsula.

ritual dances, re-enacting events which occurred in the early Dreaming era. The wooden objects are either held by the dancers or arranged on the dancing ground itself.

Geometric designs were carved out of living wood in south and south-eastern Australia, especially in New South Wales. Called dendroglyphs by ethnologists, these carved trees were found on burial grounds and were also used in initiatory rites. They had mythological significance. Other examples of differing type, from the Daly River in the Northern Territory, include human and animal carvings. An example illustrated here, on a living tree at Jigalong in Western Australia (in 1957), is a vivacious carving of a spirit character.

Returning to the Arnhem Land region, recent innovative carvings have appeared at Groote Eylandt and Woodah Island. There was, however, no traditional carving of this kind in that area—it was confined to painted poles used in secret-sacred ritual, and to smaller carvings of various creatures.

This discussion underlines the contention that most traditional Aboriginal art is closely associated with religious matters and derives its primary inspiration from that source. While Aboriginal cultural styles can be more or less clearly distinguished, this does not mean that they remained static. Within particular limits of aesthetic and social acceptability, they were varied, and allowed for individual treatment. Moreover, innovation is discernible within a specifically traditional milieu. The increasing encroachment of the outside world, however, provided a springboard for 'true' innovation. This, as we shall see in Chapter Six, allowed more scope for further developments which led to some extent away from more traditionally defined forms of art.

Nevertheless, many Aborigines seem to have had fundamentally conservative views about what they defined as being Aboriginal, as contrasted with something else. These have restrained the development of what might be regarded as atypical. This is exemplified in the items we illustrate, all of which, except for rock paintings and incisings, represent living Aboriginal art. All of these are seen through the medium of myth, and emphasize people's relationships with the land and the creatures and things it contains. All of these are seen as being under the direct auspices of the Dreaming characters, who are themselves symbolized in various aspects of nature but are transmuted both socially and personally. It is not just any land that is significant. Specific tracts and sites are important to particular persons with particular rights in them—rights which focus on land and what is on and within it, and rights that link such persons to particular, named spirit beings in terms of reciprocal relations, constituting a religious framework of action and belief. This kind of relationship between artists and their work, expressed through their carvings and paintings and other media, provides a crucial social underpinning, documenting and commenting on and supporting a coordinated way of life. It is against this wide social and cultural background that we must approach Aboriginal art if we want to have any real understanding of what was happening in the traditional past, and what seems to be happening now.

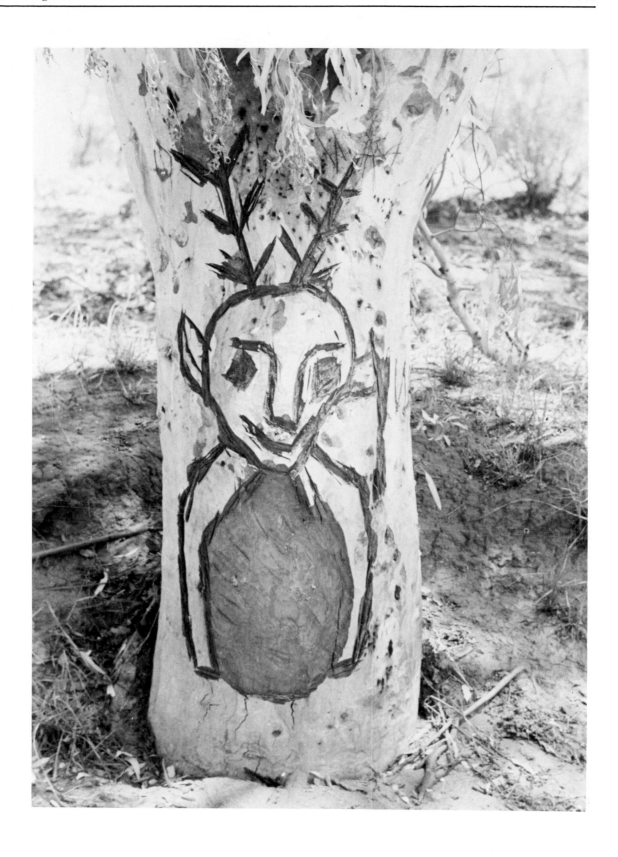

Plate 96: A tree-incising at Jigalong, west-central Western Australia.

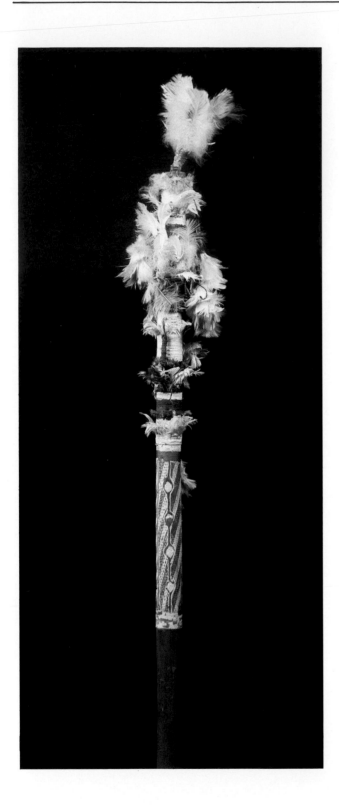

*Plate 97:*
   A Morning Star dancing-pole.
   Elcho Island, north-eastern Arnhem Land.

# CHAPTER FOUR

# *Art in Everyday Affairs*

APART FROM LARGE-SCALE SCULPTURE such as we were looking at in Chapter Three, there is a wide assortment of smaller carvings. Many belong directly in the sphere of religious ritual activity. Others are magico-religious in significance, and some are used in sorcery (black magic). Others again fall within what we can call 'domestic art' or craft.

# Other carving and modelling

These smaller carvings are very numerous and very varied, especially in Arnhem Land. Those of direct religious significance are incised and painted, with feathered attachments. Generally, they may be called *rangga* (as they are in north-eastern Arnhem Land) and are mostly secret-sacred, so they cannot be illustrated here. Some, however, bear close resemblance to the long 'Macassan'-type pipes introduced into that area by early Indonesian traders, and made by Aborigines. Presumably tobacco was introduced at the same time. In most other regions of Aboriginal Australia local 'tobaccos' were not smoked, but rolled in specially prepared ash and chewed. These pipes are cylindrical, made from the pithy stem of the *lungin* bush from which they take their name. The wood is scraped clean and smooth, the mouthpiece tapered and ridged, and the whole stem smeared with red ochre. They are either left plain, or incised with *mada-mala* (dialectal unit-clan) emblemic designs; when a design was secret, it was then hidden by wrapping bark or rag around it. The two wooden examples illustrated here are virtually unique. They were made especially as gifts in 1947. One represents the *dua* moiety Goanna Tail *rangga* associated with the Djanggau (see Chapter Three) and is highly stylized; the other is of a 'Macassan' mast pole similar to those of the *yiridja* moiety used in mortuary rituals. While the second example

can be freely displayed in public, the first, in its separate *rangga* form, is secret-sacred. Within its context as a pipe its religious significance is not diminished. Remember that Aboriginal religion traditionally permeated all aspects of social living, and utilitarian usage was no exception. Nevertheless, even though it is not wrapped with its design hidden, it is essentially a symbolic representation, although it would not be identified as such except by men familiar with its esoteric interpretation.

In western Arnhem Land, *maraiin* rituals of a secret-sacred character provide opportunities for the production of many differently shaped wooden figures—of birds, animals and fish, painted in ochres, as well as some made of bound grass, painted stones and lumps of hard beeswax. Some represent parts of the human body; others, slices of turtle meat, crocodile tongues, emu hearts, wallaby livers, snakes' eggs, yams, and so on. Many are naturalistic, others highly stylized. They were stored in repositories or in rock shelters, or smaller ones were carried in sacred dilly bags when not in use. In the *maraiin* rituals, men posture with them as songs are sung; and different sets belong to differing ritual sequences. Many have mythological significance. Especially, they are associated with local descent groups (called *gunmugugur*)—that is, with stretches of named and owned territories. Central Australian *tjurunga*, and incised boards of the Western Desert, are tangible manifestations of mythic and spirit beings. The *maraiin*, however, are more impersonal, and their bond is with particular social groups. Mythic beings may be and are responsible for their creation (actual and simulated), but the objects are not necessarily representations of those beings in their shape-changing capacity.

In north-eastern Arnhem Land, secondary *rangga* closely resemble the western Arnhem Land variety. For instance, there are carved wooden yams, complete with feathered twine representing creepers and runners with buds, leaves and flowers; tortoises, turtles, barramundi and other fish, emu, dugong, echidna and

so on. All of these are linked to specific mytho-song cycles. An interesting point here is that in the case of the western Arnhem Land *maraiin* they have remained entirely ritualized; so far, none has been made deliberately for an external market, although occasionally some appear in bark paintings. North-eastern examples, on the other hand, have been adapted for commercial sale, although they have never been as popular as bark paintings or larger pieces of sculpture.

This state of affairs, in which religious things were used more widely than in settings narrowly defined as religious occasions, illustrates the true concept of the sacred in Aboriginal Australia. The dimension of the sacred was not limited to what we call the *secret-sacred*: it covered a very wide spectrum of belief and action. For instance, in publicly open rituals which most members of a given community attend and participate in, decorated poles with feathered attachments are common in north-eastern Arnhem Land. Perhaps the best known are the Morning Star (*banumbir*) poles, with their great lengths of twine interwoven with feathers and interspersed with balls of seagull feathers. They are used in *dua* moiety mortuary dancing to the accompaniment of songs which tell of the spirits at Bralgu, the *dua* moiety island of the dead. These spirits dance, sending out the morning stars to a list of named places in Arnhem Land. Apart from the Bralgu mortuary song cycle, they are also linked to the Djanggau. Other poles of similar structure can refer to the Wawalag sisters and to Woial the Honey man. In the case of Woial, the feathered lengths representing lines of swarming bees are interspersed with hard wax discs symbolizing their 'homes'. Some of these poles are not unlike the Aranda *tnatantja* objects which represented, symbolically, living mythic beings; but the *tnatantja* were secret-sacred.

The movement of designs directly relevant to the 'closed' area of the sacred, into the mundane area, is not confined to north-eastern Arnhem Land, as we will see later. In north-eastern Arnhem Land, however, it is perhaps more marked. An outstanding example painted on the outer surface of a modern European-style dinghy comes from Yirrkala. The painting refers to the dinghy's dedication, in which it is named, and is intended to ensure its protection from storms and to aid its users in fishing. The design is wholly traditional and similar to emblemic bark paintings, and has both mythological and territorial significance. On the other hand, canoe paddles, clapping sticks, iron-bladed spear heads and bobbins, as well as didjeridus were and are painted with sacred and mythic designs. As we noted before, an artist who paints his *mada-mala* emblem on such an object always expects compensation from the user.

Pairs of clapping sticks, beaten rhythmically to the accompaniment of singing, were traditionally painted with patterning which correlated with the appropriate song cycles. In western Arnhem Land, each songman is responsible for his own songs, which he composes on the basis of those taught to him by a spirit-familiar in the course of a dream. The clapping sticks he uses in this public setting may be carved stylistically to represent a particular spirit—a frog, goanna, snake, and so on. In parts of the Western Desert boomerangs are used for the same purpose, sometimes painted only at the tapping ends.

Didjeridus were traditionally unpainted except for those used specifically in ritual—like the long, secret-sacred Yulunggul-type (Rock Python) drone pipe used in circumcision ritual (see Chapter Three for reference to the Wawalag sisters). Traditionally they were not widely distributed, although in recent years they have become enormously popular. They were mainly used only along the northern coast and immediately inland, and as far south as Katherine. In the early 1940s they were gradually infiltrating the Victoria River Downs-Wave Hill district, spreading west and south-west, via Birrundudu, to Halls Creek and into the Kimberleys. On the other hand, some came westward into the Kalumburu-Ord River region, probably before the 1940s. The whole of the Western Desert, including Cen-

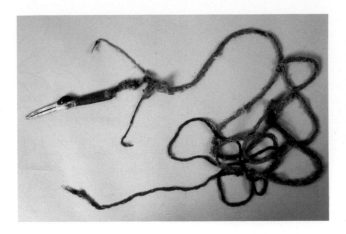

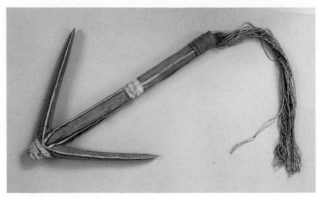

*Plate 98:*
  A love magic seagull. Yirrkala,
  north-eastern Arnhem Land.

*Plate 99:*
  A Macassan anchor used in love magic.
  Yirrkala, north-eastern Arnhem Land.

*Plate 100:* Macassan mast and Goanna Tail pipes. Yirrkala, north-eastern Arnhem Land.

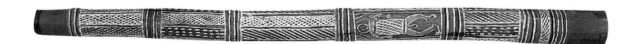

*Plate 101:* Didjiridu, with Thunder Man painting. Yirrkala, north-eastern Arnhem Land.

*Plate 102:*
  A Murchison district
  ceremonial message stick,
  Western Australia.

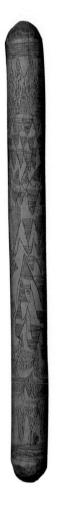

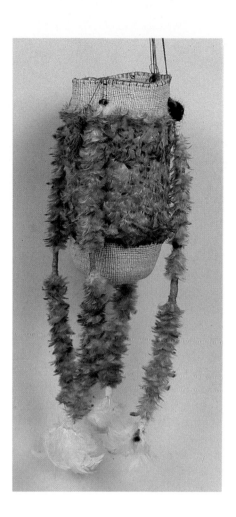

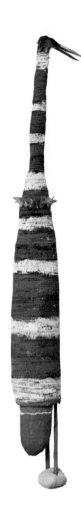

*Plate 103:*
  A man's sacred dilly bag.
  Yirrkala, north-eastern Arnhem Land.

*Plate 104:*
  Brolga emblem used in *rom*
  trade ceremonies. Oenpelli,
  western Arnhem Land.

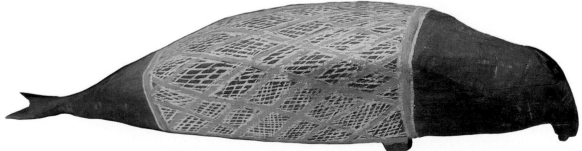

*Plate 105:* A dugong; Yirrkala, north-eastern Arnhem Land.

tral Australia, remained uninfluenced by the didjeridu until well after that time, although the Aranda did have a short 'trumpet' called *ilpirra*, used in love magic. Most Desert communities still refuse to accept them as part of their customary song-and-dance repertoire.

Two other varieties of carving should be noted.

First, mortuary paraphernalia. In Chapter Three we mentioned that in northern Arnhem Land a dead person's skull might be specially painted and carried around. If, however, a body had been lost through drowning or was not available for some other reason, a wooden substitute skull might be carved and painted. The *bugamani* mortuary rituals of Bathurst and Melville Islands also produced a rich crop of material objects. For example, dancers wore armlets with projecting decorations of feathers and red seeds and held painted disc circlets. And in the *kulama* initiation rites, belts made of alternate panels of human hair and banyan bark string, edged with sewn split cane and the whole painted with conventional designs, were worn, along with elaborate hanging pendants with red seeds and discs terminating in balls of feathers.

Secondly, love magic. Again, north-eastern Arnhem Land offers some interesting examples. Primarily, there are two types, dependent on the moiety of the person who uses them. *Dua* moiety men carve and paint a seagull head and body and attach to it lengths of feathered string, one as its tail, two shorter lengths as its wings. When it is held, it resembles a bird in flight. Other birds are carved for a similar purpose. The more traditional varieties were usually shown holding in their beaks a small beeswax model of a worm, mouse or fish. This is appropriate to the kind of creature the bird catches for food. So, the magico-ritual performance symbolizes the man 'catching' a desired woman. Men of the *yiridja* moiety, in contrast, make small wooden replicas of anchors resembling those used by Baiini and Macassan visitors to the coast, carved and painted, with twine attachments. When these are used

the object is placed near the girl's camp, the ball of twine is unrolled and stretched from one tree to another: the performer sits at the far end and sings songs associated with the seagull or anchor, as the case may be. This in itself constitutes a public declaration of his suit. For her part, the girl is expected to sit quietly among her relatives, wearing a feathered chaplet hung with pendants. On completing the songs, the suitor rolls back the string, drawing it in toward him and with it, supposedly, the girl's affection. There are variations on this theme.

In a large number of areas in Aboriginal Australia, especially in the Kimberleys, Central Australia and the Western Desert, individual men and women can use small bullroarer-type wooden objects incised with mythic designs consisting (commonly) of entwined snakes and identifying marks of a beloved person; some also show human figures, naturalistic or conventionalized. One of these is swung around at the end of a piece of twine, with or without singing. The assumption is that the humming sound will be carried to the desired person, however distant he or she may be, and irresistibly draw him or her to the performer.

Love magic lends itself to imaginative design, and to songs. They range from very frank, direct statements focusing on physical aspects of love, to subtle and highly poetic compositions that are art forms in themselves.

Sorcery, black magic, can provide an incentive for expressive art forms. The sorcery paintings of western Arnhem Land (see Chapter Two) are outstanding in this respect. In the same area, heads moulded out of pipe-clay (or white ochre) or red ochre were said to have been used for the same purpose. Those illustrated here were among fifteen made for us in 1949-50 by Gunwinggu men reproducing an art medium which by then was only remembered. All show the victim's head, and in three cases the shoulders and breast. Originally, so the makers said, the features of the effigy should

correspond roughly with those of the victim, and the body should be included too. The sorcerer would either sing over it or call the victim's name, breaking up the figure bit by bit. As each part or limb was broken the victim would feel pain or suffer injury in his own, and the final destruction of the image would bring death. To our knowledge, none of the heads collected represents a living person. The clay or ochre used for making these images was collected and dried a little, then moulded into an oblong shape, rolled on a clean piece of bark and left to harden. When required, it was pounded up or broken with the fingers, moistened and mixed with water to make it malleable. It was shaped with much fingering, a small twig being used to introduce eyes, nostrils and ears, and the head lightly incised to indicate hair, beard, breast design, etc. Once completed, it was left to harden in the sun.

This form of plastic art is almost unique, although it has some parallels. For instance, moulded pipe-clay or hardened-mud 'breasts', a pair linked with a length of local twine, were worn around the shoulders of young girls in north-eastern Arnhem Land to induce the growth of their own; and girls playing 'mothers (and fathers)' would carry, in paperbark baby containers, little shaped cylinders or rolls of hard clay representing children. Some were made for us at Elcho Island in the mid-1960s, but it is unlikely that children used them seriously after the 1930s. Some clay figures modelled by Djaru men in 1937, near Halls Creek in east Kimberley, represent a rider on horseback, a horse and an emu. While not 'traditional' in a strict sense, they suggest that such figures may have been made more frequently in the past than is usually supposed.

In western New South Wales, early writers have reported moulded ground figures of the mythic spirit Baiami, in *bora* rituals. In north-eastern and north-central Arnhem Land various figures, including spirit and mythic personages, were formed out of sand and incorporated in elaborate ground structures during mortuary rituals.

Beeswax was a handy substance in eastern Arnhem Land, in art and in everyday tasks. It could be shaped into small ritual objects, and human figures for sorcery and love magic. It was also widely used to mend various things, to attach a mouthpiece to a didjeridu, to hold bunched feathered tassels (for sacred objects and for personal decoration), and for a multitude of other tasks, just as wax from burnt spinifex grass was used as a solid adhesive in, for instance, spearthrower (womera) preparation in Desert areas. We have already mentioned wax discs interspersed with feathers on lengths of twine, and small wax creatures held by carved love-magic birds. Other moulded creatures were children's toys. Ritual objects of wax are extremely rare, and resemble secret-sacred *rangga*. Some were carried by messengers as invitations to religious ritual gatherings. Others were carried in men's dilly bags to ensure good hunting and fishing. The small wax human figures used in sorcery are often indistinguishable from those used in love magic—except that the last are more carefully made, with genitals, and some are shown in coitus. Sorcery figures are more crudely made, and are either plain or painted with a victim's *mada-mala* (dialectal unit-clan) emblemic design: some are covered with eaglehawk or seagull feathers. Other wax figures are moulded to represent specific mythic characters, especially Woial (see Chapter Three).

The question of where art begins or ends is raised again when we consider images made from bound paperbark. In eastern Arnhem Land these, called *bii* (pronounced 'bee'), were used in sorcery. Similarly constructed effigies might be put alongside a corpse on its mortuary platform, especially in the case of a woman who had died leaving young children: she would be comforted by these substitutes, and not try to take the living children with her. In western Arnhem Land, small figures of bound fibre and twine or paper-

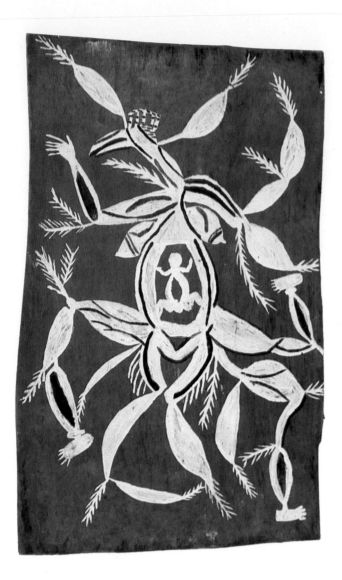

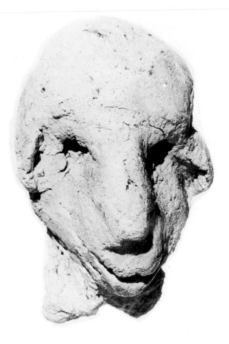

Plate 107:
Ochre head of a man.
Oenpelli, western Arnhem Land.

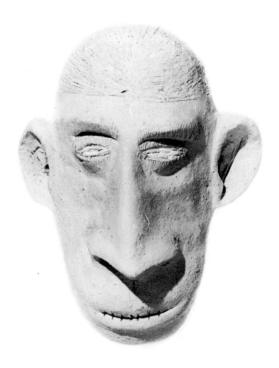

Plate 106:
Sorcery painting of a pregnant woman.
Oenpelli, western Arnhem Land.

Plate 108:
Mask-like face of a man, in ochre.
Oenpelli, western Arnhem Land.

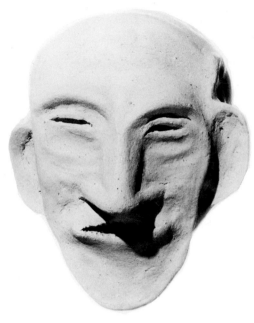

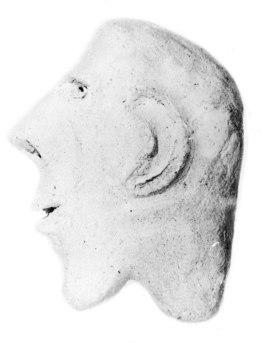

*Plate 109:*
    A man's head, in ochre.
    Oenpelli, western Arnhem Land.

*Plate 111:*
    Moulded head in profile.
    Oenpelli, western Arnhem Land.

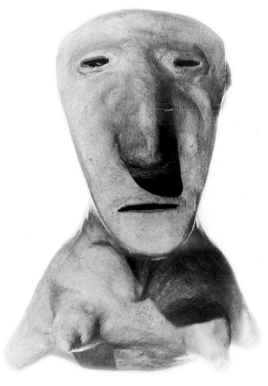

*Plate 110:*
    Bust of a pubescent girl.
    Oenpelli, western Arnhem Land.

*Plate 112:*
    Moulded beeswax figures: Woial the
    Honey Man and his sister. Yirrkala,
    north-eastern Arnhem Land.

bark used to be set up near a mortuary platform or grave, one arm pointing to the corpse, the other in the direction of the new camp site; people always moved camp when one of their number died. Three-dimensional human figures of bark and grass and other materials were not uncommon. In one ceremony we saw at Adelaide River Army Settlement in 1945, Wogaidj men danced with a bound-grass figure of a child; this was part of a mortuary rite, but fertile women who did not want babies were warned not to go too close, because its animating spirit power was strong. In a humorous story from western Arnhem Land, a man who could not get a real woman made a life-sized one from grass, complete in all its surface details. More seriously, in secret-sacred rituals of the Gadjari Fertility Mother in the central-west of the Northern Territory, elaborate effigies were made to symbolize her presence. A base of bound saplings and grass was overlaid with a patterning of featherdown and ochres, with pearlshell for her eyes, her head decorated with bunched feathers; she was both beautiful and transient—and, above all, 'alive' with sacred power.

As far as Aboriginal Australia is concerned, most of the objects we refer to here, with some obvious exceptions, fall within the dimension of art, as creations by particular artists for social purposes. Those purposes, in this context, are religious and magical. In all such cases the object stands for more than itself, and is more than a work of art. It is imbued with additional qualities—in a sense, it is possessed of a life of its own, but under the control of the artist or ritual participant.

In the traditional scene, the categorizing of certain items or activities as secret-sacred, while not necessarily distinguished as being so by an outsider, was not called into question by Aborigines familiar with them. However, it is important to remember that the realm of the sacred is very much wider, and the secret-sacred is only one aspect of it. In any traditionally-oriented Aboriginal community, the open-sacred includes a large range of religious material that is not subject to restrictions, although the actual identification of symbolic meanings may be. With that in mind, we can say that virtually all religious visual art is, broadly or specifically, expressive of mythology and is associated either directly or indirectly with ritual. Mortuary sequences also fall within that category. Essentially they too are religious, and so are initiatory, revelatory, fertility and species-renewal rituals.

When we speak of this last variety we are in the realm of the magico-religious. These days, most anthropologists would not attempt to separate out the 'religious' from the 'magical'. Nevertheless, it is customary to refer to objects and rites designed to attract a desired partner as 'magical'. With some exceptions, notably in western Arnhem Land, beliefs and actions clustered round love magic and songs are sponsored by mythic beings, who may be the same as those responsible for the 'big' religious cycles. In fact, there are often quite close connections between the two dimensions. Where sorcery is concerned, the situation is not so clear-cut. But even there, mythological justification is often present.

Most of the objects we have discussed here make use of the supernatural or the non-empirical. Most, too, draw their 'power' (their efficacy) from the Dreaming—which is the source of both life and death, providing certainty in the face of uncertainties. In these circumstances, all of the art manifestations we have discussed have an additional quality associated with them. In a mundane sense, we can say they all have a kind of 'magical quality' and are possessed of something over and above their meaning and interpretation—over and above their aesthetic value. When we consider European religious art, we come closer to understanding the significance of Aboriginal art.

# CHAPTER FIVE

# *More Art in Everyday Affairs*

# Domestic art

WHEN WE CONSIDER THE SPHERE of Aboriginal domestic art, we might expect to be able to distinguish a movement away from 'art', or at least away from religious art. In general we tend to classify such material as being primarily utilitarian, and in those circumstances to regard it as craft. However, if we look closely at this issue, we will remember that much of religious art *is* also utilitarian: most of the objects within that context are designed to achieve particular purposes. It is not, therefore, necessarily the context of art that defines it *as* art—nor, for that matter, whether or not it is put to a mundane use. It could correctly be said that *all* Aboriginal art is essentially utilitarian, that its aesthetic qualities are incidental. We can turn that statement around too, and claim that even in the entirely domestic arena the question of aesthetics is of primary concern.

Take, for example, a multi-purpose wooden carrying dish in the Western Desert. There are some crude, hastily made specimens, but in general it is not a rough makeshift affair; its delicately balanced proportions, its detailed chipping and hollowing and smoothness produce an object which is both pleasing in appearance and eminently usable. Traditionally, such carriers were undecorated, but that did not detract from their essential beauty. In western and eastern Arnhem Land, pandanus woven baskets or dilly bags were of high quality, carefully finished, some elaborately worked with human hair and featherdown at the 'mouth'; some, too, were decorated with ochred designs of human figures and other creatures, plants and foliage.

The division between art and craft is therefore blurred. This is evident even in such a commonplace domestic 'tool' as a spearthrower. We can regard this as being 'domestic' because it was used in hunting, even though it also served as a weapon or weapon-supplement for projecting spears in attack and defence. In the Western Desert, as contrasted with some other areas, one kind of spear might serve either purpose—to kill an animal for food, or to spear a man in fighting. The Desert spearthrower is a gracefully carved and balanced instrument, broad, and either flat or concave, with a peg at one end (into which the spear fits), and wide 'shoulders' tapering to a 'handle' usually ending in a stone cutting flake affixed with hard wax. The concave variety did not normally have incised designs, because it was intended to be a multi-purpose object in which ochre pigments could be prepared or seed 'flour' mixed and kneaded. The flat variety was also used as a platter. In both cases the spear was held horizontally along the concave trough or, in the case of the flat thrower, along the design itself. The design was, therefore, placed on the inner or spear side, the outside usually being left unadorned. When it was not serving as a spearthrower, the stone flake could be used as an adze.

The designs incised on spearthrowers are of particular interest. They represent, if we can put it that way, the secularization of essentially secret-sacred, mythologically based patterning, symbolically significant and often topographic. They resemble those on secret-sacred boards, which underlines the fact that traditionally the context was more important than the

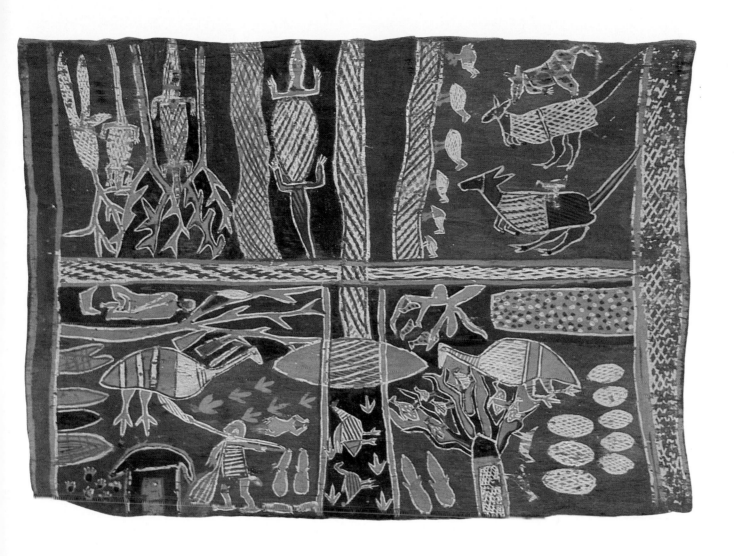

*Plate 113:* A hunting scene. Yirrkala, north-eastern Arnhem Land.

actual designs in drawing that distinction. On the other hand, it draws attention to what we said before—that sacredness was a facet of ordinary living, not compartmentalized, and not solely the concern of the ritual ground. Similar designs were also incised on the flattened narrow boards usually worn in the Desert as hair-skewers by newly initiated youths. Along with its shape, the spearthrower was a work of art. Some of the most popular designs were stylized representations of land snakes or the huge Wonambi snake associated with water; others referred to clouds, flood water, wind, willywillies, dust, shadows, features of particular areas of country, and so on. Virtually all have mythic connotations.

Spears which accompanied such spearthrowers were entirely plain. But in the context of fighting, Desert shields were light in weight, not too broad, tapering at both ends, slightly curved, with a carved handpiece. Their inner surface was usually plain, the outer 'face' deeply grooved or incised, commonly with a 'snake' or Wonambi design, although other patterns were used—just as the overall shield shapes varied, some having convex fronts. The traditional grooved kind was effectively outlined or enhanced by 'inlaid' red and white ochres.

In the southern Kimberleys and at Balgo, near the northern limits of the Western Desert, shields are heavy blocks of wood, tapering at each end, with a plain convex face. The inner flat surface bearing the handle usually has a conventionalized geometric design referring to local topography—or shadows from passing clouds, creek beds and so on. In this case, as in others, the patterning resembles closely that on secret-sacred boards. Like many Aboriginal shields, these are used for parrying, particularly when clubs are used in fighting. In that area, spearthrowers are long, tapering to the pegged, spear-holding end, with a cut-in handle at the other end; they are plain, or painted with ochred bands or circles. In many areas, as in Arnhem Land, no shields are used and spearthrowers are of light wood, rather stumpy, less tapering, with their handles not so pronounced, and commonly decorated with ochred designs. One rare spearthrower comes from north-eastern Arnhem Land: it is cylindrical with bunched strands of human hair at its holding end, and is also used in ritual as a baton, or more generally as a fly whisk. A further rare example of a short spearthrower with a spear-rest and handle comes from western New South Wales.

While many shields are designed for parrying, those of north-east Queensland are fairly wide and of irregular sizes, painted with a variety of patterns representing various creatures, plants, artefacts and so on. The broad shields of Central Australia and farther north have a convex face, with graceful curving ends. Many were painted in ochres with varying designs. Some were used in specific rituals, when their patterning had mythological associations. Wooden seed containers, large shallow dishes, were also painted, but less so traditionally than they are today.

It was, however, in New South Wales, Victoria and South Australia that the art of shield manufacture reached its aesthetic peak. For instance, there are the board shields of the Lachlan and Murrumbidgee rivers and into Victoria, so shaped as to provide protruding ends for parrying. On their outer surface they are

intricately incised and carved with diamond and herring-bone designs, parallel chevrons, diagonal flutings and multiple lozenges. The 'bow-shaped' parrying shields from western New South Wales are unique in form and have incised grooves, often filled in with white and red pigments. Those from the River Murray are heavy, long, tapering objects beautifully incised with many designs, including those just mentioned as well as concentric triangles and diamond figures, etc. Some of the broader shields of the lower and upper reaches of the River Murray had stylized figures of human beings and other creatures. The meanings of many of these complex patterns are not known today, but some bear a close similarity to the designs on secret-sacred boards.

Coordinated stylistically with them are the boomerangs and clubs of those areas. The long, curved fighting boomerangs are outstanding in this respect, expecially those from western New South Wales and western and central Queensland. Their convex surfaces are elaborately incised with patterns depicting, for example, fishing nets, leaves or shell marks or ripples on the bank of a river. Those from the Kimberleys are a combination of stylized curvilinear designs and, sometimes, naturalistic figures. Some reflect the incising on ritual boards. Many boomerangs were undecorated or only partially so, with simple ochred markings.

Fighting clubs varied considerably in shape and in the designs they bore; mostly incised, some were also ochred. The spatulate bladed *lillil* from western New South Wales are perhaps the most outstanding. With their broad 'blades' at one end, they are incised with curving parallel grooves and with circles, ovals and the tracks of various animals. Many of the objects from eastern Australia have been stained with vegetable juice and polished, with ochre rubbed into the incising. Other clubs had knobbed or bulbous heads and were incised with both elaborate and simple designs. Long 'paddle-like' clubs have an elongated handle with a concave crescent-shaped cut at one end, with almost a cutting edge, and the flat 'blade' often had simple designs. These were wielded with both hands in duelling by men and by women (not in mixed-sex encounters) from western Arnhem Land to the Daly River, and even farther to the south-west. Heavy ironwood clubs up to two metres or so in length, with a circular or oval trunk, were commonly used in the north. Flat hardwood throwing weapons of 'cricket-bat' shape were used in the Adelaide River area of the Northern Territory. There were many throwing-clubs: shorter ones in the Western Desert and Central Australia, whereas the Tiwi of Melville and Bathurst Islands traditionally made a large variety of differently shaped clubs.

We have included weapons in the general category of 'domestic art'. This recognizes that spears and their throwers and often clubs and boomerangs were used in hunting and fishing and in fighting, as well as in ritual contexts. However, Aborigines distinguished between different kinds of spear: plain or pronged, some with ornately carved barbs, others tipped with stone or iron blades or stingray 'nails', and multi-pronged spears used for fishing. Each had its own local type-name which indicated its differing purpose, and there were some marked regional contrasts: for example, the long painted-barbed spears of the Tiwi people, with their

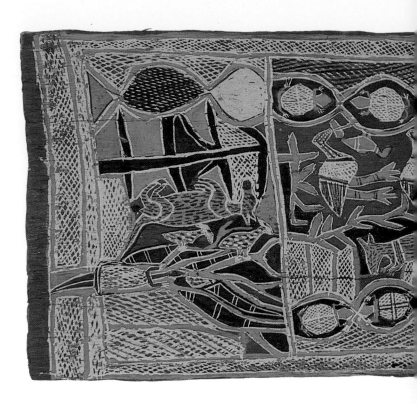

*Plate 114:*
   A Western Desert
   spearthrower.
   Ooldea, western
   South Australia.

*Plate 115:*
   A spearthrower from the Warburton
   Range. Western Australia.

*Plate 116:*
   A hunting scene.
   Yirrkala, north-eastern
   Arnhem Land.

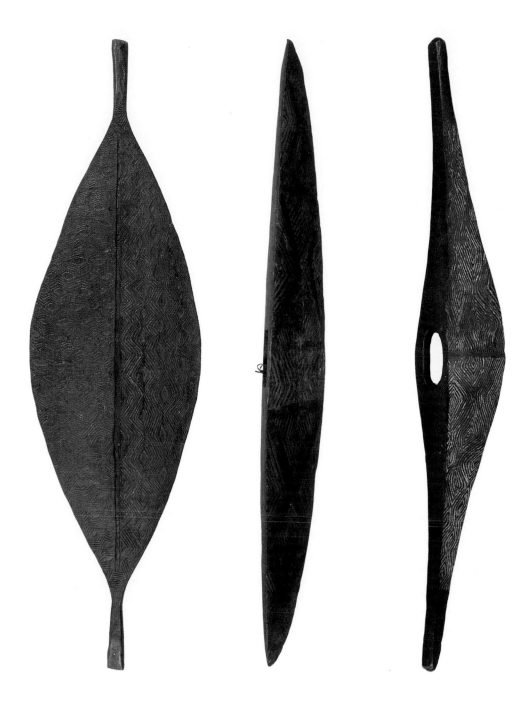

*Plate 117:*
  A south-eastern
  Australian parrying
  shield.

*Plate 118:*
  A shield from the
  lower River Murray,
  South Australia.

*Plate 119:*
  A bow-shaped shield
  from the Darling River,
  New South Wales.

unmistakeable brilliant ochres and patterns.

One of the most distinctive of the smaller objects is the incised pearlshell. Most come from the Kimberley coast and are decorated on the inner 'polished' surface with an assortment of highly stylized and naturalistic incised designs, often with red ochre or charcoal rubbed into them. The traditional type-design consisted of geometric figures depicting local topography and human beings; others illustrate various marine and land creatures. Some bore the easily-identified water and rain patterns, and were associated with seasonal fertility. Still others point to the impact of the outside world: Christian symbols, horses, windmills, stockmen's boots, 'planes, and so on. They were used as necklet-pendants or as pubic coverings, often presented to novices completing their initiation sequences, and generally worn at particular ceremonies and rituals. They were not in themselves sacred. They ranged in size from the large trimmed pearlshell to the small *maban* disc (of about a centimetre in diameter) used by Aboriginal traditional doctors in easing pain or healing the sick, or projected magically by a sorcerer into his victim. They were also regarded as enhancing an Aboriginal doctor's x-ray vision, which was said to be one of his attributes. Some pearlshells were cut into various shapes for love magic. Generally, pearlshells (as finished products, complete with incising) were traditionally traded over immense expanses of the continent, passed from one group to another. Probably no other object has moved so widely from its original source as the pearlshell. It was highly prized for its shining attractiveness, and because it was considered to have magical qualities. In some Western Desert areas fragments were scraped from it and used in rain-making. Pearlshells found their way into the west-central part of the Northern Territory, across to Darwin, into southern Australia and to the transcontinental railroad.

There were more localized developments. The (boab) baobab nuts of the north-western Kimberley coast have become well known in the last few years because of their tourist appeal. Originally they were used as ritual rattles. Many today are incised, painted or have rubbed-in ochres on the inner brown colouring of the nut from which the outer surface has been scraped. The more traditional examples bear both geometrical and naturalistic designs of various creatures, including plants and human figures. Recent work is more elaborate, with topical scenes far removed from traditional style.

Message sticks were and still are widely distributed. They vary in shape and length and in the designs incised or painted on them. These are not written messages; however, the symbols can be interpreted within the context of oral communication. The messenger who carries such a stick explains the intended meaning, while the design serves to validate the message. Some are small flat slabs of wood (as in Arnhem Land), others intricately-incised cylinders (as from the Murchison district of Western Australia). Many of the north-eastern Arnhem Land designs replicate sectionally or in part *mada-mala* (dialectal unit-clan) em-

blems, indicating the affiliation of the sender. Such message sticks relate to economic transactions. Others, more ornate, sometimes made in wax to resemble a ritual emblem, and hung with feathered tassels, notify people in distant camps of a death or an impending ritual event, and constitute an invitation to attend.

Religious representations, then, were not entirely absent from what can be regarded as domestic art.

On one hand, as far as religious art is concerned, most cultural areas in Aboriginal Australia were, and some still are, responsible for a wide variety of material cultural items, linked specifically to mythology and ritual. An object had to be used in appropriate social contexts and not outside them. Such objects would differ in shape and in design from one social circumstance to another. Also, sets of material cultural items were distinguishable in style from other sets, between different Aboriginal communities.

On the other hand, in regard to domestic art the range of objects *commonly* used in the course of everyday living was strictly limited. Religious art lent itself to proliferation. Domestic art did not. A great deal of religious art was traditionally of an impermanent nature—apart from items left to stand in particular places or hidden away in repositories, and the more durable stone examples. Only on rare occasions were sacred boards carried over long distances, although here too there are exceptions. Domestic objects, except for the heavy stone grinding-implements, were designed to serve a relatively mobile situation—they had to be carried in hunting and food-collecting. Even so, the designs and shapes of spearthrowers, shields, boomerangs, clubs and spears in the case of men, and wooden dishes and baskets and digging sticks in the case of women, were quite diverse, and particular cultural styles are recognizable. Whether an object was intended for transitory or long-term (semi-permanent) use, the same care and pride went into their workmanship. Those of a domestic kind, including weapons, were made to last, and when they were damaged they were mended where possible with beeswax and sinew—particularly in the case of spears and spearthrowers.

Whether such objects were intended to be permanent or impermanent did not detract from their relevance as art. One of the most crucial aspects to be taken into account here is the wide significance of religious design.

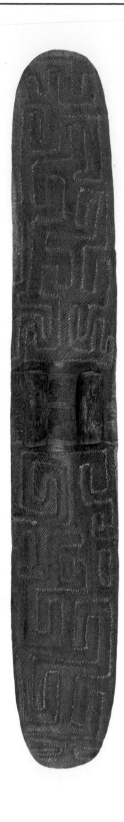

*Plate 120:*
  A Central Australian shield.

*Plate 121:*
  A La Grange shield,
  Western Australia.

*Plate 122:*
  A traditional Western
  Desert shield. Ooldea,
  western South Australia.

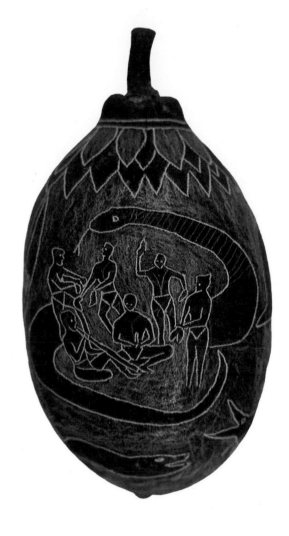

Plate 123:
Incised pearlshell from
Christmas Creek, Kimberley.

Plate 124:
Incised baobab nut from
Halls Creek, Kimberley.

# CHAPTER SIX

# *Changing Directions*

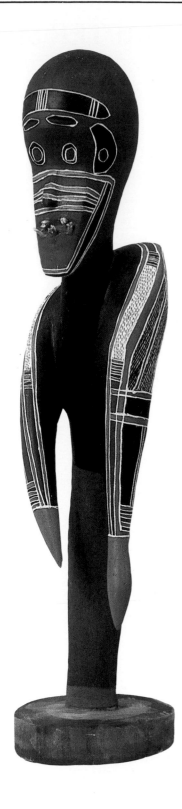

SO FAR WE HAVE FOCUSED almost entirely on Aboriginal art forms that are primarily traditional in inspiration. In the process, however, we have seen that, against a background of a particular cultural style, individual artistic interpretation and even innovation were not absent. Probably the most outstanding examples come from north-eastern Arnhem Land, with the *wuramu* sculpture undoubtedly influenced by Indonesian visitors to the north Australian coast prior to European settlement.

In regions where Aborigines were not totally overwhelmed and crushed by an invading population, alien contact brought in its train the incorporation of new ideas. This gave artists an opportunity to include in their work new themes and techniques, and to record aspects of intruding non-Aboriginal features. On some rock shelter walls in the Wessel Islands, in the western Arnhem Land galleries, and in the Kimberleys, as elsewhere, 'foreign' elements are depicted graphically in ochres. Aboriginal artists were keen observers, acutely attuned to everything which happened in their environment. To them the whole country was full of signs, and they recorded these in their naturalistic, stylized, symbolic or mythic forms. When non-indigenous aspects were projected into the landscape, these too appeared in their record as a matter of course. Innovation itself was not, therefore, something that was irrelevant to the traditional scene. With increasing Australian-European contact this whole process changed its directions, and these are what we turn to now.

*Plate 125A:*
The mythic being Mareiyalyun with snake. Elcho Island, north-eastern Arnhem Land.

# *Alien pressures*

Europeans did not overrun the whole Australian continent all at once. In the regions where they first landed and settled, many Aboriginal societies were devastated and, among other things, their art forms destroyed. In other areas the most concentrated signs of conquest came later and were rather less severe, and while considerable inroads were made into virtually every aspect of social living, indigenous art forms struggled on. Where there was no internal *and* external stimulus they deteriorated, and were often debased for a non-discriminating alien commercial market. In some other areas, as in north Australia, the Central and Western Deserts and the Kimberleys, which were not at first so attractive or accessible to alien visitors, traditional Aboriginal life survived as a living reality—although, again, inevitably modified. After the 1940s, no Aboriginal community remained entirely immune from the influences of the wider society. However, in these areas at least, traditional art remained an integral part of social life. A large number of the items illustrated in this book belong to that category. They represent a vivid and living contemporary art.

Of course, even in the cultural strongholds where traditional art still flourishes, adaptations have become a normal and socially acceptable feature. As far as Arnhem Land is concerned, the north-eastern sector is the scene of greatest development of genuine innovative styles based on traditional topics and myths. The subject matter has remained relatively constant, but the ways of depicting it involve elaboration and modification of the indigenous style. Western

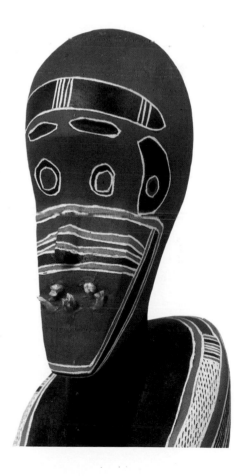

Plate 125B:
A close-up view of the
head of Mareiyalyun shown
in Plate 125A.

Arnhem Land shows the same trends, but not so conspicuously or on such a large scale. In a different time and setting, the Birrundudu brown paper drawings (from central-western Northern Territory) suggest the development of an entirely new art form which incorporates traditional art styles drawn from several areas, concentrating primarily on traditional subjects. In Papunya art, which stems directly from the sacred art of Central Australia, the medium is different but not the style: the subject matter remains unchanged, and so does the highly conventionalized patterning of the designs.

# The trend in innovative art

What do we mean here by innovation? The criterion is not simply the introduction of new techniques, pigments or media. For instance, an Arnhem Lander may turn to a sheet of introduced board instead of bark, or to brushes bought from a local store. Using these may lead, as it has done, to a more painstaking effort on the part of the artist, resulting in less freedom in flow of line, and a tendency for the production to appear as craft rather than 'true' art—but not in all cases. Birrundudu artists used lumber crayons and brown paper, Papunya artists board, canvas and European paints.

Innovation in Aboriginal art consists of building on what is already there, developing new themes and new ways of treating their natural subject matter—the world around them, which they know intimately. The real issue, for many artists who are still traditionally-oriented, lies in the dilemma of reproducing time-honoured designs which are still significant to them, but at the same time avoiding fossilization of elements which in the long run could stultify artistic development. To put it another way, they are faced with the problem of retaining an essentially Aboriginal flavour, while at the same time taking into account the changes which face them in regard to the demand for their work, and the uses it can serve in their present circumstances.

The overall Aboriginal scene in regard to visual art is very uneven. Art productions comparable to the great work of the traditional artists of the immediate past are still being made—not just as copies or replications, but 'complete' (if that word can be used in this context) with their mythological significance. They are works which can be identified by members of a particular society as intrinsically and aesthetically their own, as having a direct relevance to themselves in personal and social terms. These same paintings and others may be available through organized commercial channels. But, that aside, they remain products of a living tradition—whether or not they show innovations in style.

# Working through a European medium

In contrast, many Aborigines are turning their attention to Western European art styles. This development, by no means recent, poses difficulties in categorization *and* evaluation. In numbers of traditionally oriented communities, Aboriginal school children have been

taught or encouraged to draw or paint in essentially non-Aboriginal ways. In styles, in perspectives, even in subject matter, they tend to diverge radically from their elders, even though some of them pay lip-service to the idea and ideal of 'Aboriginal culture'. Their influence on the future of their people in this respect will be great, and could conceivably mean the destruction of traditional inspiration. While alien influence on still-vital communities has led to 'traditional innovation', in many cases it has not.

Two interesting developments took place in different parts of Australia at about the same time. The first, in the Carrolup Aboriginal school in Western Australia in the mid-1940s, produced an outstanding collection of pictorial art. The school headmaster taught the children of Aboriginal descent how to merge pastel colouring, and how to represent clouds, hills and trees and the like. The children were responsive to their own local environment, and expressed their fantasies through that environment. Their productions are resonant with life. Against a vivid bush background, various creatures move and blend in dramatic colouring. There are also scenes of imagined Aboriginal life— because for these children that traditional life was a thing of the past, not a part of their own experience. This art form, although produced by children who had no direct contact with a traditional Aboriginal setting, is truly great. Mostly it remains unappreciated by a 'sophisticated' art world which is more concerned with its own products than with its by-products. The Carrolup school closed a long time ago. But one of its students, Revel Cooper, has continued his painting as an adult, and two of his mature works are illustrated here.

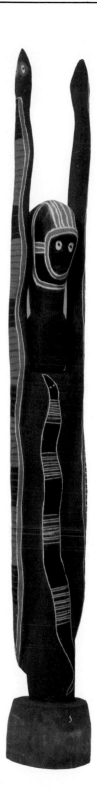

*Plate 126:*
Mareiyalyun with snake arms. Elcho Island, north-eastern Arnhem Land.

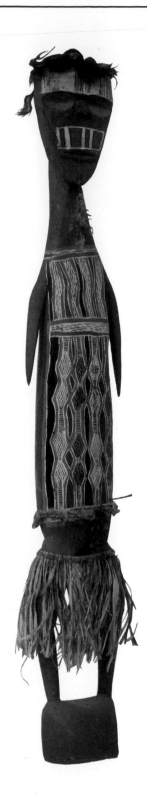

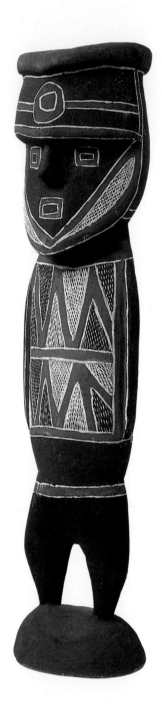

*Plate 127:*
   Portrait sculpture of Ngulumung. Yirrkala,
   north-eastern Arnhem Land.

*Plate 128:*
   A Darwin policeman. Yirrkala,
   north-eastern Arnhem Land.

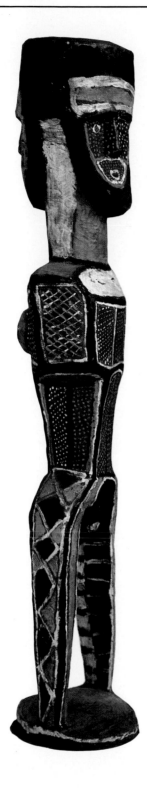

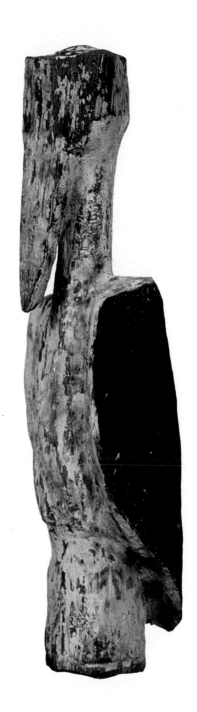

*Plate 129:*
  Co-joined male-female figures in a
  *bugamani* grave post.
  Bathurst Island, Northern Territory.

*Plate 130:*
  Part of a *bugamani* grave post.
  Melville Island, Northern Territory.

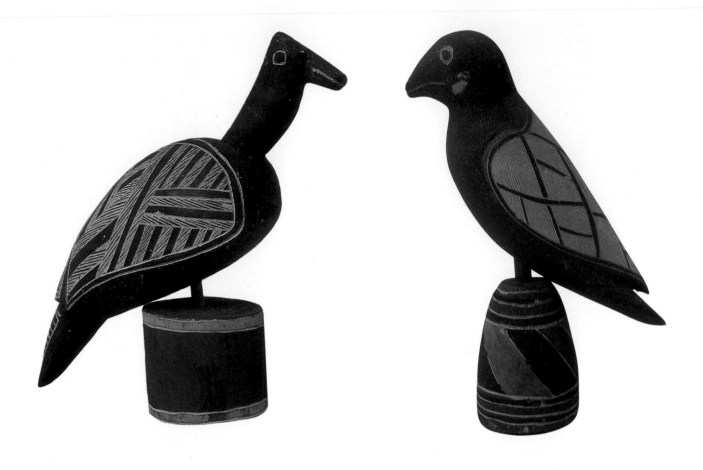

*Plate 131:*
   A *gadaga* bird. Yirrkala,
   north-eastern Arnhem Land.

*Plate 132:*
   A *djiwilyilyi* bird. Yirrkala,
   north-eastern Arnhem Land.

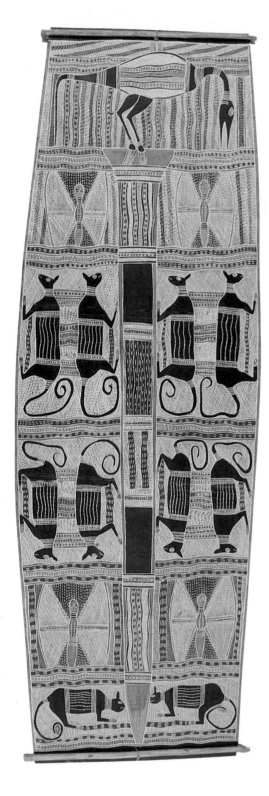

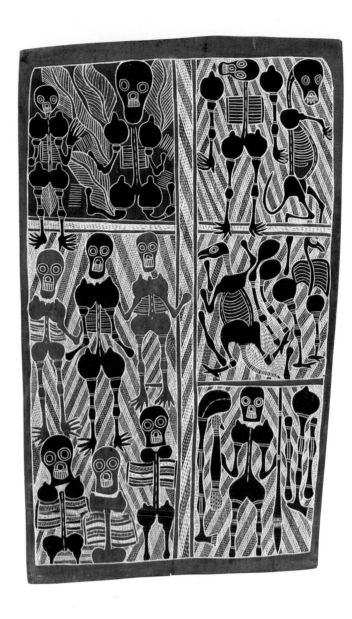

*Plate 133:*
  A *guwag* night bird on a wild
  plum tree, with possum. Yirrkala,
  north-eastern Arnhem Land.

*Plate 134:*
  Probable result of bauxite mining.
  Yirrkala, north-eastern Arnhem Land.

Snake Bay

Bathurst Island

Melville Island

Port Essington

Cobourg
Peninsula

Croker Island

Goulburn Islands

Barclay Point

Wessel Islands

Drysdale Island

Truant Isl.

Elcho Island

Flinders Point

English Company Islands

Cooper's Creek

Gunadir Creek

Maningrida

Milingimbi
Glyde Inlet

Bremer Isla

Nhulunbuy

Melville Bay

Nimbuwa

Arnhem
Bay

Yirrkala

Cox Peninsula

Darwin

WESTERN

Oenpelli

East Alligator River

Mount Dundas

Gove Peninsula

Cape
Arnhem

Port Bradshaw

Adelaide River

West Alligator River

South Alligator River

Nourlangie Rock

Liverpool River

MID–
NORTH

Goyder River

NORTH–EASTERN

Dead Adder Creek

Caledon Bay

Adelaide River

ARNHEM

LAND

Trial Bay

Myaoola Bay

Cape Shield

Daly River

Woodah Island

Blue Mud Bay

Port Keats

Groote Eylandt

Katherine
Manbulloo

Beswick

Roper River

Victoria River

0      50      100 km

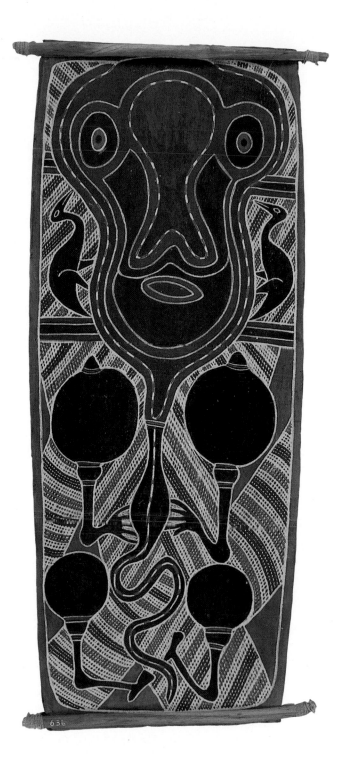

The other development is much better known. This is the famous Hermannsburg School of Aboriginal painting which was popularized by Rex Battarbee and C. P. Mountford. The most famous exponent was Albert Namatjira, an Aranda man, who learnt from Battarbee and others the basic techniques and skills of water-colour landscape painting. Exhibited in the capital cities in the late 1930s and 1940s, his work was almost immediately acclaimed for the beauty and warmth and emotional atmosphere of his Central Australian scenes. His approach was essentially through a European style. It departed markedly from traditional Aranda art, which was generally highly conventionalized and abstract, and dependent on symbolic interpretation—even though some art-critics claim to find such stylized symbols within his naturalistic treatment. What the two approaches had in common was their representation of the land, almost to the exclusion of the creatures and human beings which inhabited it. Other artists followed: Albert's sons Enos, Oskar and Ewald; the three Pareroultja brothers, Otto, Edwin and Reuben; Walter Ebatarinja, Henoch Raberaba and Richard Moketarinja, who have all worked in the same 'tradition'. We illustrate a few brown paper drawings we obtained from the Hermannsburg school in 1944. These provide clues to this development. While this School of Art is without question Aboriginal, it draws on the inspiration of the country in Western European terms rather than in a distinctively Aranda way. Each water-colour stands on its own, can be understood immediately for what it is, and, unlike traditional Aboriginal art, requires no interpretation. It has, in fact, moved in a non-Aboriginal direction, virtually severing its traditional ties.

*Plate 135:*
A corpse on its disposal platform.
Yirrkala, north-eastern Arnhem Land.

# *The trend away from traditional forms*

This movement away from a rich Aboriginal heritage is to some extent understandable, in the light of increasing pressures for socio-cultural change—involving, almost inevitably, changes in aesthetic appreciation. If we stand a little further back, not too far, we come closer to understanding what has been taking place in Aboriginal Australia.

Initially, Aboriginal art was regarded as 'primitive', as being unworthy of consideration *vis-à-vis* the productions of the great art schools of the world, either classical or modern. When Aboriginal art was taken into account, it was classified as 'tribal'. Ethnologists collected such work and placed it in the custody of museums, as representing part of the history of man or the beginnings of culture: and Aboriginal cave paintings and incisings added to that image. As far as Australia is concerned, it was not until the 1930s that the first glimmerings of a positive approach appeared. It took much longer, though, for Aboriginal art to move into the public arena and to capture the attention and interest of Australians generally. A series of exhibitions in most of the main cities, from 1929 to the early 1960s, attracted growing interest. Eventually Aboriginal art was moved into the national art galleries, and increasingly stimulated the imagination of other, non-Aboriginal, Australian artists.

While this was happening—while Aboriginal art *per se* was gradually coming into its own and being recognized both in this country and overseas as a unique form of considerable merit, among which great masterpieces were to be seen—Aboriginal art in some traditionally—oriented communities remained depressed. It is true that in some areas, as in Arnhem Land, Melville and Bathurst Islands, in the Central and Western Deserts, painting and sculpture and parallel forms continued to serve social and religious needs. In many other situations they were withering away. At the same time, the people themselves were desperately in need of money and few channels were open for them to attain more than, at best, token sums.

In response to growing interest in the cities, material for sale was sent down south. These channels were gradually developed, on the basis of several earlier efforts, notably by the Methodist Overseas Mission in Darwin. At first, sales were small, but interest was steadily increasing and led to the commercialization of Aboriginal art. Various intermediaries, including Aborigines themselves, were quick to recognize the tourist potential of their productions and to appreciate the income derived from this source. However, the Australian public was largely uninformed about Aboriginal artistic standards and undiscerning in its purchases. Moreover, the potential buyers had preconceived ideas of what constituted Aboriginal art. Consequently, Aboriginal artists were more or less obliged to straightjacket their work to meet demands. This inevitably lowered aesthetic values and resulted in the mass production of objects. In the late 1950s and early 1960s we saw at Yirrkala large heaps of discarded works which were of a quality unsuitable for commercial sale—even though the anticipated purchasers remained, on the whole, undiscriminating. The same was the case with

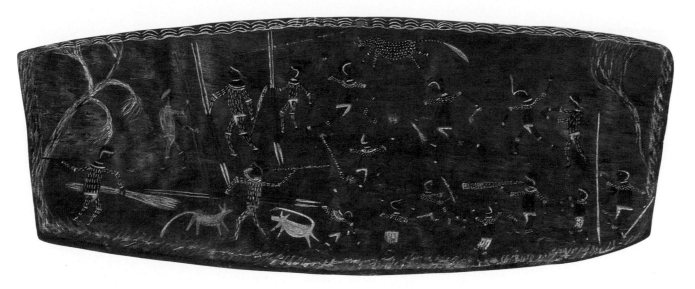

*Plate 136:* A ceremony. Port Keats, Northern Territory.

small carved and incised wooden creatures from the Warburton Range in the Western Desert: such material flooded the market. With all this came many bark paintings which were virtually daubs. Among them, however, were some of outstanding importance.

It was in this turmoil, so to speak, that in many cases the divorcement of traditional art from its social context took place. Or, rather, as far as north-eastern Arnhem Land was concerned, and some other places, the emergence of compartmentalization became apparent. On one hand, material still retaining its traditional style and quality was being produced for ritual purposes. On the other hand, objects being produced for external sale were not only limited in range, but the question of artistic achievement in respect of them was almost irrelevant. In these circumstances, a further development emerged. Experiments were being made in innovative art—building on traditional styles and elaborating well-known themes. Initially, these were often rejected or discarded because to other Australians, non-Aborigines, they were not 'typically' Aboriginal.

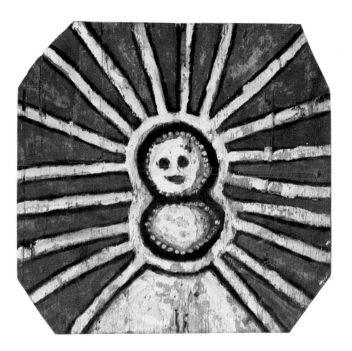

*Plate 137:* Jellyfish. Kalumburu, Kimberley.

*Plate 138:*
   A South-West bush scene,
   Western Australia, by Revel R. Cooper.

*Plate 140:*
   The MacDonnell Ranges.
   Hermannsburg, Central Australia.

*Plate 139:*
   Bush scene with gums and blackboys,
   Western Australia, by Revel R. Cooper.

*Plate 141:*
   Mount Sonder, with emus and white gum.
   Hermannsburg, Central Australia.

*Plate 142:*
White gums and kangaroo, near Hermannsburg,
Central Australia.

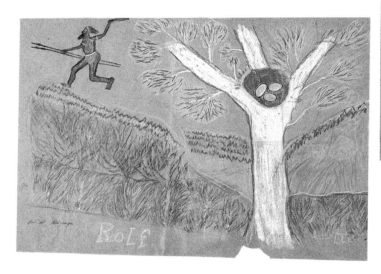

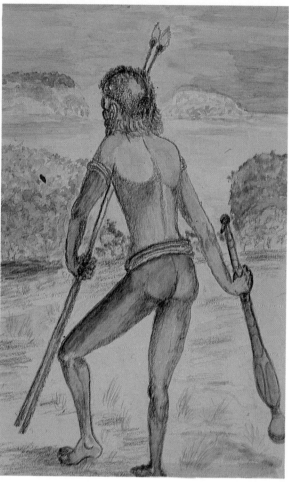

*Plate 143:*
A hunter and bird's nest in a white gum tree.
Hermannsburg, Central Australia.

*Plate 144:*
The hunter, by Joe Nangan.
Beagle Bay, Kimberley.

# *Stemming the deterioration of Aboriginal art*

One reaction to aesthetic deterioration, combined with monetary considerations and the necessity—if Aboriginal art was to survive—of removing it (at least in part) from that predicament, eventually led to the nurturing of expressions which could be regarded as art or as craft in a broader sense.

While this does not account for the emergence of the Hermannsburg School, it does for Ernabella in the Musgrave Ranges, in the north-west of South Australia. Employment had come to be a vital issue there. On the basis of women's spinning—through which they traditionally produced threads from human hair and wallaby and other ,fur—they were set to work at spinning wool. Subsequently, the loom was introduced in 1948. Rugs were made, incorporating distinctive Ernabella designs chosen from pastel drawings prepared by school children, and later by adult artists. These are both bold and colourful and mostly pseudo-abstract, although butterflies, wings of birds, various insects, etc., may be distinguished within them. Only the fact that they are abstract, links them with traditional Western Desert art. In that sense, this art form is innovative, seemingly leading away from traditional inspiration. Partly, this can be explained through mission influence; but partly too, this particular expression is the prerogative of women who did not traditionally have access to men's secret-sacred designs. However, they *did* have their own body painting, as well as secret-sacred patterns; and, as we have already seen, some Western Desert domestic art had traditional designs closely related to religious art. But these forms do not appear to have been adapted to weaving and rug-making. More recently, batik prints have been developed. Again, the designs of these are moving further

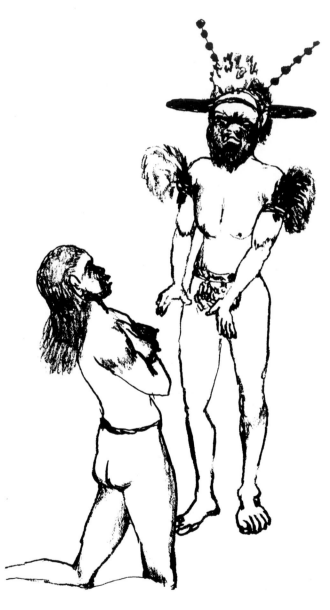

*Plate 145:*
Giridin, the Moon Man, by Joe Nangan.
Beagle Bay, Kimberley.

away from traditional styles. Another reason for the adoption of a new style is that, as far as the Western Desert is concerned, religious designs are strictly supervised and, despite their appearance in traditional domestic art, are not publicly displayed.

Apart from the sale of particular artefacts and Ernabella craft-work, Desert commercial art has mostly consisted of carving small creatures in wood. Some of these reach a high standard of workmanship. They are carved from mulga, quondong and bloodwood. Some are naturalistic, some stylized, and they are usually decorated in intricately organized incised or poker-work designs. The earliest of these now available come from Ooldea on the transcontinental line or from the Warburton Range (in the 1930s and 1940s) and were made by men. Recent examples are carved by women, who traditionally did no carving or incising.

In contrast, Papunya art (see Chapter Two) developed as late as 1971 and represents true innovation. Having deep roots in their own traditional past, when this art form was expressed through the medium of sand or ground paintings, these Aborigines have adapted to changing views and have succeeded quite remarkably in producing the aesthetically pleasing work available in the contemporary scene. They have also been able to separate out secret-sacred religious designs and patterns from those which can be displayed publicly. This has not been accomplished without difficulty, since more conservative groups in the Western Desert constellation were at first upset at viewing publicly designs which so closely resembled those within the secret-sacred dimension. All of these paintings concern the natural environment; they relate to mythology and to particular sites, as well as to the current interests of the people.

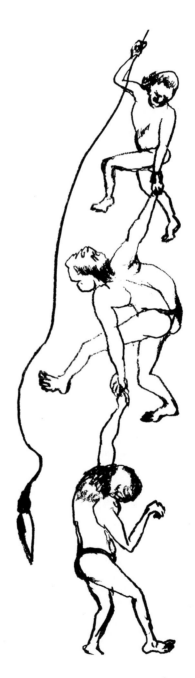

*Plate 146:*
Climbing a hair string rope, by Joe Nangan. Beagle Bay, Kimberley.

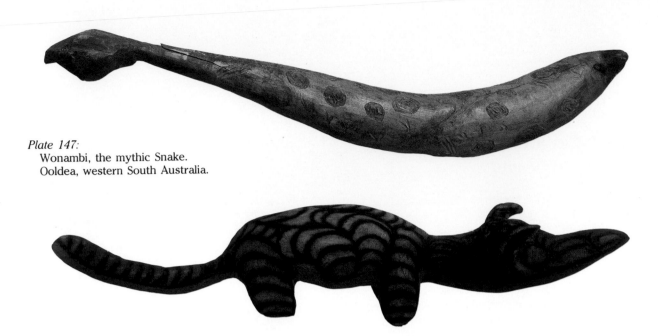

*Plate 147:*
  Wonambi, the mythic Snake.
  Ooldea, western South Australia.

*Plate 148:* A dog. Warburton Range, Western Australia.

At Bathurst Island, among Tiwi people, wood-block and silk-screen painting processes have been introduced and incorporate traditional local designs which are made for the external market. The new cloth-products are intended as wall-hangings, dress-lengths, table cloths, mats, and so on. At the same time, the traditional forms of wood-carving and painting (as used in mortuary ritual) continue, and the availability of these made possible the development of the present industry, which was commenced in 1969. A further venture was pottery-making at the Bagot Road Aboriginal settlement in Darwin in 1966: Aboriginal motifs were also included in this context. It was extended, in 1971, to Bathurst Island, where two Tiwi have developed some unique examples of pottery.

*Plate 149:*
  Sculptured stone head from
  La Grange, Western Australia.

# Renascence of Aboriginal art

The changing art of Aboriginal people is moving away from reproduction or replication of traditional forms. Their future, in this respect, rests in developing on the basis of what is already there. In saying this, we emphasize that in traditionally-oriented communities religion continues to dictate those forms that are manifested in ritual: these should conform, basically, to time-honoured styles and themes. Outside that sphere no such limitations are ordinarily imposed, provided the new approaches keep within the rules regarding what is locally considered to be secret-sacred, or appropriate to persons of one sex rather than the other, or of differing ages. Most, but not all, traditionally-oriented Aboriginal societies have come to terms with such matters. For instance, at La Grange and Balgo in the Kimberleys of Western Australia stone sculpture has appeared without, initially, external encouragement, and not at the expense of traditional art forms.

External demands continue to dictate what is considered to be Aboriginal art, and because of economic necessity on the part of Aborigines they cannot easily be evaded. The Aboriginal Arts Board of the Australia Council has in recent years (since it was an interim advisory committee to what was then the Australian Council for the Arts) played a significant part in systematizing the commercial sale of Aboriginal art and artefacts, by sponsoring the establishment of Traditional Aboriginal Art shops and galleries located in all Australian capital cities. Such a move has ensured, generally, a greater commitment on the part of Aboriginal artists to the quality of their work. It has also led

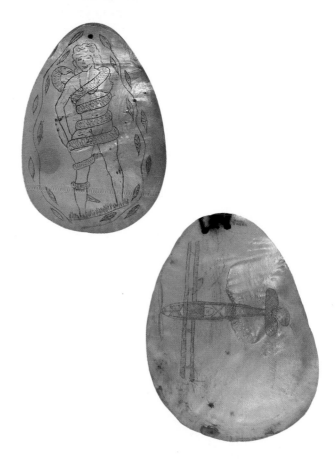

*Plate 151:*
  Incising of a woman
  entwined by a
  snake. Kimberley.

*Plate 152:*
  Incising of a 'plane on
  a pearlshell. Kimberley.

to the stabilization of monetary values. In the past these fluctuated considerably, with only small percentages of the sale prices finding their way back into the hands of the artists themselves. As well, the Board has been able to encourage the continuation and development of the work of outstanding artists.

The last few years have seen a renascence of artistic endeavour. We have provided a few examples of this, but there are very many more. In Western Australia, for instance, in such areas as Mowanjum, Kalumburu, Turkey Creek and so on, cultural revivals are taking place, and the avenues of distribution and rewards are more apparent now than they were in the past. What is clear is that Aboriginal art continues as a living reality, with potentialities to develop and to innovate while, simultaneously, not losing sight of its unique background. There is more recognition that aesthetic expressions can take many different directions.

As long as Aboriginal art depends on external com-

mercial demands, however, there remains the danger of deterioration. There are now more choices available to Aboriginal artists. Nevertheless, other dangers remain—some of them perhaps more far-reaching. In traditionally-oriented communities where Aboriginal religion retains its significance, art remains an integral part of social life. Although this does not rule out other aesthetic developments, it does imply that, where artists paint or carve traditional themes which have mythological meaning, that meaning is not necessarily communicated to those persons outside the community who purchase such work. In many cases today, a reference to the subject matter of a painting or object is attached to the work—so that it is possible for the new owner to know in summary what it is intended to convey. But this does not reveal its real significance or indicate what it means to the Aboriginal artist and his group. That dimension is lost in the process of its transference. In other words, every work of art moving out of its original setting is divorced from its socio-cultural milieu. What is originally intended as a socio-cultural document, and in many cases much more than that, must rest almost solely on its own visual impact, subject essentially to alien interpretation. That point must be recognized.

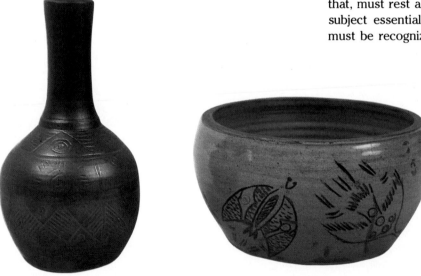

*Plate 153:* Two pieces of Tiwi pottery. Bathurst Island, Northern Territory.

# Survival of Aboriginal art

The varying directions taken in the field of Aboriginal art underline the fact that they can survive in their many manifestations even when—as in the case of the productions of the Hermannsburg School or the Ernabella rugs and the Bagot Road and Bathurst Island pottery—they move close to the Australian-European end of the continuum. Something distinctively 'Aboriginal' remains, over and above the fact that Aborigines are producing them; but the likelihood of their merging with the artistic framework of the wider society is evident. The problems here are many: for instance, the borrowing or 'taking-over' of designs by Aborigines who have themselves no direct channel to what was once the culture of their forbears; and Australian-European artists seeking inspiration from Aboriginal art but adapting it for their own purposes, or simply reproducing it. Even more serious is the pirating of Aboriginal art for commercial use.

It is also clear that Aboriginal art as a distinctively recognized form, having its own unique attributes and its varying stylistic approaches, can survive as viable art only if it keeps in touch with the changes that are taking place within the communities in which these artists work. Inevitably, this will bring about much more in the way of innovation; but if the distinctiveness of their art is to be retained, the people involved must not lose touch with the mainstreams of their own culture. Of course, this presupposes the continuation of Aboriginal communities as such—even though radical changes will take place within them.

Many, many more Aboriginal societies and cultures have disappeared from the face of this continent than have survived in a modified form to this day. For the most part, their going has been unremarked or unrecorded—except in the annals of anthropologists and a few others (more today than a few years ago!). In spite of that, a great deal does remain, some in a near-traditional state. For Aborigines in this situation, while they may be concerned to sustain what they have, their art forms in a broad sense are not necessarily in jeopardy—provided they take a long view, keeping in mind the factor of change. For Aborigines who do not have that traditional background or who are far removed from it, the problem is more difficult. For them it is a matter of contriving an ideological frame, identifying themselves within that context and capitalizing on their background.

Within recent years two elements have contributed toward a strengthening of interest in Aborigines, their cultures and their problems. One has been and is a growing appreciation, on the part of other Australians, of Aboriginal life and the issues facing people of Aboriginal descent. The other has been and is an upsurge of concern for Aboriginal identity on the part of Aborigines themselves: the firming up of a belief that they have a unique role to play in the affairs of this country, the realization that they are not solely (as they were in the past) on the receiving end but are in a position to make positive contributions. Aboriginal art, as an essential part of their own heritage, has already made a considerable impact on the Australian scene. That impact could, and should, be much greater, reflecting the growing importance of Aboriginal people in this wider framework.

# *Postscript*

It is difficult to comprehend the almost explosive efflorescence of Aboriginal art that has taken place in Australia since we were commissioned in 1980 by the book's original publishers, Methuen Australia, to write this volume. While Arnhem Land bark paintings, themselves largely a response to the demand for portable art from early missionaries and anthropologists, were well established within the market place, and the acrylic paintings from Papunya were being purchased increasingly by museums and art galleries across the nation, other great developments had yet to emerge.

And great these developments were. They have played a crucial role in the imagining, and imaging, of contemporary Australian society, both Aboriginal and non-Aboriginal, particularly since 1988 when the Bicentennial celebrations created a fertile environment for a widespread, but sometimes largely introspective, pondering on the nature, and future, of a distinctive Australian identity *vis-à-vis* the rest of the world.

Much else has happened in the intervening years, too. Just as Aboriginal art has played its role in a forceful reconciliation between Aboriginal and non-Aboriginal, so too has it cemented the essentialist relationship of Aboriginal peoples to their lands. More recently, in a period marred by crises in Aboriginal health and housing, key judicial processes have investigated issues relating to Aboriginal deaths in custody and the forced removal of children from their parents and their communities. Perhaps most important of all has been the so-called Mabo Decision in the High Court of Australia, which was followed by the establishment of the Federal Native Title Tribunal and the subsequent Wik Decision. All these events, important as they are to both Aboriginal and non-Aboriginal alike, have been associated with the expansion and mainstreaming of Aboriginal arts within the wider Australian society. Dance, song, music, poetry, drama, photography and cinema have all played a vital and continuing role in the re-definition of what it means to be Aboriginal, and Australian. Perhaps more than any other Aboriginal art form, it is the visual arts that have triggered a national, indeed international, response.

These events have not emerged unhindered, nor unassisted. Many people have played a role in this process, quite apart from the artists themselves. The early missionaries and anthropologists who were, alone, the first proponents of Aboriginal art to the wider Australian society, have been augmented in this role by community art coordinators, gallery managers, regional art associations, and the like. Each region of Aboriginal Australia has had its own experience and perspective, its own process in achieving commercial viability, while maintaining a context of continuing cultural relevance.

Much has been published, too, since this volume first appeared in 1982. Quite apart from innumerable exhibition catalogues and ephemeral compilations, a steady series of scholarly and commercial publications has infiltrated the bookshelves of public and academic libraries—as well as those of members of the public: my own bookshelf is a witness to this. Today, having collected most if not all the books that have been published on Aboriginal art, these stretch for over three metres. In 1980, they would not have even spanned a fraction of this distance.

Other events have occurred in the intervening seventeen years. Perhaps most importantly, from a purely personal perspective, has been the passing of my colleagues, and friends, Ronald and Catherine Berndt: Ron first, in 1990 after a long illness, then sadly Catherine too almost precisely four years later. Their deaths are a great loss to Aboriginal people, to the discipline of Anthropology, and indeed to Australia as a whole. Although I have written about them both in greater detail elsewhere (Stanton 1990, 1994), I would note here simply that, for almost fifty years, their unique personal collaboration played a major role in

communicating to both the public and the academe the richness and diversity of Aboriginal societies across the continent, past and present. For it was the Berndts (with their teacher, Professor A.P. Elkin) who were the first to write extensively about these works as Aboriginal *art*. Their book (Elkin, R. & C. Berndt 1950) was the first to deal in detail with the complex symbolic structures and meanings of Aboriginal art. Later books such as *Australian Aboriginal art* (1964), and *The Australian Aboriginal heritage* (with E.S. Phillips 1973), along with this publication, elaborated on these themes. Other writers from this earlier period, such as Strehlow (1964), Mountford (1948, 1962), Groger-Wurm (1973) and Munn (1973), among others, also addressed some of these issues in detail.

But it was not until the 1980s and 1990s that the rapidly changing and swiftly elaborating Aboriginal art forms were to be documented extensively in the literature. For the most part, catalogue essays accompanying exhibitions provided the opportunity for a detailed assessment of assembled art works, giving an enduring record to carefully researched and curated collections long after the life of the individual exhibitions themselves. Some, such as (Crumlin 1991) focussed on specific religious elements as these were expressed through Aboriginal art, in this case for an exhibition mounted to coincide with the meeting of the World Council of Churches at Canberra. Other exhibitions included Sayers' historical examination of Aboriginal artists of the nineteenth century (1994) which provided a fascinating insight into hitherto little-known material. My own travelling exhibition of Aboriginal children's art from the south-west of Western Australia (Stanton 1992) exposed an entirely new genre of Aboriginal landscape art to the wider Australian community, just as Hutcherson's detailed study (1995) of Yolngu relationships with the land in Northwest Arnhem Land drew, in part, on the extensive collection of crayon drawings not previously exhibited that were collected by Ronald Berndt in 1946–47 (some of these are illustrated elsewhere in this volume).

Of special note are the exhibitions curated by the National Gallery of Victoria such as *Mythscapes* (Ryan 1989), *Spirit in land* (Ryan 1990a), *Paint up big* (Ryan (1990b), and *Images of Power* (with Akerman 1993). All of these have provided a sensitive and well informed approach to the appreciation of Aboriginal art, unusually so for those writing from within an art gallery context. The Queensland Art Gallery has mounted a number of highly successful exhibitions, perhaps most importantly *The Inspired Dream* (West 1988) and *Balance 1990* (Hogan 1990). More recently, the Art Gallery of New South Wales has mounted a major permanent exhibition, *Yiribana* (Neale 1993).

These exhibitions have served to encourage public interest in contemporary art forms, offering an alternative to a stifling of artists in their 'traditional' forms. The continuing elaboration of 'non-traditional' contemporary arts has been a notable feature from the mid-1980s. Ulli Beier edited a special issue of *Aspect* on Aboriginal art and literature (1986) and another in 1988, this time with Colin Johnson (Beier 1988). This interest was stimulated, at least in part by the Australian Bicentennial. *Art and Australia* produced a special Bicentennial edition (1988), focussing on contemporary Australian, including Aboriginal, art.

The 1990s have experienced a refreshing period of artistic creativity by contemporary artists located throughout Australia. Although Isaacs provided relatively early encouragement in this direction (Isaacs 1989b), it was not until *Artlink*'s special double issue on contemporary Australian Aboriginal art (1990) that a detailed review was made of what was happening across Australia at that time. A subsequent special issue (*Art and Australia* 1993) extended this commentary on contemporary Aboriginal art.

The influence of corporate collectors has also been significant, most particularly Lord Alistair McAlpine (West 1967, Dodo, Akerman & McKelson 1989) and Robert Holmes à Court. The Holmes à Court Collection has been carefully documented in several large format publications by Brodie (1990a, 1990b, 1997).

Nor has an interest in the world of children been ignored, either. Among many children's books focussing on Aboriginal issues, Greene, Tramacci and Gill's (1992) presentation of a dual language account of local Dreaming stories is a significant contribution to children's publishing. It is illustrated throughout by Green, herself a well-established artist (*cf.* Stanton 1989). In a different way, H.A.L.T. (1991) emphasised the role of art in the expression of community health issues, in order to educate local health workers, and

others. Haagen (1994) contextualised Aboriginal children at play, documenting the making and usage of indigenous toys within the bush environment and providing a detailed account of the diversity and complexity of Aboriginal children's toys across the whole of Australia.

As the distinction between arts and crafts becomes increasingly compromised, the role of craft production has also been the subject of review (for example, Isaacs 1992). Akerman & Stanton (1994) made a stylistic analysis of engraved pearlshells from the Kimberley, noting their significance to local groups as well as their dispersal along customary trading routes across the continent. Crafts have been an important focus for production among particular Aboriginal communities. Warburton Ranges, WA, for example, have developed travelling exhibitions highlighting local craft production (Proctor 1993).

Several writers documented the life works of individual artists from both historical and contemporary perspectives. Hardy and Megaw (1992) reflected on the contribution of Albert Namatjira to public awareness of Aboriginal art, building on Amadio's earlier work (1986). Holmes' lifetime collaboration with Yirawala encouraged her to write his biography (1992), just as Johnson (1994b) reflected on the prodigious artistry of Central Australian artist, Clifford Possum Tjapaltjarri. Marika (1995) benefited from his close friendship with Isaacs who assembled his autobiography posthumously. Other contemporary artists, such as Sally Morgan (1996), Gordon Bennett (with McLean 1995) and Harry Wedge (1996), were approached directly by publishers for their own stories.

With the passing of time, the artistic productivity of particular communities has also been the subject of close examination. Of key importance here is Morphy's detailed and scholarly interpretation (1991) of Yolngu religious knowledge, as expressed in art at Yirrkala, NT. Jones and Sutton (1986) examined the significance of art in the landscape in reference to the Toa sculptures created by the Dieri of South Australia. Further north, in Central Australia, Amadio and Kimber (1988) and Bardon (1991) produced highly illustrated books that examined the emergence of contemporary acrylic painting at Papunya, while Cowan (1994) documented similar events at Balgo Hills. Glowczewski's scholarly

account (1991) contrasted the art works produced at Balgo Hills (WA) and Lajamanu (NT), both culturally contiguous but demonstrating very different aspects of local stylization. Strocci (1994) compiled a useful retrospective account of Aboriginal women's art from Haasts Bluff, NT, during the period 1992–4, and the Yuendumu Community published (Warlukurlangu Artists 1992) an account of the development of contemporary acrylic art at their settlement. Johnson's invaluable biographical dictionary of Western Desert artists (1994a) has highlighted the need for comprehensive biographical information on artists from other regions of Australia; a project that has been pursued by the Australian Institute of Aboriginal and Torres Strait Islander Studies.

Perhaps the publications most influential in the wider Australian arena have been those that have sought to provide a holistic insight into Aboriginal art, with varying success, such as Isaacs (1984, 1989a) and Caruana (1993), as well as this volume. Of particular relevance in this respect has been the sponsorship by major overseas institutions in the production of major monographs to accompany travelling exhibitions. Most importantly, the *Dreamings* exhibition at the Asia Society of New York provided the first large-scale display of traditional Aboriginal art in an overseas venue, creating enormous international interest and appreciation (Sutton 1988). Others have followed (for example, Luthi 1993, Barou & Crossman 1990), focussing more on more contemporary works—but still 'traditional' in style.

These developments have been seen, within a broader perspective, as being conducive to the affirmation by Aboriginal artists of their fundamental linkage with their land, of their collective experience of the colonial and post-colonial encounter, and of the immediate and pressing needs of their communities and societies today. But this has not come entirely without cost to Aboriginal peoples themselves.

Not only has the emergence of Aboriginal art created varying expectations of continued productivity and reward; so too has it nurtured an environment within which artists' rights are being used and abused by small (but identifiable) sectors of the Aboriginal art 'industry'. The Altman Report (1989) considered some of these issues closely; since then, issues have emerged

such as the 'Carpet Case', in which several artists sued a carpet-making company for reproducing works without licence. This is certainly not the first time that artists have been 'ripped off'. The innovative exhibition *Copyrites* (Johnson 1996) was designed to highlight the need for artists' rights to be protected—and respected. There have also been cases where Aboriginal artists (quite apart from non-Aboriginal artists) have been adopting (and commodifying) sometimes deliberately, sometimes unwittingly, designs to which they have no rights; designs from other areas of the continent that are owned by identifiable individuals, families and indeed cultures.

These issues have important implications for the future integrity of Aboriginal art in Australia and beyond, implications that have not always been appreciated by those constrained by the notions of the 'idealogically sound'. Michaels (1994) is one of few writers to question, in *Bad Aboriginal art*, the validity of some examples of Aboriginal art; that is, validity in terms of cultural statement and cultural veracity. The writers of this volume were strongly criticised from some quarters for using a heading (p.140) 'Stemming the deterioration of Aboriginal art', as if to suggest that, *ipso facto*, Aboriginal art could never deteriorate. And yet this is precisely something that many Aboriginal artists, and their communities, are striving to avoid.

The continued vitality, creativity and spirit of contemporary Aboriginal art is essential for its future viability. It must continue to speak to the people who see it, the people who buy it, the people who cherish it. This art must not draw primarily on the traditions of others, whether Aboriginal or non-Aboriginal: it must emerge from within the spirit of the artists themselves, uniquely localised histories and perspectives that serve to re-define, and indeed re-emphasise, some of the universals of the Australian Aboriginal experience.

Dr John Stanton
Curator, Berndt Museum of Anthropology
University of Western Australia

# References

Abdulla, I. 1993 *As I grew older*. Omnibus: Adelaide.

Akerman, K. with J. Stanton 1994 *Riji and jakoli: Kimberley pearlshell in Aboriginal Australia*. Darwin: Northern Territory Museum of Arts and Sciences, Monograph Series 4.

Altman, J. 1989 *The Aboriginal arts and crafts industry: Report of the Review Committee, July 1989*. Australian Government Publishing Service: Canberra.

Amadio, N. 1986 *Albert Namatjira: the life and works of an Australian painter*. Macmillan: Melbourne.

Amadio, N. and R. Kimber 1988 *Wildbird Dreaming: Aboriginal art from the Central Deserts of Australia*. Greenhouse: Melbourne.

Artlink 1990 Special Double Issue: contemporary Australian Aboriginal art. *Artlink* Vol. 10, Nos 1 & 2.

Art & Australia 1988 Bicentenary Special Issue: Contemporary Australian Art. *Art and Australia* Vol. 26, No. 1 (Spring 1988).

Art & Australia 1993 Special Issue: Aboriginal art now. *Art and Australia* Vol. 31, No. 1 (Spring 1993).

Bardon, G. 1991 *Papunya Tula: art of the Western Desert*. McPhee Gribble: Ringwood.

Barou, J.P. and S. Crossman *1990 L'été australien à Montpellier: 100 chefs-d'œuvre de la peinture australienne*. Musèe Faber: Montpellier.

Beier, U. (special ed.) 1996 Long Water: Aboriginal art and literature. *Aspect* (Special Issue). Aboriginal Artists' Agency: Sydney.

Beier, U. and C. Johnson 1988 *Longwater: Aboriginal art and Literature Annual*. Aboriginal Artists' Agency: Sydney.

Brodie, A.M. 1990a *Contemporary Aboriginal art from the Robert Holmes à Court Collection*. Heytesbury Holdings: Perth.

Brodie, A.M. 1990b *Utopia—a picture story: 66 silk batiks from the Robert Holmes à Court Collection*. Heytesbury Holdings: Perth.

Brodie, A.M. 1997 *Stories: eleven Aboriginal artists*. Craftsman House: Sydney.

Caruana, W. 1993 *Aboriginal art*. Thames & Hudson: London.

Corbally Stourton, P. 1996 *Songlines and Dreamings: contemporary Australian Aboriginal paintings—the first quarter-century of Papunya Tula*. Lund Humpheries: London.

Cowan, J. 1994 *Wirrimanu: Aboriginal art from the Balgo Hills*. Craftsman House: Sydney.

Crumlin, R. ed. 1991 *Aboriginal art and spirituality*. Collins Dove: Melbourne.

Dodo, J., K. Akerman and Fr K. McKelson 1989 *Kimberley sculpture: a selection of carvings by Aboriginal artists of North Western Australia from the Collection of Australian City Properties Limited*. Australian City Properties Limited: Perth.

Glowczewski, B. 1991 *Yapa: peintres Aborigènes de Balgo et Lajamanu*. Baudoil Lebon L'editeur Paris.

Greene, G., J. Tramacci, L. Gill 1992 *Roughtail: the Dreaming of the Roughtail Lizard and other stories told by the Kukatja*. Magabala Books: Broome.

Haagen, C. 1994 *Bush toys: Aboriginal children at play*. Aboriginal Studies Press: Canberra.

H.A.L.T. (Healthy Aboriginal Life Team) 1991 *Anangu Way: In the past we were happy and free from sickness; and in the future we will become strong and healthy again*. Nganampa Health Council: Alice Springs.

Hardy, J., J.V.S. & M.R. Megaw 1992 *The heritage of Namatjira: the watercolourists of Central Australia*. William Heinemann Australia: Melbourne.

Hogan, S. ed. 1990 *Balance 1990: views, visions, influences*. Queensland Art Gallery: Brisbane.

Holmes, S. le B. 1992 *Yirawala: painter of the Dreaming*. Hodder & Stoughton: Sydney.

Hutcherson, G. 1995 *Djalkiri wänga: The land is my foundation—fifty years of Aboriginal art from Yirrkala, northeast Arnhem Land*. Perth: Berndt Museum of Anthropology, Occasional Paper No. 4.

Isaacs, J. 1984 *Australia's living heritage: arts of the Dreaming*. Lansdowne: Sydney.

Isaacs, J. 1989a *Australian Aboriginal paintings*. Weldon: Sydney.

Isaacs, J. 1989b *Aboriginality: contemporary Aboriginal paintings and prints*. University of Queensland Press: St Lucia.

Isaacs, J. 1992 *Desert crafts: Anangu marukku punu*. Doubleday: Sydney.

Johnson, V. 1994a *Aboriginal artists of the Western Desert: a biographical dictionary*. Craftsman House: Sydney.

Johnson, V. 1994b *The art of Clifford Possum Tjapaltjarri*. Craftsman House: Sydney.

Johnson, V. 1996 *Copyrights: Aboriginal art in the age of reproductive technologies*. National Indigenous Arts Advocacy Association: Sydney.

*Jones, P. and P. Sutton 1986 *Art and the land: Aboriginal*

*sculptures of the Lake Eyre region*. South Australian Museum, in association with Wakefield Press: Adelaide.

Luthi, B. ed. *Aratjara: Art of the First Australians*. Dumont Buchverlag: Cologne.

Marika, W. (as told to J. Isaacs) 1995 *Wandjuk Marika: life story*. Queensland University Press: St Lucia.

Michaels, E. 1994 *Bad Aboriginal art: tradition, media and technological horizons*. Allen & Unwin: St Leonards.

Mclean, I. and G. Bennett 1995 *The art of Gordon Bennett*. Craftsman House: Sydney.

Morgan, S. 1996 *The art of Sally Morgan*. Viking: Ringwood.

Morphy, H. 1991 *Ancestral connections: art and an Aboriginal system of knowledge*. University of Chicago Press: Chicago.

Neale, M. 1993 *Yiribana*. Art Gallery of New South Wales: Sydney.

Proctor, G. 1993 *Yarnangu ngaanya: our land–our body*. Perth Institute of Contemporary Arts: Perth.

Ryan, J. 1989 *Mythscapes: Aboriginal art of the desert*. National Gallery of Victoria: Melbourne.

Ryan, J. 1990*a Spirit in land: bark paintings from Arnhem Land*. National Gallery of Victoria: Melbourne.

Ryan, J. 1990*b Paint up big: Warlpiri women's art of Lajamanu*. National Gallery of Victoria: Melbourne.

Ryan, J., with K. Akerman 1993 *Images of power: Aboriginal art of the Kimberley*. National Gallery of Victoria: Melbourne.

Sayers, A. 1994 *Aboriginal artists of the Nineteenth Century*. Oxford University Press, in association with the National Gallery of Australia: Melbourne.

*Stanton, J.E. 1989 *Painting the country: contemporary Aboriginal art from the Kimberley region, Western Australia*. University of Western Australia Press: Perth.

Stanton, J.E. 1990 Obituary: Ronald Murray Berndt 14 July 1916–2 May 1990. *Australian Aboriginal Studies* 1990 No. 2: 95–99.

Stanton, J.E. 1992 *Nyungar landscapes: Aboriginal artists of the South-West–the heritage of Carrolup, Western Australia*. Perth: Berndt Museum of Anthropology, Occasional Paper No. 3.

Stanton, J.E. 1994 Obituary: Catherine Helen Berndt 1918–1994, *Australian Aboriginal Studies* 1994 No. 2: 93–96.

Strocchi, M. compl. 1994 *Ikuntji: paintings from Haasts Bluff 1992–1994*. IAD Press: Alice Springs.

*Sutton, P. (ed.) 1988 *Dreamings: the Art of Aboriginal Australia*. Viking, in association with The Asia Galleries, New York: New York.

Warlukurlangu Artists 1992 *Yuendumu doors*. Aboriginal Studies Press: Canberra.

Wedge, H. 1996 *Wiradjuri spirit man*. Craftsman House: Sydney.

West, M. 1987 *Declan: a Tiwi artist*. Australian City Properties: Perth.

West, M. ed. 1988 *The inspired dream: life as art in Aboriginal Australia*. Queensland Art Gallery: Brisbane.

Wild, S. ed. 1986 *Rom: an Aboriginal ritual or diplomacy*. Aboriginal Studies Press: Canberra.

*Indicates already listed in previous edition's Bibliography.

# Descriptive Annotations to the Plates

The following descriptions of the plates illustrated in this volume are coordinated with each of the six chapters in the main text, except that for Chapter One we limit our examples to rock art. This may be regarded as a setting for contemporary art, as expressing perhaps more closely the 'old' indigenous forms. Not all such rock paintings and incisings were produced prior to European settlement on this continent, but many of them were. With some exceptions and stylistic variations, they illustrate a continuing Aboriginal tradition or complex of traditions, despite changing media.

Although in most cases illustrations 'fit' particular chapters, some are relevant elsewhere in the book too. For example, bark paintings are discussed in Chapter Two, and most of them are assembled so that they refer to this. Others, however, are found in relation to Chapters Three, Four, Five and Six. There are similar 'cross-illustrations' as far as innovative art is concerned.

The following abbreviations are used in these descriptions:

An asterisk (*) appears against all Plates where items are held by the Anthropology Research Museum of the University of Western Australia.

'Berndt coll.' refers to items obtained by R. M. Berndt in the course of fieldwork, except where otherwise noted. Where appropriate, the initials 'C.H.B.' are added to refer to items obtained by C. H. Berndt.

Where north-eastern Arnhem Land material is discussed and with reference to particular artists, *mada* = dialectal unit; *mala* = 'clan'; and m. = moiety.

References appear at the end of particular sets of material: these are abbreviated, and full entries are given in the Bibliography.

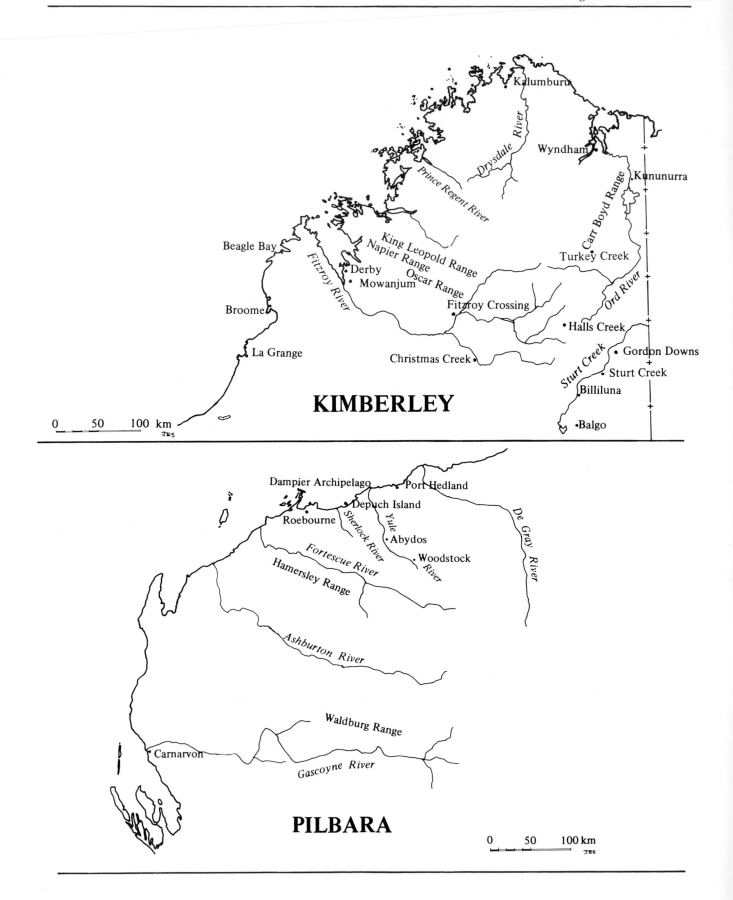

**KIMBERLEY**

0    50    100 km

**PILBARA**

0    50    100 km

## *Rock Art*
## CHAPTER ONE

PLATES 1 TO 24

*PLATES 1 TO 5:* Western Arnhem Land, with its many galleries, contains some of the most outstanding and imaginative rock paintings of Aboriginal Australia.

*Plate 1:* Paintings at Nourlangie Rock shelter, near the East Alligator River. Two female figures are on the left and three on the right of a male figure. Several subsidiary figures are depicted, among them two x-ray fish and, to the right, a further female figure. The style of the main figures belongs to the 'old' East Alligator River culture, and who they represent is not now known with any degree of certainty. The posturing of their arms, however, suggests that they are dancers. Two of the women have dots on their breasts; this was a common decoration in *ubar* rituals. The rest of their decoration has been said to be 'abstract x-ray': it is more likely to be body painting. The fish are in true x-ray style. The paintings are superimposed on earlier ones.
*Photo:* R. Edwards, 1970.

*Plate 2:* Ochre paintings from the main gallery at Deaf Adder Creek Valley (Balawuru). There are two central female figures, superimposed on others. To the left is a woman in side view, a dilly bag suspended from her head. There are also x-ray fish.
*Photo:* E. J. Brandl, 1969: through courtesy of the Australian Institute of Aboriginal Studies.

*Plate 3:* An excellent example of 'Mimi' art from Obiri Rock, near the East Alligator River Crossing. The distinctively drawn head has feathers attached. In his left hand (right) this Mimi holds a barbed spear and a goose-wing fan, in his right hand (left) a spearthrower. From his neck is suspended a dilly bag, and from each elbow hangs a feathered tassel.
*Photo:* R. Edwards, 1973.

*Plate 4:* A 'Mimi' figure of a squatting man, East Alligator River near Red Lily Lagoon. On the right are his spearthrower and spears. He wears cane bangles with tassels at the elbows, and his bag rests on his chest, although his body is seen through it. This figure is superimposed on smaller Mimi figures.
*Photo:* E. J. Brandl, 1969: through courtesy of the Australian Institute of Aboriginal Studies.

*Plate 5:* A fine x-ray painting (central figure) of a grey female *gulubar* kangaroo from the Oenpelli area. Below it, on the lower left-hand side, is a smaller figure (probably the *galgbeid* red wallaby). Both are associated with *ubar* ritual. Note that these two figures are superimposed on a range of earlier ones.
*Photo:* E. J. Brandl, 1969: through courtesy of the Australian Institute of Aboriginal Studies.

REFERENCES: R. M. and C. H. Berndt (1974: plates 43-9); Brandl (1973), in Berndt and Phillips eds (1973/1978: 92-107), in Ucko ed. (1977: 220-42); Chaloupka in Ucko ed. (1977: 243-59); Edwards ed. (1975); Edwards (1979); McCarthy (1958b: 45-53); Mountford (1956: 109-264).

*PLATES 6 TO 7:* Galleries of rock art abound near Laura, north-west of Cairns, as well as in other parts of North Queensland. In the one noted here, the paintings belong to what has been called the 'Quinkin' tradition because many concern spirits known by this general term, although they are associated with a wide range of mythology.

*Plate 6:* A large white-ochred kangaroo with vertical divisions at Magnificent Gallery, Lone Star Creek. With this are two white human figures with the outstretched arms characteristic of this art form.
*Photo:* P. J. Trezise, 1979.

*Plate 7:* A large white-ochred, probably mythic, being with outstretched arms, superimposed on other figures. From the same location as the paintings in Plate 6.
*Photo:* P. J. Trezise, 1973.

REFERENCES: Trezise (1969), (1971), in Berndt and Phillips eds (1973/1978: 118-27), in Ucko ed. (1977: 325-33).

*PLATES 8 TO 11:* The Kimberley region of Western Australia contains a wide variety of rock art. Although the Wandjina style predominates, there are others too—for instance, the 'Bradshaw' tradition. The more typical Wandjina are those in the vicinity of the Prince Regent, Sale and Glenelg rivers, between the Drysdale River and the King Leopold Range. Generally, they are broad-shouldered, cloud-like figures, their heads encircled by curved bands with radiating lines; conventionally, no mouth is shown. Wandjina are mythic beings, both male and female, with individual names. They are associated with fertility and with spirit children, and through their power come the cyclones and storms that bring the monsoonal rains to the Kimberleys.

*Plate 8:* A full-length Wandjina from the Napier Range, east of Derby. It shows the typical headdress, shortened

radiating lines, no mouth, with the shoulders decorated. The oval ochred disc-like design below the shoulders has been said to represent this being's breast bone. A number of other figures surround the central figure.
*Photo:* P. Bindon, 1978.

*Plate 9:* A Wandjina named Pindjauri who 'turned into' a fresh-water crocodile, leaving his human form at a site in the Oscar Ranges, east of Derby. An elaborate head-dress tops the radiating head lines, with an elongated 'nose'. In this case, the 'breast bone' design appears as a pubic covering. Surrounding designs remain from the superimposition of this Wandjina.
*Photo:* P. Bindon, 1980.

*Plate 10:* A remarkable red-ochre painting from Trent River, representing a *yerdagul* (lightning) figure. This probably falls within the 'Bradshaw' art tradition, which consists mainly of small red paintings, distributed widely throughout the Kimberleys. Two 'boomerang'-like designs are shown at the base of the figure.
*Photo:* P. Bindon, 1977.

*Plate 11:* Several red-ochred and decorated figures from the Carr Boyd Range, south of Kununurra. The central figure includes characteristics of both Wandjina and 'Bradshaw' traditions. It has lines radiating from the head, and horizontal bands on the body.
*Photo:* P. Bindon, 1978

REFERENCES: Berndt (1974: Fasc. 3, Plates 33-36); Crawford (1968), in Berndt and Phillips eds (1973/1978: 108-17), in Ucko ed. (1977: 357-69); Elkin (1948); Petri (1954).

*PLATES 12 TO 13:* Western Desert art is highly abstract in its representation, and the following are excellent examples.

*Plate 12:* Wall paintings from Wina rockhole in the Feltham Hill area, south-west of Ayers Rock (Uluru). They relate to the myth of Crow and Fire. The figures refer to the relevant ritual.
*Photo:* N. Wallace, 1968

*Plate 13:* Paintings at Kulpitjata, where there are many caves. They are associated with the Emu (*kalaya*) myth. The figure to the right is a mythic being, with various tracks to the left.
*Photo:* N. Wallace, 1968.

REFERENCES: Mountford (1965), (1968); McCarthy (1958b: 58-63); Strehlow in Berndt ed. (1964/1968: 44-59); P. and N. Wallace (1977).

*PLATES 14 TO 15:* The rock paintings of eastern Australia contrast markedly with the petroglyphs or rock engravings, which are better known and more varied in style. The paintings in western New South Wales (where the galleries are few) depict small-scale men and women. Some are dancing; others are engaged in hunting, holding clubs and boomerangs. A wide range of creatures is also painted.

*Plate 14:* Three white-ochre dancing male figures. From Nerriga, near Braidwood, New South Wales.
*Photo:* P. Bindon, 1971

*Plate 15:* Paintings from Gudgenby, near Canberra, New South Wales. They are probably of a dog and her pups, with a tortoise-like creature at the top.
*Photo:* P. Bindon, 1975.

REFERENCES: Maynard (1977: 387-402); McCarthy (1958b: 39-41), in Berndt ed. (1964/1968: 33-43), (1976), in Ucko ed. (1977: 403-13).

*PLATES 16 TO 24:* Rock engravings and pecked intaglios are widely distributed. The earliest written reference to them was made in 1788, in relation to the Port Jackson and Broken Bay areas. Those of the Sydney-Hawkesbury district are perhaps the best known; but there are also outstanding galleries in South Australia (for instance, at Panaramittee), in the Cleland Hills (Central Australia) and from the Murchison to the Pilbara districts in Western Australia, where some of the most beautiful are to be found (for example, on the upper Gascoyne and Ashburton rivers, in the Ophthalmia Range, at Roebourne, on the Dampier Archipelago and Depuch Island, the Hamersley Range, Port Hedland, the Yule River, Abydos and at Woodstock, etc.). Many of these are of great age and are no longer in use; but many too refer to mythological topics, and the sites where many are to be found are still of significance to living Aborigines.

*Plate 16:* Graceful figures of women, one with head tassels, supposedly dancing. Upper Yule River, Pilbara area.
*Photo:* B. J. Wright, 1964.

*Plate 17:* Two figures of men, each with a smaller figure of a female alongside. They are engraved side-face, with lengths of 'twine' stretching from their heads. Gallery Hill, Woodstock, in the Pilbara area.
*Photo:* B. J. Wright, 1964

*Plate 18:* An inverted engraving of a woman and child, at Sherlock River, near Roebourne. The elongated fingers of the woman hold some object on her head.
*Photo:* B. J. Wright, 1972.

*Plate 19:* Representations at Drawings Mill, Dooley Downs station, between the Ashburton and Gascoyne rivers, showing an anthropomorphic figure along with a man wearing an ornate headdress.
*Photo:* D. L. McCaskill, 1975.

*Plate 20:* This abstract incising from the Waldburg Range, near the Gascoyne River, resembles designs which appear on Western Desert shields and on various ceremonial boards.
   *Photo:* D. L. McCaskill, 1967.

*PLATES 21 TO 22:* The Cleland Hills, on the western side of Central Australia, are well known for the remarkably expressive 'heart'-shaped faces and figures located there. While they are not unique, since similar examples occur in the north-west of the Kimberleys and the Canning Stock Route area, these engravings are outstanding.
*Plate 21:* A mask-like face from the Cleland Hills, expressively executed.
   *Photo:* R. Edwards, 1968
*Plate 22:* A full-length figure showing the 'heart'-shaped face, and a stylized body with internal engraving.
   *Photo:* R. Edwards, 1968.

*PLATES 23 TO 24:* The engravings of the Sydney-Hawkesbury River area are 'free' naturalistic figures of wide variety, covering marine and land creatures as well as human beings. Their subject matter ranges from hunting and fishing scenes to others that imply an association with mythology and ritual. Some of the animals and their tracks, and human outlines, are enormous in size.
*Plate 23:* An engraving of a dog. Woy Woy, Hawkesbury River area.
   *Photo:* R. M. Berndt, 1940.
*Plate 24:* A large engraved human figure with others above it.
   *Photo:* R. M. Berndt, 1940.
REFERENCES: Crawford (1964: 23-63); Dix in Ucko ed. (1977: 277-85); Edwards (1968: 647-70); McCarthy (1956-1959: 37-58, 203-16), (1958b: 14-30), (1962); McCaskill in Ucko ed. (1977: 184-90); Worms (1954: 1067-88); Wright (1968), in Berndt and Phillips eds (1973/1978: 129-54), in Ucko ed. (1977: 110-16).

## Paintings: Part 1
### CHAPTER TWO

PLATES 25 TO 41
The paintings in this section are in the western Arnhem Land tradition. All are on prepared stringybark, except for Plates 39 to 41. These last three should be compared with some of those in Plates 1 to 5, especially in so far as the x-ray art is concerned, and the standing figures in Plates 1 and 2 with Plate 25. Also, note the contrasting 'Mimi' styles.

*Plate 25:* The art style of this painting should be compared with Plates 1 and 2, and also with Figs. 79 and 82 in Spencer (1914). It depicts four women in the 'old' East Alligator River style. The positioning of their arms suggests dancing movement. The designs on their bodies could be incipient x-ray relevant to the backbone, but are more likely to be ochred decorations. On some occasions this has been categorized under Mimi art. In this case, however, it is not.
   * Painted at Croker Island, western Arnhem Land, 1964, by Neiimbura, Gunwinggu. Berndt coll. 35.5 x 96cm.

*Plate 26:* This is Nadulmi (or Narol'mi), a mythic being in his kangaroo manifestation, as principal leader of the *ubar* rituals (see R. M. and C. H. Berndt 1970: 119-21, 128-32). A ball dilly bag hangs from his neck, he has a beard, and white crane feathers are attached to his head. His body is decorated with a special design called *gunmed* used by *ubar* actors: and between his testes and penis is a stingray 'nail'. Two *malbululug* grass night-birds are shown: they are his companions. Note that only his backbone and outlines on his chest (heart and lungs) imply x-ray treatment; all the other designs are body decorations. A smudge to the right of the ears above the feathers reveals that the artist first put the feathers there, but wiped them out to place them where they are now.
   * Painted at Oenpelli, western Arnhem Land, 1950, by Midjaumidjau, Gunwinggu. Berndt coll. 58 x 76 cm.

*Plate 27:* Two human hunters, not Mimi. The taller holds a spear poised and clasps a bundle of them. The smaller also carries spears, and over his shoulders a pole from which hang small creatures he has speared.
   * Painted at Oenpelli, 1947, by Samuel Manggudja, Gunwinggu. Berndt coll. 21 x 39 cm.

*Plate 28:* This depicts one of a series of incidents in the life of Mimi spirits. In this case, a Mimi hunter has brought back a kangaroo (x-ray and trussed up) and thrown it to the ground (top left). Other Mimi soon dismember it, each holding part of the carcass. Note tree to right, spears and spearthrowers, and open oven.
   * Painted at Oenpelli, 1968, by Jimmy Naguridjilmi, Gunwinggu. Berndt coll. 40 x 65 cm.

*Plate 29:* This is a representation of Aranga, a malignant spirit associated with the Oenpelli area, whose likeness

is painted on rock walls at Inyalag. The painting here, in the 'old' East Alligator River tradition, was not intended as a replica of the rock painting although they were identified as being the same (see Mountford 1956: 141-2, who mistakenly criticizes it on that score).

Antagonistic to human beings, Aranga had an abnormally long penis and injured women in coitus. He was eventually speared and pushed into a pit, which was filled in. But he was not dead. Men preparing to leave the hole heard a peculiar sound: it was Aranga, who had bent round his penis and was playing it like a didjeridu (this was the origin of this instrument). The men turned back, cut up his penis and re-covered him with earth. The painting shows Aranga with a Rainbow Snake (Ngalyod) head tipped with feathers; hook ornaments are suspended from his elbows and his long penis has feathers at its apex. His body is incipiently x-ray (spine and ribs).
* Painted at Oenpelli, 1947, by Midjaumidjau, Gunwinggu. Berndt coll. 54 x 72 cm.

*Plate 30:* Representation ('old' tradition) of the giant Dreaming Barramundi fish who once lived at the head of the East Alligator River. He was observed one day by three hunters. One of them, Nagongbid, speared him: the painting shows him doing this (top, right). Barramundi, however, broke loose and swam toward the coast, making the river as he went, followed by the hunters. Finally, at the river's mouth, he 'turned himself' into a rock (at Gulari Point) which may be seen at low tide today. The painting is an example of x-ray at its best.
* Painted at Oenpelli, 1949-1950, by Nipper Maragar, Manger (Mangerdji). Berndt coll. 44 x 84 cm.

*Plate 31:* Spearing fish from a tree which overhangs a billabong: the top fish is a garfish, the bottom a barramundi, both painted in x-ray style.
* Painted at Oenpelli, 1968, by Dick Ngulei-ngulei, Gunwinggu: explanatory details by P. J. Carroll. Berndt coll. 37 x 52 cm.

*Plate 32:* An x-ray painting of an echidna: note extended tongue.
* Painted at Oenpelli, 1974, by Dick Ngulei-ngulei, Gunwinggu. Obtained from the Church Missionary Society, Sydney. 30 x 48 cm.

*Plate 33:* Ngalyod, the Rainbow Snake in her (his) snake and rainbow manifestations. There are many myths and stories about her, or him (see R. M. and C. H. Berndt 1970: 20-4, 117, *et seq.*).
This Ngalyod followed Gumadir Creek (river) from Gugadji (at the headwaters of Gumadir river) until she came to Gabari, where she swallowed a mythic man named Nayugyug and his dog (Djanbugong) who were hunting goanna. In the cooking, the goanna burst and the noise annoyed Ngalyod. She was later metamorphosed as Igudandji Hill, together with Nayugyug and the dog. Note the Snake's skin and horn, with a stingray 'nail' ('spine'): immediately below is the actual rainbow, a reflection of Ngalyod.
* Painted at Oenpelli, 1950, by Ngaiiwul, Gunwinggu. Berndt coll. 37 x 61 cm.

*Plate 34:* A more recent example of the Rainbow Snake, Ngalyod, shown with two horns and a crocodile tail. The painting could concern one of the many versions of a story about an orphan: the child, by crying and misbehaving, attracts the attention of Ngalyod, who swallows him and all the people living in the same camp. It is more likely, however, to refer to a version of a bark painting done by the same artist and illustrated in Aboriginal Arts Board (1979: 62). In that, Ngalyod has swallowed some people; three birds (previously men; one is a peewee) peck at Ngalyod, to make a hole through which the victims can escape. This painting can, therefore, be interpreted as follows: the peewee is shown; and the human being above the dying Ngalyod has emerged (escaped) from her belly.
* Painted at Oenpelli, 1974, by Dick Ngulei-ngulei, Gunwinggu. Obtained from the Church Missionary Society, Sydney. 33 x 55 cm.

*Plate 35:* Manmaral (or Maralmaral), a *djang* mythic being who in her human form is seen within a termite mound (*gambi*). The u-shaped band around her represents the anthill. She 'turned herself' (made herself *djang*) into a beetle or grub (*gundi*) and lives on ants.
* Painted at Oenpelli, 1949, by Djamargula, Gunwinggu. Berndt coll. 45 x 83 cm.

*Plate 36:* This painting of a prominent natural feature, Nimbuwa, at the headwaters of Cooper's Creek, western Arnhem Land, shows the head and face of the metamorphosed mythic character of that name. Below (right) is a stone representing a mythic man, Djindi (or Guringau), who in one version tried to cut off Nimbuwa's head. On the left-hand side is another man, Gilinnyalgan, who was also turned to stone. Nimbuwa came from the south-west of Oenpelli. For details of this myth see R. Berndt (1969: 43, 45-6), R. M. and C. H. Berndt (1970: 12-13).
* Painted at Oenpelli, 1961, by Daniel Nalambir, Gunwinggu-Maung. Berndt coll. 23 x 42 cm.

*Plate 37:* This painting is about an adventure in the escarpment country on the fringe of western Arnhem Land where Mimi spirits are said to live in caves. A human being with spear and thrower (left) has wandered into this country and is invited by one of the Mimi to return to the Mimi's cave home. In the course of his stay there, he refuses the hospitality which is offered to him, but in escaping is captured by a Mimi headman (central figure) who cuts flesh from his living victim. He shows this to the other Mimi, who emerge from their caves and dance for joy in anticipation of a feast of human flesh: three Mimi are shown dancing. In the meantime, the headman has removed all the flesh from the man and has eaten it; he is shown (right) sitting and holding the corpse while removing the flesh. This painting is one in three depicting different events in this story. It is of Maung (Goulburn Islands) style, with Gunwinggu influence.

* Painted at Goulburn Island, 1947, by Old Wurungulngul, Maung. Berndt coll. 50 x 60 cm.

*Plate 38:* This is a scene from a myth about Frog (*mularig*), a woman, and Blanket Lizard (*gundamen*), a man. On the right are two areas of land, divided by sea; at the top are Barclay Point (Wandjuli) on the mainland, and South Goulburn Island (Waruwi) at Madbalg, which is directly opposite Wandjuli. Before Frog spoke, the mainland was joined to the island; when she began to speak, it separated, and remains so today.

* Painted at Goulburn Island, 1947, by Tom Namagarainmag, Maung. Berndt coll. 32 x 63 cm.

*PLATES 39 TO 41:* These are x-ray paintings in the 'old' western Arnhem Land tradition. They are all painted in ochres on brown cardboard derived from plug-tobacco boxes, since no sheets of bark were available at that time: the tobacco brand is visible in Plate 41, with the painting superimposed on it. These three (parts of a series of nine) were obtained in 1945 at the Native Affairs Settlement, Donkey Farm, Katherine, Northern Territory and were painted by Carpenter Paddy Djalgulg, an old man of the Djauan (Djawun) language group.

Berndt coll. Each is 30 x 30 cm.
* *Plate 39:* Rock kangaroo (*balg*).
* *Plate 40:* Stingray (*bogbogan*).
* *Plate 41:* Two crayfish (*dara*).

REFERENCES: Aboriginal Arts Board (1978), (1979); Allen (1975); C. Berndt (1978: 6-18); R. Berndt (1969), in R. Berndt ed. (1964/1968: 1-10); R. M. and C. H. Berndt (1970); Carroll (1977: 119-30); Elkin, Berndt and Berndt (1950); Groger-Wurm in Berndt and Phillips eds (1973/1978: 201-24), in Ucko ed. (1977: 147-55); Holmes (1972); Kupka (1962); Mountford (1956: 181-264), (1962: 207-25); Spencer (1914).

## Paintings: Part 2
### CHAPTER TWO

#### PLATES 42 TO 59

*PLATES 42 TO 52:* These are examples of north-eastern Arnhem Land art, except for Plates 42 and 52; Plate 42 belongs to the western side of this cultural bloc, Plate 52 to the south-eastern side. All of these can be contrasted with the western Arnhem Land art style.

*Plate 42:* Two grass snakes (*burula*), one at each side of the Glyde River (Goyder River running into Glyde Inlet, north-central Arnhem Land), represented by the central band with water flowing. This style allows more space around the design-items than is typical for the 'old' traditional north-eastern art, and in that respect resembles western Arnhem Land work. The patterning on the snakes is not x-ray, but relates to their skin.

* Painted at Milingimbi, 1964, by Malangi, Djinang *mada*, Wurgi'gandjar *mala*, *dua* m. Berndt coll. 31 x 55 cm.

*Plate 43:* A thick-shelled turtle. The bands indicate parts of the shell that are commercially useful. The representation is conventionalized; but, as in Plate 42, it demonstrates a use of space atypical for this area. In this case, it is hardly likely to be a result of direct western Arnhem Land influence.

* Painted at Yirrkala, 1947, by Wonggu, Djabu *mada*, Dagobabwi *mala*, *dua* m. Berndt coll. 37 x 57 cm.

*Plate 44:* This painting is in the 'typical' traditional style of the region. It concerns specific country and associated mythology, and is essentially emblemic. However, it relates also to a dream experienced by the artist and to a place named Guludi in the Blue Mud Bay area, Dalwongu *mada* territory (*yiridja* m.), which is linked with his mother and mother's brother. The central hatched band is a Dreaming paperbark tree lying in the water (it is also a *rangga* emblem); at each end are its leaves. On either side of the tree is a creek in the middle of a swamp, and a diving duck with head under the water and bubbles

(dots) rising to the surface. The birds are surrounded with diamond designs representing freshwater weed; that motif extends into each of the four panels, where wavy lines are running water and the linked diamonds surface weed.

* Painted at Yirrkala, 1946, by Madaman, Riradjingu *mada*, Wurulul *mala*, *dua* m. Berndt coll. 40 x 68 cm.

*Plate 45:* In traditional north-east style, this relates to country and associated mythology and is also emblemic. The place is Djaragbi at Cape Shield (below Trial Bay). The subject matter refers to two sacred Manggalili *mada* (*yiridja* m.) hollow logs (the two central bands), each with a bird perched on it (a *guwag* night bird or black-beaked jungle bird). On the right are crab holes and their tracks on the wet sand. At the left are sandhills: from top to bottom are four possums (*marnga*), the second with snails it has collected; the rest of this side shows possum tracks and their nests. Compare with Plate 133.

* Painted at Yirrkala, 1946, by Naradjin, Manggalili *mada*, Bilin (or Yiduwa) *mala*, *yiridja* m. Berndt coll. 55 x 74 cm.

*Plate 46:* Again, this traditional north-eastern example is associated with country and mythology, and is also emblemic. The painting concerns the Wawalag myth, and is localized at Muruwul (or at Mirara-minar) on the mainland near Milingimbi, home of the Yulunggul python (see R. Berndt 1951*a*). From right to left, following each elongated panel (of which there are seven): (1) cliffs at Duridjmanu (*yiridja* m.: all the rest of this country is of the *dua* moiety), with dots representing rocks; (2) tracks of the *gardjambal* kangaroo; (3) this whole panel represents the *gareiga* stringybark tree which Lightning Snake (*wididj*—that is, Yulunggul) has split with his lightning so that it is in pieces (rectangular designs); (4) from top to bottom is spring water running from Riala to Muruwul; the dots are cabbage palm fruit (or 'nuts') floating in the water; then follow a cabbage palm, further spring water, another palm and more water; (5) new palm trees, spring water and 'nuts'; (6) new palm plants, water and 'nuts'; (7) spring water with floating 'nuts', followed by three pointed stone blades against a black background, the dots in this case representing rocks; then spring water and 'nuts', stone spear heads and spring water and 'nuts'. The stone spear blades belong to Woial, or Wudal, the mythic Honey Man, associated with the Wawalag Sisters (see C. H. Berndt 1970).

* Painted at Yirrkala, 1946, by Mawulan, Riradjingu *mada*, Wurulul *mala*, *dua* m. Berndt coll. 52 x 60 cm.

*Plate 47:* Another traditional style painting representing country and mythology, also emblemic. It concerns a scene at Me'yun (or Meyuru) near Cape Shield at Myaoola Bay, and has associations with the mytho-ritual hollow log constellation of the *yiridja* m. At the bottom of the painting, the first band represents mangroves at the edge of the sea: the first three round holes are springs in a bamboo swamp partially covered and surrounded by water; from these run salt water mixing with fresh water until the middle set of three circles; these are bamboo swamps with fresh spring water (which at high tide, is mixed with the salt water). The circles (holes) are linked by running water under the ground, the surface being dry. On one side of the bottom half (left) a dingo runs after a rat (*ngigngig*), and immediately above are human track marks; above are springs with flowing water and a band of lily roots, with more spring water. On the opposite side (bottom, right) is spring water at each side of the hardened and cracked surface of a billabong. The upper area is of fresh water springs with bamboo 'spear' foliage; on the left are strewn seaweed, lily plants and water running, on the right the tracks of rats (two of which are shown) which have been collecting lily roots and foliage to make nests; in the adjacent billabong are mullet and white *galeia* crane.

* Painted at Yirrkala, 1946, by Old Nanyin, Manggalili *mada*, Bilin (or Yiduwa) *mala*, *yiridja* m. Berndt coll. 41 x 80 cm.

*Plate 48:* This is associated with Gumaidj *mada* territory (*yiridja* m.) at Ngalawi at the top of Caledon Bay, and with the Dreaming Crocodile. At Blue Mud Bay he made a sacred shade (or hut) in which were stored *rangga* emblems. While he and other mythic men were dancing, the shade caught alight and the fire quickly spread, destroying the *rangga* and killing some of the men. Crocodile was burnt about the forearms and escaped to Caledon Bay. The crossed bands are the posts of the shade. On the right is Crocodile in lily grass, moving his tail and legs, dragging up the grass to cover himself. In the upper part of the painting are burnt lily grass and wood; at the bottom are burnt tree logs, and ashes with dots representing coals.

* Painted at Yirrkala, 1947, by Munggaraui, Gumaidj *mada*, Raiung *mala*, *yiridja* m. Berndt coll. 35 x 74 cm.

*Plate 49:* A coastal scene at Dalingura, near Cape Arnhem (Yirrkala area) in territory linked to the Gumaidj and Lamamiri *mada*, with mythological significance. The

paired triangular design is a cloud, the black area heavy with rain falling on the sea (bottom, right). Immediately to the left are 'squared blocks' representing a reef; the round circles are the marks made by stingray before they go out to the open sea, surrounded by strips of sand in between, with two lines of stingray—the first within the protection of the reef and sand banks, the second (at left) going out to sea as the rain falls. On the left are clouds with rain falling on the sea; a *radalyi* jumping fish is shown—when the rain comes, he jumps up to see what the weather is like.

* Painted at Yirrkala, 1946, by Munggaraui, Gumaidj *mada*, Raiung *mala*, *yiridja* m. Berndt coll. 48 x 54 cm.

*Plate 50:* A seascape at the reefs, Cape Arnhem. On the left are two large diamond stingrays (*barangbarang*) surrounded by waves they have churned up. On the right-hand panel, dividing the sea from the reef area, is the sea at the top and, below, two young stingray (*malara*) surrounded by queen fish (*gunggalur*) who are frightened of the *malara*; there is a canoe named *damalama* which belonged to an old (dead) Gumaidj man of this country. At the bottom are two 'tortoise-shell' turtles (*gawaidji*) between reef sections where they rest.

* Painted at Yirrkala, 1946, by Bununggu, Gumaidj *mada*, Raiung *mala*, *yiridja* m. Berndt coll. 42 x 84 cm.

*Plate 51:* This painting depicts two Djabu *mada* (*dua* m.) manifestations of Thunder Man, Bodngu, who is associated with Wulawuli at the top of Blue Mud Bay. They hold carved spears and are urinating rain. Bands of rain are falling (bottom panel) between two *wondera* trees associated with Bodngu, but also 'marked' (horizontal lines) by his thunderbolt.

* Painted at Yirrkala, 1946, by Mama, Djabu *mada*, Dagobabwi *mala*, *dua* m. Berndt coll. 38 x 75 cm.

*Plate 52:* A Groote Eylandt bark painting of mythic echidna, pythons and sawfish.

Painted by Nekaringa. By courtesy of the Western Australian Art Gallery, 1963: 37 x 59 cm.

REFERENCES: C.H. Berndt (1970); R.M. Berndt (1951*a*); Berndt and Stanton (1980: 7-10); Elkin, Berndt and Berndt (1950); Groger-Wurm (1973), in Berndt and Phillips eds (1973/1978: 203-8, 221); Kupka (1962); Morphy in Ucko ed. (1977: 198-204); Mountford (1956: 267-411); Norton (1975: 36-65).

*PLATES 53 TO 54:* Two examples of bark paintings from the Kimberleys, north-west Western Australia, in the Wan-djina tradition. Both were obtained by P. Lucich in 1963 and were painted at Mowanjum, near Derby, by Micky Bungguni, Ungarinyin language.

*\*Plate 53:* A representation of an *agula* ghost, or trickster spirit of the dead, mostly antagonistic to living persons. It is called Man-mandji, has big ears, and is very tall: it lives in caves and lightning plays round its head. Size: 27 x 68 cm

*\*Plate 54:* This painting was originally said to be a *naranara* spirit called Wariwari, similar to an *agula*, with the axe he uses in collecting wild honey. However, in 1972, a Wunambal man said it represented an ordinary man named Djangargun, wearing a feathered headdress and carrying an axe. Size: 33 x 70 cm.

REFERENCES: Crawford (1968), in Berndt and Phillips eds (1973/1978: 108-17); Petri (1954).

*PLATES 55 TO 59:* The first three examples belong to the Papunya School of art; the last two, to an incipient 'outlier' development which parallels the Papunya. All are directly based on traditional perspectives of local country with mythological and ritual significance.

*Plate 55:* The focus of this painting is on Warriwarri, a site on Mount Allen station, north-west of Alice Springs, where the bush plum Manukitji (a mythic being) emerged. The large concentric circles are Manukitji's camps, while the smaller circles are *manukitji* plum trees: background dots are their fruit, some ripe, some unripe. The straight lines are mirages, common in this type of country. The site is tended carefully and rites are performed to ensure a plentiful supply of this fruit.

* Painted at Mbungerra (near Papunya), 1979, by Clifford Possum Tjapaltjarri (*djabaldjari* subsection), Anmadjera language. From Aboriginal Traditional Arts, Perth: acrylic on canvas: 99 x 169 cm.

*Plate 56:* This is about the emergence of two mythic Yunganba (possum) men from Nuda soak at dusk in search of food, represented by clustered dots. Concentric circles from right to left are three soaks: Girradi, Yudidja and Nuda. Lines between the soaks are tracks left by the Possum men dragging their tails, while on each side are their paw marks. This is in Anmadjera country, in this case associated with men of the *djabaldjari* and *djungarai* subsections.

* Painted at Papunya, 1977, by Billy Stockman, *djabaldjari* subsection, Anmadjera language. From Aboriginal Traditional Arts, Perth: acrylic on canvas: 170 x 200 cm.

*Plate 57:* The site depicted here is Galibinyba, in Bindubi country, associated with the mythic Rain Dreaming. Broad meandering lines represent the movement of Rain across the land; smaller connecting lines are streams of water. Smaller patches are scrub and spinifex clumps.
\* Painted at Papunya, 1976, by Walter Djambidjinba (subsection), Bindubi language (dialect). Gift from the Aboriginal Arts Board of the Australia Council: 91.5 x 122 cm.

*Plate 58:* A painting depicting country at Naru, south of Balgo, in the northern fringe of the Western Desert. It belongs to the religious *dingari* cycle and concerns the Dreaming Fire which 'got up' at this place (at the squares in the centre of the painting). The meandering 'key' pattern at each side is Fire spreading across the country, leaving ashes. This refers to a long myth where Fire issued from the apex of several *daragu* (sacred) ritual boards, burning some of the people (in the myth).
Painted at Balgo, 1979, on chipboard, by Brandy Gunmanara, *djungurei* subsection. The photograph was taken when a series of these was shown to R. M. B. at Balgo.

*Plate 59:* This painting concerns the *djuburula* subsection Dreaming man, Djaldubi (*dingari* cycle). He was walking and running from Nundalbi rockhole (which also has spring water)—bottom, first large concentric circle—south of a big hill called Manggai, to two unnamed soaks (two concentric circles) and to Yindaramu (at top), a rockhole with a spring. The linked lines encircling these four concentric circles down the middle of the painting are Djaldubi's tracks. Other concentric circles surrounding them are the designs he wore on his body (still worn in the appropriate ritual). Meandering lines are his tracks, and three u-shaped designs his windbreaks.
Painted at Balgo, 1979, on chipboard, by Mora 'Nagamara', *djagamara* subsection. The photograph was taken by R. M. B. at Balgo.
REFERENCES: Bardon (1979); Edwards ed. (1978).

## Drawings
CHAPTER TWO

PLATES 60 TO 73
The originals of all these plates are drawings in lumber crayons and (rarely) chalk on brown paper. Plates 60 to 62 came from Ooldea, in South Australia on the transcon-tinental railway line; Plates 63 to 68 from the central-west of the Northern Territory; and Plates 69 to 73 from north-eastern Arnhem Land. They are all of traditional inspiration.

PLATES 60 TO 62
*Plate 60:* Drawings in chalk of *mamu* and *gordi* spirits. Among people of the Mandjindji, Bidjandjara and Andingari dialectal groups who had come into the Ooldea area from the Great Victoria Desert (and other places), the *gordi* was (is) the spirit or soul of a newly dead person which would eventually be reborn; the *mamu* was (is) a trickster spirit, usually antagonistic to human beings. (See R. M. and C. H. Berndt 1943: 367-9, 149-58; 1944: 339-46.) The three bottom figures show a *gordi* between two *mamu*; above is a *mamu*, the larger circle beside it a dog, the smaller circles puppies.
Drawn at Ooldea, 1941, by Wiriga, an elderly woman. C. H. B. coll. 37 x 53 cm.

*Plate 61:* A female *mamu*.
Drawn at Ooldea, 1941, by Mindinanga, a nine-year old girl. Berndt coll. 30 x 38 cm.

*Plate 62:* Conventionalized representation of a young man's initiation, depicting the dancing grounds, windbreaks (boomerang-shaped), people present (circles), and a central actor (foreground) wearing an *inmadali*, a wreath-like headdress.
Drawn at Ooldea, 1939, by a young man, Uninga. Berndt coll. 37 x 53 cm.

REFERENCES: Mountford (1937*a*: 5-28), (1937*b*: 84-95), (1937*c*: 236-40), (1938*a*: 241-54), (1938*b*: 111-14), (1939*a*: 3-13), (1939*b*: 73-9); Tindale (1936: 169-85), (1959: 305-32).

PLATES 63 TO 68
*Plate 63:* This shows a Dreaming site at Djidulbura, south-west of Birrundudu (in the Northern Territory) and south-east of Sturt Creek (in Western Australia). The rocks lying there are mythic Yams (*bura*). The drawing depicts the yams and the tendrils attached to them.
Drawn at Birrundudu, 1945, by Djambu 'Lefthand', Ngari (or Ngadi) language. Berndt coll. 40 x 61 cm.

*Plate 64:* Mytho-topographic representation of Bandubada, near Djunggara on the road to Tanami, in Nyining-language country. The lines are creeks, and the blank spaces they enclose are rockholes. Mythic men of the *djuburula*, *djambidjin* and *djungurei* subsections are associated with this place.

Drawn at Birrundudu, 1945, by Old Charlie Ralnga, Nyining language. Berndt coll. 41 x 61 cm.

*Plate 65:* Dancers in a religious ritual. The figure without eyes represents the *bayaya* bird, of the *djangala* subsection, while the other two are the *burad* bird, *djambidjin* subsection.
Drawn at Birrundudu, 1945, by Munguldjungul, Wailbri (Walbiri) language. Berndt coll. 43 x 61 cm.

*Plate 66:* A *wanbada* dance, shown to circumcisional novices before the restricted *mandiwa* ritual. This, and its associated songs, come from Sturt Creek and Billiluna (in Western Australia), brought up from the southern desert area by Gugadja people. A group of men sit around a fire, singing, and a row of dancers wearing *ilyi* headdresses hold double-pointed boomerangs.
Drawn at Birrundudu, 1945, by Badawun, Gugadja language. Berndt coll. 46 x 61 cm.

*Plate 67:* This remarkable drawing focuses on the important mythic site of Killi Killi (Giligili) Hills far south of Birrundudu and west of Tanami, near the Western Australian-Northern Territory border. Note, especially, the treatment of this hill which is seen from its base as well as from its top (facing downward), behind the ridges. The human figures below the hill are all Dreaming men: three, drawn full-length and standing, are of the *djabalyi* subsection. The other two, with legs bent up, are of the *djabalyi* and *djungurei* subsections respectively and are commencing to climb. The 'standing' men walk around telling the two climbers (who are young *maliara* novices) not to climb because they might fall. Horizontal bands on the rock surface of the hill are ridges: the central dot is water running from a small rockhole (spring).
Drawn at Birrundudu, 1945, by Djambu 'Lefthand', Ngari language. Berndt. coll. 42 x 61 cm.

*Plate 68:* The great mythic Rainbow Snake emerges from Djabia well surrounded by sand, south-west of Birrundudu, near Tanami, and goes to Galibinba, from where he has heard the cry of another Rainbow Snake. However, he 'turns off' from Galibinba and goes on to Munggadura. In the drawing, seven *maramara* Aboriginal doctors are shown riding astride the Snake as it glides through the sky; they are said to have special power over it. Stretching from Djabia to Galibinba is an actual rainbow (*barari*) which comes out at the same time as the mythic Snake moves from one place to the other: it is the Snake's reflection. Note that the Rainbow Snake has a mane and a long tongue.
Drawn at Birrundudu, 1945, by Djambu 'Lefthand', Ngari

language, for Munguldjungul (see Plate 65) whose Dreaming it is—that is, Wailbri language. Berndt coll. 42 x 61 cm.

REFERENCES: R. M. and C. H. Berndt (1946: 67-78, plates); (1950: 183-88, plates 1-10).

### PLATES 69 TO 73

*Plate 69:* This drawing illustrates parts of Bremer Island and adjacent areas, opposite Cape Wirawawoi, near Yirrkala, in north-eastern Arnhem Land. It shows part of Riradjingu *mada* (*dua* m.) territory, as well as part of Gumaidj *mada* (*yiridja* m.) territory. It covers almost every aspect of the mythology, along with place names relevant to this island—too many to be noted here. Briefly, it refers to the famous Muruwiri rocks, where part of the spirit of the Bremer Island Turtle Hunter remains, with his canoe containing a turtle. Two other Turtle Hunters are shown: they kill and roast Gagaral (seagull) because of his greed. There are Baiini ('pre-Macassan') sites, where these visitors built houses and made iron knives; the Malaluneingu *mogwoi* (Dreaming spirit of the dead); the various Dreaming snakes (including Tiger Snake and Yalarinya ghosts dancing). There are also whistle trees, wild apricot and red apple trees.
Drawn at Yirrkala, 1947, by Mawulan, Riradjingu *mada*, Wurulul *mala*, *dua* m. Berndt coll. 74 x 114 cm.

*Plate 70:* Baiini people at Bangubalang, on the eastern coast of Arnhem Land. In the bottom panel is their boat with anchors, alongside a spirit-canoe which has drifted to the north coast (perhaps from Papua New Guinea). Baiini men have axes and smoke pipes (a modern addition in this particular form), and two circular designs are earthenware pots, one with handles. On the far right, Baiini men and women sit cooking fish under jungle trees. The narrow central design with circle is Bangubalang well, with Baiini, and jungle fowls (*weiguda*) said to have been brought by them. In the top panel are more Baiini, one with his dog: on the left are two buffalo, which are not associated with Baiini but were drawn here because a couple had wandered across to the east coast from western Arnhem Land just prior to 1946: they were originally introduced by European settlers at Port Essington.
Drawn at Yirrkala, 1947, by Djimbaryun, Magalranalmiri *mada*, Munyugu *mala*, *yiridja* m. Berndt coll. 74 x 114 cm.

*Plate 71:* This relates to the mythic Duramungadu spirits at Arnhem Bay, said to be good turtle hunters. In the

bottom right-hand corner is their canoe, with paddle and pandanus sail. In the top right-hand panel are the spirits with their footprints and rocks: they are on their way to a dance. On the left-hand side, they are performing their rain dance with arms extended as the rain falls: on either side are goanna and emu.

Drawn at Yirrkala, 1947, by Banggalawi, Djambarbingu *mada*, Durili *mala*, *dua* m. Berndt coll. 74 x 114 cm.

*Plate 72:* This is a scene at the *yiridja* m. land of the dead, Badu, said to be somewhere in the Torres Strait Islands area, but formerly located somewhere to the north of the Wessel Islands. In the bottom half, spirits (ghosts) cut trees with axes to obtain posts for house-building. In the upper half a row of women carry loads of cut grass for thatching; on the upper right-hand side is a house with roof gables.

Drawn at Yirrkala, 1947, by Bununggu, Gumaidj *mada*, Raiung *mala, yiridja* m. Berndt coll. 74 x 114 cm.

*Plate 73:* This drawing refers to a myth about the making of cycad nut 'bread', used in religious ritual; it also deals with a mythical event in which Nguriri killed one of the two men named Wirilyi and Muniweingeru. This happened at Madamada, in the Caledon Bay area. The top panel, from the left, shows the killing, and wailing women; the Dreaming shade or shelter, with Wirilyi and Muniweingeru sitting on one side, Nguriri on the other; dilly bags hang from the rafter; on the right are three women with their dogs, carrying cycad palm nuts in bags. In the bottom panel, from the left, are women collecting cycad nuts, with palms; two men with their dogs hunting bandicoots; at right, women getting ready to return to their camp with loaded bags of nuts.

Drawn at Yirrkala, 1947, by Bununggu, Gumaidj *mada*, Raiung *mala, yiridja* m. Berndt coll. 74 x 114 cm.

REFERENCES: R. M. Berndt (1951*a*), (1952), (1964: 280-4); R. M. and C. H. Berndt (1954: Chaps. 5, 9).

## *Sculpture*
### CHAPTER THREE

PLATES 74 TO 96

Plates 74 to 76 show the Elcho Island 'Memorial'. This contains a number of sculptured objects, many of them highly conventionalized. Linked with these are the carvings of mythic beings from eastern Arnhem Land (Plates 77 to 82). A bark painting (Plate 83) introduces a series of *wuramu* image posts (Plates 84 to 89); these are followed by mortuary posts, with a bark painting (Plates 90 to 91); a painted boat (Plate 93); two ceremonial carvings from Cape York (Plates 94 to 95); and an incised figure on a tree (Plate 96).

*PLATES 74 TO 76:* Elcho Island in eastern Arnhem Land in 1957 was the scene of a local Adjustment Movement. To provide a visible, tangible focus for the Movement, its leaders arranged for the setting up of what became known in English as the Memorial. Out in the open near what was then the old Mission church, near the main camps and houses of the settlement, they got together a public display: a cluster of sacred *rangga* poles and posts, carved and painted with emblemic patterning, all with mythological significance associated with various *dua* and *yiridja* m. *mada* and *mala*. (See R. Berndt 1962.)

*Plate 74:* A close-up view of some of these objects. The central figure with the face is Laindjung-Banaidja, a great *yiridja* m. mythic being. His arms are held above his head, the vertical band is his beard, and the body design refers to mangrove worms and octopus. To the left of this figure is a post which includes mythic patterns associated with eighteen *mada*: the attachments on either side are bobbins (in this case, ritually relevant). On the right-hand side of the figure is the sun *rangga*, associated with the mythic Djanggau (see R. M. Berndt 1952).
*Photo:* R. M. B., 1958.

*Plate 75:* A full view of the Elcho Island Memorial. The addition of a Christian cross implies recognition of the introduced religion.
*Photo:* R. M. B., 1958.

*Plate 76:* The Memorial has been neglected over the last few years because of politico-religious changes in this area.
*Photo:* R. M. B., 1979.

*PLATES 77 TO 82*

*Plate 77:* Used in *djunggawon* circumcision rituals, this post (called *djuwei*) represents the younger Wawalag Sister who, with her elder sister, was swallowed by the mythic Yulunggul Python (see R. M. Berndt 1951*a*). The shredded bark represents her hair, and hanging from it is a pendant of feathered twine. Her head is actually above this, and the design shows seeds and flowers of the *durili*

stringybark tree. On her 'body' (the trunk) are designs of spring water and menstrual blood (it was blood that attracted Yulunggul). In the lower section are designs of flat stones, which are made into knives and spear heads.

* Made at Elcho Island, 1964, by Gidbaboi, Marangu *mada*, Durili *mala*, *dua* m. Berndt coll. 97 cm high.

*Plate 78A:* Outstanding carvings of the elder and younger mythic Wawalag Sisters, which really fall within the context of innovative art. They are included here because Chapter Two mentions the Wawalag. The elder is the taller. Feathered pendants hang from their heads, and their body designs are those that are traditionally relevant.

Both were made at Yirrkala, 1967, by Dundiwuy, Maragulu *mada*, Durili *mala*, *dua* m. By courtesy of the Western Australian Art Gallery: the tall figure is 170 cm high; the smaller, 145 cm.

*Plate 78B:* A close-up view of the elder Wawalag Sister. See Plate 78A.

*Plate 79:* Laindjung, a major *yiridja* m. mythic being. He emerged from the sea at Blue Mud Bay in north-eastern Arnhem Land, and his face is stained white from the sea foam. On his flattened head, with its painted headband, human hair has been attached with blood; at each corner of his mouth are parakeet feathers, his moustache; and a feathered chin pendant is his beard. From ear to ear, passing across his nose, is a ritual decoration. The designs on his neck and body were formed from variegated water-marks and refer to fresh-water weeds, fire and ashes in seaweed and mud.

This was made at Yirrkala, 1946-1947, by Liagarang, Dalwongu *mada*, Nargala *mala* and by Munggaraui, Gumaidj *mada*, Raiung *mala*, both of the *yiridja* m. It was obtained by R. M. B., as part of his original Yirrkala collection; however, it is now held by the Institute of Anatomy, Canberra. Full height of the figure, 81 cm.

*Plate 80:* The mythic being Banaidja, as the son of Laindjung. His face is white to symbolize the white sea foam, and he wears a headband. His body design, from top to bottom, refers to spring water on the beach ('copied', it is said, from the place where Laindjung emerged); salt mixing with fresh water; the separation of the two kinds of water; and running water.

* Made at Yirrkala, 1946-1947, by Liagarang, Dalwongu *mada*, Nargala *mala*, *yiridja* m. Berndt coll. 75 cm high.

*Plate 81:* A representation of Bunbulama, a Dreaming ghost (*mogwoi*). He is also called Paddle Maker, because he meets spirits of newly dead *dua* m. persons and makes or helps them to make paddles, or himself paddles them to Bralgu, the *dua* m. land of the dead. Across his chest are bands of rain falling in the jungle where he lives (on Melville Bay, in north-eastern Arnhem Land). The central area shows rain falling on sandhills, where there is a sacred goanna; at the side, wavy lines indicate where he dragged his paddle over the sand to the beach; horizontal lines at his hips are rain falling on the sea; on his neck are streaks of mud.

* Made at Yirrkala, 1947, by Mawulan, Riradjingu *mada*, Wurulul *mala*, *dua* m. Berndt coll. 66 cm high.

*Plate 82:* A Dreaming *yiridja* m. spirit (*mogwoi*) named Burulu-burulu. There are a number of myths relating to him and the size of his penis. He was an excellent hunter and collector of wild honey. The figure is red-ochred and incised with designs. For instance, he has a headband and facial markings; a line round his neck is the cord of his dilly bag which falls to his back. Incised under his right arm are a spearthrower (with bunched human hair) and two iron bladed spears; below, at his hip, is an axe.

* Made at Yirrkala, 1947, by Naradjin, Manggalili *mada*, Bilin (or Yiduwa) *mala*, *yiridja* m. Berndt coll. 61 cm high.

*PLATES 83 TO 89:* Indonesian traders (Macassans) visited the north coast of Australia over a fairly long period. North-eastern Arnhem Land Aborigines commemorate those visits in song and, especially, in mortuary ritual.

*Plate 83:* A bark painting of a Macassan prau in full sail. On the deck, shown immediately under the sails, are three men. The round object is a tank for curing trepang, and an anchor is visible. Below are the deck planks with two canoes, and on the surrounding edge of the prau (at each side and below) are deck rails.

* Painted at Yirrkala, 1946, by Mundugul, Mararba *mada*, Malarwadjari *mala*, *yiridja* m. Berndt coll. 65 x 78 cm.

*Plate 84:* A *wuramu* post figure from Milingimbi, north-central Arnhem Land, made from local cypress. Below its square-block head and neck are 'shoulders' with a triangular 'cloud' design (said to be also a cloth pattern introduced by Macassan traders). The weather-worn painting on the trunk refers to tamarind tree fruit (a tree also introduced by Macassans) and the *mundugul* water snake, with further cloud designs. It is connected with

a small island, called Nanggiala, in Arnhem Bay where this Snake has its Dreaming centre.

* Made at Milingimbi prior to 1946 when it was obtained by R. M. B.: carved by Magarwala, Wonguri *mada*, Mandjigai *mala*, *yiridja* m. Berndt coll. 127 high.

*Plate 85:* A *wuramu* post figure with traditional cloud designs, said to take shape from the spray of a mythic whale. Although it has no specially defined facial markings, it represents a human figure, with head, body and buttocks.

* Made at Elcho Island, 1961, by Wananyambi and Mambur (or Dick Marambur) for a man named Ngulberei, all of the Waramiri *mada*, Bralbral *mala*, *yiridja* m. Berndt coll. 69 cm high.

*Plate 86:* A *wuramu* post figure of a Macassan woman. Her face is decorated in the conventional design for this type of object. Below her shoulders is a crossed chest-strap; a white disc at the middle represents a Macassan silver coin, *rupia* (general term for money). Horizontal lines are plugs of tobacco; and at each side and below is the cloud pattern.

* Made at Yirrkala, 1946-1947, by Munggaraui, Gumaidj *mada*, Raiung *mala*, *yiridja* m. Berndt coll. 60 cm high.

*Plate 87A:* A fine example of a *wuramu*, in this case a realistic image of a dead person. Below the shoulders, on its trunk, is the *yiridja* m. cloud design.

* Made at Elcho Island, prior to 1966 when it was obtained by R. M. Berndt, by Madjuwi, Waramiri *mada*, Bralbral *mala*, *yiridja* m. Berndt coll. 200.5 cm high.

*Plate 87B:* A close-up view of the carved head shown in Plate 87A.

*Plate 88A:* A *wuramu* post figure with a square-block hat and black face; below the neck are conventional cloud or cloth designs. This figure was said to represent Deimanga, a Macassan prau captain who possibly visited the north coast prior to 1895. (See R. M. and C. H. Berndt 1954: Chaps. 6-8.)

* Made at Elcho Island, 1964, by Mambur (or Dick Marambar), Waramiri *mada*, Bralbral *mala*, *yiridja* m. Berndt coll. 174 cm high.

*Plate 88B:* A close-up view of the carved head shown in Plate 88A.

*Plate 89:* Carved head of a Japanese named Kimasima (or Kimishima). It is red-ochred and incised, with vertical lines signifying *dal* (*daal*), or power. Across the bridge of his nose, on his cheeks, below his mouth and on his neck are marks representing maggots which crawl out of the head on death, after decomposition. The carving represents the head and neck with some flesh adhering. Kimasima was speared late in 1932 in an incident involving Aborigines at Caledon Bay: he was a cook on a Japanese lugger. (See R. M. and C. H. Berndt 1954: Chaps. 15-16.) In Elkin, Berndt and Berndt 1950: 59-60, this head is wrongly said to be Macassan.

Made at Yirrkala, 1947, by Munggaraui (who was involved in the killing), Gumaidj *mada*, Raiung *mala*, *yiridja* m. Berndt coll. 27 cm high.

PLATES 90 to 96

*Plate 90:* A hollow-log bone-receptacle. The whole object with its four prongs represents *in toto* a *marabinyin* saw-fish, although it has also been said to represent a *bulmandji* shark. Eyes are shown. Down the log, is a design showing male and female sharks, and two green-back turtles; on either side are waves on the coast at Ngainmara-ngura, Flinders Point. The object is known as a *nganugu-laragidj*, and the patterning and mythology are of the Djambarbingu *mada*, *dua* m. It has, however, been foreshortened by cutting.

* Made at Milingimbi, prior to 1946 when it was obtained by R. M. B. Artist unknown. Berndt coll. 121 cm high.

*Plate 91A:* A full-length hollow-log bone-receptacle from Gungurugoni-language territory. Originally located half-way up the Liverpool River in north-central Arnhem Land, this may be regarded as one of the 'bridging' cultures between the western and north-eastern sociocultural areas. Unfortunately, the information supplied about its design is sparse. It was said to be associated with 'djerrka', a goanna, and 'Wanduk'. However, it refers to the *djirgan* goanna and to Wondjug (an alternative name for Woial or Wudal, the Honey Man). *Djirgan* was one of the creatures which the Wawalag tried to cook at Muruwul but, because of the presence of Yulunggul, all of these jumped out of the fire and went into the waterhole (see C. H. Berndt 1970, and R. M. Berndt 1951*a*): the dots are bubbles rising to the surface of the water. It is of the *dua* m.

* Made at Milingimbi, prior to 1978, by Janbarri, a Gungurugoni man. Obtained from Aboriginal Traditional Arts, Perth, with a grant from the Aboriginal Arts Board. 172.5 cm high, 21 cm diameter.

*Plate 91B:* A bark painting to accompany the bone-receptacle illustrated in Plate 91A. The *djirgan* goanna

is seen, along with (top, left) two paperbark representations of Wondjug (Woial or Wudal, the Honey Man); the surrounding design refers to country.

\* Painted at Milingimbi, prior to 1978, by Janbarri, a Gungurugoni man. Obtained from Aboriginal Traditional Arts, Perth, with a grant from the Aboriginal Arts Board. 67 x 117 cm.

*Plate 92:* Emblemic patterning relevant to the Riradjingu *mada, dua* m., painted on the side of a modern dinghy and used in a dedication rite to ensure protection from storms and as an aid in fishing. On the left is a painting of two turtles, surrounded by waves; they are associated with the *dua* m. mythic Mururuma, the Bremer Island Turtle Man at Muruwiri Rocks, while the two turtles (Marban and his wife, Woiaba) are now rocks. See Plate 69. On the right is a painting of Bodngu the Thunder Man at Yilgaba Hill (Mount Dundas), near Yirrkala; he urinates rain. He holds long yams from their creeper-strings, symbolizing thunderbolts he hurls to the ground. Surrounding lines are clouds and beach, while three dark circles are round rocks (his 'eyes').

*Photo:* R. M. B., Yirrkala, 1968.

*Plate 93:* A *bugamani* grave post representing a highly stylized image of a dead person. No meanings are provided for the designs, except that the central apertures are said to be for the deceased's spirit to look through when his grave is visited.

\* Made at Bathurst Island, prior to 1977, by Paddy Teeampi, Tiwi language. Obtained from Aboriginal Traditional Arts, Perth. 150 cm high.

*Plate 94:* A wood carving from Aurukun, Cape York Peninsula. It represents a young man (*wintjinum*), with cockatoo feathers on a bark band in his headdress.

Made at Aurukun, but artist unnamed. Collected by F. D. McCarthy, 1962. Photo by C. Roach, Australian Institute of Aboriginal Studies. 71 cm high.

*Plate 95:* A wood carving of a dingo (*kua*) from Aurukun, Cape York Peninsula: it has dog's teeth, and blue marbles as eyes.

Made at Aurukun, but artist unnamed. Collected by F. D. McCarthy, 1962. Photo by C. Roach, Australian Institute of Aboriginal Studies. Approx. 45 cm high.

*Plate 96:* A lively incising of a spirit character, cut into a living tree on the edge of a creek bed at Jigalong, Western Australia. Note whittled-stick headdress, and arms: legs and penis faded (not incised).

*Photo:* R. M. B., Jigalong, 1957.

REFERENCES: Allen (1975); C. H. Berndt (1970); R. M. Berndt (1951*a*), (1952), (1962: 52-63), (1974), in Berndt ed. (1964/1968: 1-10), in Berndt and Phillips eds (1973/1978: 156-200); R. M. and C. H. Berndt (1948: 309-26), (1949: 213-22); Berndt and Stanton (1980: 11-15); Elkin, Berndt and Berndt (1950: 48-60, 92-100); Hoff in Ucko ed. (1977: 156-64); McCarthy (1964); Mountford (1956: 415-75), (1958); Mountford and Tonkinson (1969: 371-90).

## *Figures and Modelling*
### CHAPTER FOUR

PLATES 97 TO 112
These show various carved and decorated wood carvings and other objects used in ceremonies, including love magic, as well as moulded clay and ochre heads (Plates 107 to 111), and two wax figures.

*Plate 97:* An elaborate song cycle relates to Bralgu, the *dua* m. land of the dead. Spirit characters there send out morning stars to different places on the mainland; the stars are attached to strings, with which they can later be pulled in again. The Morning Star (*banumbir*) pole illustrated here is decorated with feathered strings, and 'balls' or bunches of seagull feathers. In the mortuary ritual which replicates events at Bralgu, it is used in dancing. The design represents the sand dunes on which the spirits themselves dance, and the round circles the morning stars.

\* Made at Elcho Island, 1964, by Gaguba, Galbu *mada,* Maidjara *mala, dua* m. Berndt coll. 155 cm full height.

*Plate 98:* A carved head of a *narila* seagull, with feathered string attached: the two short ends are its wings, the long string its body. In this case it is a small seagull, and wears an armband of parakeet feathers (which link the carving with its two wings) because in the Dreaming, *djerag* (the fully grown gull) was a man who lived at Arnhem Bay. Such an object is used in love magic, symbolically swooping on and catching the affections of a desired girl. But it is also used in ceremonies when the Seagull song cycle is sung and danced; in mortuary ritual, where it may represent part of the spirit of a dead Riradjingu *mada* person; and as a message emblem, when it is carried to outlying camps informing people that a Riradjingu person has died.

* Made at Yirrkala, 1961, by Mawulan, Riradjingu *mada*, Wurulul *mala, dua* m. Berndt coll. 17 cm plus feathered string.

*Plate 99:* A 'Macassan' anchor used for 'hooking' women in the course of love magic. A man would put it into the ground near a girl and then haul it in gradually toward his own camp; it is said to bring with it the girl's desire and spirit. In the example illustrated, a length of twine is attached, originally interwoven with possum fur.

* Made at Yirrkala, 1946-1947, by Munggaraui, Gumaidj *mada*, Raiung *mala, yiridja* m. Berndt coll. 36 cm, the hooks being 18 cm each.

*Plate 100:* Two Macassan-style pipes. The larger represents the mast of a prau, similar to full-scale mast emblems used in mortuary ritual to farewell the spirit of a dead person, just as Macassans were said to have erected their masts on departing from the north coast after the monsoonal season. In this case, it was a farewell gift. The incised design on the barrel of the pipe represents clouds associated with the Waramiri *mada, yiridja* m.

Made at Yirrkala, 1947, by Buramara, Waramiri *mada*, Bralbral *mala*, for Munggaraui, Gumaidj *mada*, Raiung *mala*, both *yiridja* men, on R. M. B.'s departure from that area. Berndt coll. 89 cm long.

The smaller pipe represents the Goanna Tail *rangga* emblem of the Djanggau mythic beings. It has carved 'shoulders' (at the bowl), and a ridge down the barrel is its backbone; the incising refers to the Goanna and its country at Port Bradshaw, north-eastern Arnhem Land.

Made at Yirrkala, 1947, by Mawulan and Wondjug (father and son), Riradjingu *mada*, Wurulul *mala, dua* m., on R. M. B.'s departure from Yirrkala. Berndt coll. 79 cm long.

*Plate 101:* A didjeridu with a design in ochre referring to Bodngu the Thunder Man: above him is *larrpan* (thunderbolt and water spout), at the side is his club; and below and above is rain falling on the sea.

* Made at Yirrkala, 1947, by Mawulan, Riradjingu *mada*, Wurulul *mala, dua* m. Berndt coll. 112 cm long.

*Plate 102:* A ceremonial message stick used for inviting participants from distant areas. The designs (meaning unrecorded) are finely incised.

* From the Murchison district, Western Australia: *circa* early 1900s, and probably from an Aboriginal named Mambaroo; from L. Peet. 17 cm long.

*Plate 103:* A man's sacred spirit bag with decorations and tassels made of *lindaridj* parakeet feathered twine. It would normally hold personal possessions and sacred objects. Such dilly bags are of considerable importance, and have mythic significance. This one is associated with the Djanggau. A coil of twine hangs near the holding-cord, indicating that its top binding is ritually incomplete.

* Personal gift from Mawulan, Riradjingu *mada*, Wurulul *mala, dua* m., to R. M. B., 1947, Yirrkala. Berndt coll. 24 cm high, excluding tassels.

*Plate 104:* A stylized figure of a brolga (or native companion) bird (equivalent to the *dua* m.) used among Gunwinggu people of western Arnhem Land as an invitation to *rom* ceremonies, and for dancing. These involved the ceremonial exchange of goods (such as baskets, spears and spearthrowers, stone knives and feathered string). The object is made of soft bark bound with twine, and ochred, with a wooden beak attached to a hard-wax head: feathers encircle its neck, a rounded tail-plug protrudes from the end of its body, and it has stick feet.

* Made at Oenpelli, 1950, by Samuel Manggudja, Gunwinggu. Berndt coll. 69 cm high.

*Plate 105:* A realistic figure of a dugong associated with a *yiridja* m. myth, in which a spirit being kills a large dugong. It is not connected with the well-known myth of the Moonbone, which refers to a female dugong. The design on its body is a kind of sea grass on which these creatures feed.

* Made at Yirrkala, 1946, by Naradjin, Manggalili *mada*, Bilin (or Yiduwa) *mala, yiridja* m. Berndt coll. 44 cm long.

*Plate 106:* A sorcery bark painting from western Arnhem Land. This graceful and unique example depicts a pregnant woman, with foetus inside (in x-ray style), with the head of a jabiru bird: stingray spines or 'nails' protrude from various parts of her body, as part of the technique of image sorcery.

* Painted at Oenpelli, 1947, by Midjaumidjau, Gunwinggu. Berndt coll. 42 x 71 cm.

*PLATES 107 TO 111:* These moulded pipeclay or red-ochre heads all come from Oenpelli in western Arnhem Land, and all but one are Gunwinggu. Traditionally, they were made for sorcery purposes, when the image itself should resemble the victim. However, in this case none is intended to represent a living person. All were obtained in 1949-50 by R. M. B. during the course of fieldwork and were part of his

original collection. They are at present held in the Institute of Anatomy, Canberra: see R. M. Berndt (1951*b*: 350-53).

*Plate 107:* Head of a man, in white pipeclay; the complete figure disintegrated on the field. 7 cm high. Moulded by Nipper Maragar, Manger (Mangerdji) language.

*Plate 108:* Mask-like face of a man; back hollowed for sake of lightness; eyes filled in with white pipeclay, against the terracotta colouring; edging to eyebrows, and eyes etched; further marks represent hair and teeth. 14 cm high. Moulded by Samuel Manggudja, Gunwinggu.

*Plate 109:* Man's head, partially 'triangular' face, animated and laughing; back hollowed; ears applied when object nearly dry; teeth serrated; white pipeclay: 13 cm high. Moulded by Samuel Manggudja, Gunwinggu.

*Plate 110:* Bust of pubescent girl, ears incised. red ochre: 14 cm high. Moulded by Joshua Wurungulngul, Gunwinggu.

*Plate 111:* Man's head in profile, and flat: male, with ears gouged out and moulded in relief: white pipeclay: 11 cm high. Moulded by Midjaumidjau, Gunwinggu.

*Plate 112:* Two moulded beeswax figures. The male figure is Woial (or Wudal), the mythic Honey Man. In this case, he is localized at Grugalwoi (Trial Bay area). The designs on his body refer to wild honey.

The female figure is Ngiringiri, the sister of Woial, at Grugalwoi. Her body design represents rain or streaks of liquid honey.

* Both were moulded by Madaman, Riradjingu *mada*, Wurulul *mala*, dua m. Berndt coll. 28.5 cm and 24 cm high, respectively.

REFERENCES: R. M. Berndt (1951*b*: 350-3), (1976: 192-4), in Berndt and Phillips eds (1973/1978: 156-81); Elkin, Berndt and Berndt (1950: 48-60, 84-91, 101-8); Mountford (1956: 445-75).

## Domestic Art
### CHAPTER FIVE

PLATES 113 TO 124
These concern primarily the artefacts used in some aspects of Aboriginal life outside the religious-ritual sphere, such as hunting and food-collecting and fighting. However, only a small range is illustrated, mainly for its artistic merit.

*Plate 113:* Bark painting of a hunting scene. Bottom panel, left, a man (top edge), who lives in a hut (bottom edge), sits resting before a paperbark container of honey. He is also shown spearing an emu (centre). Other figures represent termite mounds, stones for sharpening iron blades, kangaroo and dingo tracks, a frog, and a dilly bag hanging from a tree. The oval circle overlying the bottom left and right-hand panels is a billabong with ground pigeons (*damaga labar*) and emu tracks. In the bottom right-hand panel are an emu with eggs, a kangaroo track, a tree with *bibi* pigeons (bottom edge) and white cockatoos, a tree (top edge) with morning pigeons (*wanba*) and a hill with rocks. Top panel, left to right, *yugawa* yam and leaves with a feeding *biei* goanna and one climbing a tree; three vertical bands are spring water running to the billabong with a goanna in between; then (right), the *djirigid* birds and (bottom) kangaroo with a willy wagtail on its back and (top) a dingo chasing a kangaroo.

* Painted at Yirrkala, 1946, by Naradjin, Manggalili *mada*, Bilin (or Yiduwa) *mala, yiridja* m. Berndt coll. 62 x 70 cm.

*Plate 114:* Western Desert spearthrower. At the handle-end is gum, into which, ordinarily, a stone scraper would be set. The spear-peg is attached with kangaroo sinew. The linked incised u-shaped design represents camps made by the Two Men (the Wadi Gudjara), major mythical characters whose travels took them over immense distances throughout this region.

* Obtained at Ooldea, western South Australia, 1941; artist's name unrecorded. Berndt coll 77 cm long.

*Plate 115:* Squared-top Western Desert spearthrower. The design is the traditional 'snake motif' which can be interpreted as referring to snake tracks or to a water course; the upper design near the spear-peg represents rocks.

* Obtained at the Warburton Range, Western Australia, 1957; artist's name unrecorded. Berndt coll. 77 cm long.

*Plate 116:* A bark painting showing a hunting scene. In the right-hand panel is a man spearing a kangaroo; frogs are in two rows of billabongs, with trees and emus eating soft grass. In the left-hand panel are billabongs, a tree, kangaroo, a burnt-out dry tree with a climbing goanna and white cockatoos.

* Painted at Yirrkala, 1946, by Naradjin, Manggalili *mada*, Bilin (or Yiduwa) *mala, yiridja* m. Berndt coll. 34 x 55 cm.

*Plate 117:* A broad defence-shield with parrying projections. The heavily incised grooved design in relief consists of a series of multiple lozenge figures with meandering lines; the meaning is not recorded. Such shields derive from north-west Victoria and the Lachlan and Murrumbidgee rivers.
    Originally obtained from the Simpson Newland collection by A. H. T. Berndt (*circa* 1916); probable date of shield, mid-19th century or earlier. Berndt coll. 98 cm long.

*Plate 118: Mulgani* parrying shield, Yaraldi language area, lower River Murray, South Australia. Design of multiple lozenges, 'herring bone' and bands.
    Obtained by A. H. T. Berndt, probably from the Simpson Newland collection (*circa.* 1916); probable date of shield, 1850s or earlier. Identified by Albert Karloan, Yaraldi language speaker, in 1939. Berndt coll. 86 cm long.

*Plate 119:* Bow-shaped parrying shield, Darling River, New South Wales. Complex incised design with grooves infilled with pigments; multiple lozenge patterning.
    * Obtained by K. J. Oates from a relative who had been given it. Purchased at auction in Perth, 1978. Probable date of shield, mid-19th century or earlier. 93 cm long.

*Plate 120:* Central Australian shield; surface with longitudinal grooves. This is probably from the Wailbri (Walbiri) community at Yuendumu, Northern Territory. The illustration reveals a patterning of darkened areas which indicate that a design of superimposed ochre and/or featherdown has been ritually applied.
    * Obtained from Aboriginal Traditional Arts, Perth, 1979. 79 cm long.

*Plate 121:* Shield from La Grange, south-western Kimberley, with an intricate key-pattern design, mirroring those which appear on sacred boards.
    * Collected by K. Akerman, 1966. 75 cm long.

*Plate 122:* Traditional Western Desert 'snake-motif' shield, heavily grooved and infilled with ochre.
    * Made by Mardidi, Andingari dialect, at Ooldea, western South Australia, prior to 1941. Berndt coll. 77 cm long.

*Plate 123:* A pearlshell with human hairbelt attached, from Christmas Creek, south-eastern Kimberley. The incised design is of the traditional 'diffused' key-pattern, probably derived from the Broome area. This is the obverse side: see Plate 152 for the reverse.
    * Collected by K. Akerman, 1973. 22.5 cm long.

*Plate 124:* An incised baobab nut from Halls Creek, Western Australia, but probably derived from Broome or Derby.

The design shows a man playing a didjeridu, another singing with clapping sticks, and four men dancing, surrounded by a large snake.
    * Collected by K. Akerman, 1964. 21.5 cm without stem.

REFERENCES: R. M. and C. H. Berndt (1964/1977: 436, 438-43); Elkin, Berndt and Berndt (1950); McCarthy (1957: 81-97, 167-85), (1958: 14-58).

## *Innovation*
## CHAPTER SIX

PLATES 125 TO 153
All objects, paintings and other items in this section can be labelled 'innovative'. However, there are considerable variations on that theme, ranging from what appear to be obviously Aboriginal to those where there is no doubt about Australian-European influence. We need to keep in mind, too, that innovation in Aboriginal art is not confined to alien adaptations. Examples noted in other chapters should make that clear.

*Plate 125A:* This is a representation of the mythic being Mareiyalyun, who is shape-changing: in the sky he is a cloud-man; on the ground a snake. Shown with a snake round his shoulders, he wears a headband and has facial markings. Mareiyalyun may be seen as a tall man walking on the beach at Yiringa (Drysdale Island) in *yiridja* m. territory adjacent to Elcho Island. He is associated with religious ritual and with love magic.
    * Made at Elcho Island, 1979, by Wuragi Number Two, Waramiri *mada*, Bralbral *mala*, *yiridja* m. Obtained by R. M. B. from J. Thorne, Aboriginal Arts and Crafts, Elcho Island. 81 cm high.

*Plate 125B:* A close-up view of the head of Mareiyalyun shown in Plate 125A.

*Plate 126:* The shape-changing mythic being, Mareiyalyun. Two snakes, his 'arms', point toward the sky. When shown in this position, one snake's head should point upward, the other downward, to indicate his sky and earth attributes. This Mareiyalyun is associated with Gulara, Truant Island, in the English Company Islands group. Although this being is of the *yiridja* m., the artist

responsibe is *dua*. This is because Mareiyalyun was one of the snakes who erected himself after the Yulunggul Python had swallowed the Wawalag Sisters, and when Yulunggul asked various mythic snakes what they had swallowed, Mareiyalyun replied. Because of his association in this way with the *dua* m. Wawalag, appropriate *dua* m. men can carve him.

* Made at Elcho Island, in 1979, by Dalnganda, Gudji'miri *mada*, B'rangu *mala, dua* m. Obtained by R. M. B. from J. Thorne, Aboriginal Arts and Crafts, Elcho Island. 105 cm high.

*Plate 127:* 'Portrait' sculpture of Ngulumung, a leader of the Manggalili *mada, yiridja* m.; he is not a mythic character. The figure has human hair attached to his head, and wears a red-feathered beard; he also has a feathered waistband and skirt (the latter not traditionally worn by men). The design on his body is emblematic of the Manggalili, referring to the destruction by fire of a ritual shade at Arnhem Bay: the diamond patterning represents charred paperbark and ashes, and the lines on his chest a spreading fire.

* Made at Yirrkala, 1964, by Nanyin, Manggalili *mada*, Bilin (or Yiduwa) *mala, yiridja* m. Berndt coll. 83 cm high.

*Plate 128:* Figure of a policeman at Darwin.

* Made at Yirrkala, 1964, for commercial sale, by Midinari, Galbu *mada*, Malawur *mala, dua* m. Berndt coll. 42 cm high.

*Plate 129:* An innovative *bugamani* mortuary post which depicts a male figure on one side, a female figure on the other. No meaning of this has been obtained.

* Made at Bathurst Island, 1977, by Peter Porkalari, Tiwi language. From Aboriginal Traditional Arts, Perth. 100 cm high.

*Plate 130:* Part of a *bugamani* mortuary post: adaptation of a white crane.

* Made at Snake Bay, Melville Island, 1977, by H. Wonpa, Tiwi language. From Aboriginal Traditional Arts, Perth. 57 cm high.

*Plate 131:* A small figure of a *gadaga* black bird associated with Muruwiri Rocks, Bremer Island, *dua* m. territory, where the mythic Turtle Man's spirit resides. The bird is of the *yiridja* m. and perches on a piece of timber drifting in the sea (represented in the incised design).

* Made at Yirrkala, 1964, by Lardjannga, Ngeimil *mada*, Gabin *mala, dua* m. Berndt coll. 19 cm high.

*Plate 132:* Probably the *djiwilyilyi* swamp bird or pigeon, *yiridja* m., with its 'wings' incised.

* Made at Yirrkala, 1963, by Garmali, Gumaidj *mada*, Raiung *mala, yiridja* m., but sent as a present to C. H. B. by Banbanawi (*dua* m.) of Elcho Island. 19 cm high.

*Plate 133:* This bark painting is innovative in style but retains in its subject matter the traditional mythology. It is associated with the mythic Wuradilagu woman (women), also called Wuradidi, who came from Groote Eylandt. *Marnga* possums climb up a wild plum tree, spinning lengths of possum fur string for *guwag* (a night bird) which is perched at the apex of the tree; the tree is also a sacred *rangga*. Under the *guwag* and above the first four possums are a pair of butterflies. The scene is relevant to Djaragbi (Cape Shield) in Manggalili territory, *yiridja* m. Compare with Plate 45.

* Painted at Yirrkala, prior to 1974, by Banabana, one of Naradjin's sons, Manggallli *mada*, Bilin (or Yiduwa) *mala, yiridja* m. Acquired through the United Church craft shop, Sydney, by R. M. B. 59 x 173 cm.

*Plate 134:* This painting expands on the traditional mortuary theme. It represents (so R. M. B. was told) a commentary on the effects of bauxite mining at Nhulunbuy (Gove Peninsula) on the people living in the area. The eventual result, it was said, would be the removal of their physical substance. The painting, therefore, shows in skeleton form, not only human beings, but all the local creatures— dogs, birds and kangaroos (which are shown here). The bottom right-hand panel is of a hunter in skeletal form with his spears and thrower—there is nothing left for him to hunt!

* Painted at Yirrkala, 1968, by Mudidjboi, Djabu *mada*, Dagobabwi *mala, dua* m. Purchased from the local Methodist Mission store. Berndt coll. 53 x 94 cm.

*Plate 135:* Painting of a corpse lying on its disposal platform. The cross-hatching is the bark on which it rests; horizontal bars are the posts of the structure. The head is a skull; and broken lines surrounding it are maggots which move down into the decomposing body. On each side of the face is a *birgbirg* bird (bustard) from Bralgu, the *dua* m. island of the dead, waiting for the dead person's spirit.

* Painted at Yirrkala, 1968, by Mudidjboi, Djabu *mada*, Dagobabwi *mala, dua* m. Purchased from the local Methodist Mission store. Berndt coll. 29 x 73 cm.

*Plate 136:* A painting from Port Keats, west of Darwin. It illustrates a dancing scene: a didjeridu is being played, a singing man claps his sticks, and men dance with spears. A tree is drawn at each side, and on the top border the design represents clouds.

Painted at Port Keats, 1967, by Indji (affiliations unrecorded). By courtesy of the Western Australian Art Gallery. 19.5 x 63 cm.

*Plate 137:* Painted on three-ply board, this depicts a *waralu* jellyfish, associated with a dream (*balga*) song cycle (not mythic).

* Painted at Kalumburu, Western Australia, 1963, by Alec, Worora language. Obtained by P. Lucich. 47 x 48 cm.

*PLATES 138 TO 139:* The artist responsible for these two paintings, Revel Ronald Cooper, was a pupil at Carrolup School (Western Australia) in the 1940s. He was 13 years old when he did the water-colours illustrated in Miller and Rutter (1952), and showed considerable promise. Those illustrated here were painted in about 1964, and were acquired via George Abdullah in 1965 by R. M. B.

* *Plate 138:* A South-West bush scene of eucalypts and blackboys. 38 x 57 cm.
* *Plate 139:* A South-West bush scene of eucalypts and blackboys. 38.5 x 56.5 cm.

*PLATES 140 TO 143:* The Hermannsburg School of Aboriginal art has become world-famous. The four brown paper drawings in lumber crayons are examples of work being done in the early 1940s by children in the Hermannsburg school under the influence of the development of the adult School of Art. These were obtained in 1944 at Hermannsburg by R. M. B. and C. H. B. Berndt coll.

*Plate 140:* MacDonnell Ranges, north and north-east of Hermannsburg.
By Lindsay, on thin paper. 24 x 19.5 cm.

*Plate 141:* Mount Sonder, north of Hermannsburg, with emus and white gum.
By Cyril, on brown paper. 36 x 57.5 cm.

*Plate 142:* Near Hermannsburg: white gum trees and kangaroo.
By Henoch, on brown paper. 36 x 57.5 cm.

*Plate 143:* Country outside Areyonga, which in 1944 was a Western Desert settlement, an outstation of Hermannsburg. The drawing shows a hunter, and a bird's nest in a white gum tree.
By Rolf, on brown paper. 36 x 57.5 cm.

*PLATES 144 TO 146:* Joe Nangan, sometimes called Butcher Joe, is a Nyigena-language man living at Beagle Bay and Broome. For many years he has been sketching incidents from his mythology, and scenes of a traditional life which was a reality in his youth. Many of these drawings are remarkable in their realism, providing an atmosphere which is so often lacking in applied forms of Aboriginal art. The three illustrated here come from a sketch book (No. 2) which Joe Nangan sent to R. M. B. through Miss N. Kerr (a linguist who worked on the Nyigena language); the annotations were prepared by Mrs C. Cardinaux of the (then) Department of Native Welfare at Broome, 1968.

*Plate 144:* A fine watercolour and pencil drawing of an Aboriginal hunter with a long *yarindi* spearthrower used by the Nyigena. He is going out on a cloudy day, which is the best time for hunting kangaroo.
*Berndt coll. 18 x 27 cm.

*Plate 145:* Giridin, the Moon man. He comes down to earth in the late afternoon at the time of full moon. Aborigines he meets ask him to stay with them; he replies that he must return. One old man asks whether he would like a girl to accompany him; he refuses. After being pressed, he says 'yes' to one girl who is shown to him: but he doesn't really want her. He pretends to climb a *bilawal* (bloodwood) tree, which has water in its trunk and fruit (*dyulugu*) but no flowers. A fuller and slightly different version of this myth is noted in Nangan and Edwards (1976: 17-19). The drawing shows Giridin with the girl he agrees to have; he wears a headdress, with a sacred object through his hair, and shoulder feathers.
* Berndt coll. 18 x 27 cm.

*Plate 146:* Three men climbing a hair-string rope with a pointed shell at one end. It concerns a dream someone had which terrified these men. They were, however, rescued by an Aboriginal doctor who let down his hair-string and pulled them up to safety. This is associated with a ceremonial dance.
* Berndt coll. 18 x 27 cm.

*Plate 147:* This mulga wood carving represents the mythic Wonambi Snake associated with waterholes, and the concentric circles on it refer to these. It was given to R. M. B. by Aboriginal children who were playing with it. This is a 'prototype' of later wood carving of various creatures which were made for commercial sale.
* Obtained at Ooldea, western South Australia, in 1941, by R. M. B.: maker not recorded. Andingari language group. Berndt coll. 45 cm long.

*Plate 148:* Wood carving of a dog, with pokerwork body designs.

* Warburton Range, Western Australia, 1977, Ngaanyadjarra and Bidjandjadjara origin. From Aboriginal Traditional Arts, Perth. 33 cm long.

*Plate 149:* A finely sculptured Aboriginal head of yellow, darkened sandstone. It shows the traditional hair-bun, and a forehead-band of wool. This work was produced for external sale.

* Sculptured at La Grange Catholic Mission, by Big John Dodo, Garadjeri language, 1974. From Aboriginal Traditional Arts, Perth, 1975. 21 cm high.

*Plate 150:* Two innovative stone carvings from local Balgo stone: the top one is a bird (unidentified), the bottom, a camel. Produced for external sale.

* Sculptured at Balgo, south-eastern Kimberley, by Albert (*djambidjin* subsection), Gugadja language, in 1977. From Aboriginal Traditional Arts, Perth. Each 24 cm long.

*Plate 151:* A pearlshell pendant with an innovative representation of a woman entwined by a snake. The surrounding design is of *bindjau-bindjau (pindjawindja)* pointed pearlshells, two of which are attached to lengths of twine and may be used in love magic.

* Incised by Lickie Nollier, Derby; from K. Akerman, 1978. 15.5 cm long.

*Plate 152:* This is the reverse of the pearlshell shown in Plate 123. It has a human hairbelt attached, and shows an incising of a 'plane.

* Artist's name unrecorded, Christmas Creek, southeastern Kimberley. From K. Akerman, 1973. 22.5 cm in length.

*Plate 153:* Two pieces of pottery from the Aboriginal kilns of Eddie Puruntatameri, John Bosco Tipiloura and associates at Bathurst Island, Northern Territory. Each bears local Aboriginal motifs.

* From Aboriginal Traditional Arts, Perth, 1980. Vase 25 cm high; bowl 22 cm wide.

REFERENCES: Aboriginal Arts Board (n.d.); Battarbee (1951); R. Berndt (1979a: 372-6); Berndt and Phillips eds (1974/1978: 292-315); Berndt and Stanton (1980: 21-3); Brokensha (1975); Miller and Rutter (1952); Mountford (1948); Nangan and Edwards (1976).

# *Bibliography*

Aboriginal Arts Board 1978 *Oenpelli paintings on bark*. An exhibition: the Australian Gallery Directors Council.

Aboriginal Arts Board 1979 *Oenpelli bark painting*. Ure Smith, Sydney.

Aboriginal Arts Board n.d. *Aboriginal art of North Australia*. An exhibition: Aboriginal Arts Board, Australia Council, Sydney.

*Aboriginal children's history of Australia, The* 1977 Rigby, Adelaide (illustrated by Aboriginal children).

Aladdin Gallery 1977 *Tiwi pottery, Bathurst Island*. An exhibition. Aladdin Gallery, Sydney.

Allen, L.A. 1972 *Australian Aboriginal art: Arnhem Land*. Field Museum of Natural History.

Allen, L.A. 1975 *Time before morning*. Crowell, New York.

Amadio, N. (ed.) 1986 *Albert Namatjira: the life and work of an Australian painter*. Macmillan, South Melbourne.

Australian Museum 1977 *Renewing the Dreaming*. Anniversary exhibition, 1827–1977, Australian Museum, Sydney.

Bardon, G. 1979 *Aboriginal art of the Western Desert*. Rigby, Adelaide.

Basedow, H. 1907 Anthropological notes on the western coastal tribes of the Northern Territory of South Australia, *Transactions of the Royal Society of South Australia*, Vol. 31.

Battarbee, R. 1951 *Modern Australian Aboriginal art*. Angus and Robertson, Sydney.

Berndt, C.H. 1963 Art and aesthetic expression. In *Australian Aboriginal Studies* (H. Sheils ed.). Oxford University Press, Melbourne.

Berndt, C.H. 1970 Monsoon and Honey Wind. In *Échanges et Communications, Mélanges offerts à Claude Lévi-Strauss* (J. Pouillon and P. Maranda eds). Mouton, Paris.

Berndt, C.H. 1978 The arts of life. In *Westerly 21* (B. Bennett and P. Cowan eds). Fremantle Arts Centre Press, Fremantle.

Berndt, C.H. ed. and trans. 1979 *Land of the Rainbow Snake. Aboriginal children's stories and songs from western Arnhem Land* (illustrated by Djoki Yunupingu). Collins, Sydney.

Berndt, C.H. and R.M. Berndt 1978 *Pioneers and settlers: the Aboriginal Australians*. Pitman, Melbourne.

Berndt, R.M. 1951a *Kunapipi*. Cheshire, Melbourne.

Berndt, R.M. 1951b Aboriginal ochre-moulded heads from western Arnhem Land, *Meanjin*, Vol. X.

Berndt, R.M. 1952 *Djanggawul*. Routledge and Kegan Paul, London.

Berndt, R.M. 1958 Some methodological considerations in the study of Australian Aboriginal art, *Oceania*, Vol. XXIX, No. 1.

Berndt, R.M. 1962 *An adjustment movement in Arnhem Land*. Mouton, Paris.

Berndt, R.M. 1964 The Gove dispute: the question of Australian Aboriginal land and the preservation of sacred sites, *Anthropological Forum*, Vol. I, No. 2.

Berndt, R.M. ed. 1964/1968 *Australian Aboriginal art*. Ure Smith, Sydney.

Berndt, R.M. 1969 *The sacred site: the western Arnhem Land example*. Australian Institute of Aboriginal Studies, Canberra.

Berndt, R.M. 1972 The changing face of the Aboriginal arts, *Anthropological Forum*, Vol. III, No. 2.

Berndt, R.M. 1976 *Love Songs of Arnhem Land*. Nelson, Melbourne.

Berndt, R.M. 1973/1978 Australian Aboriginal sculpture. In R.M. Berndt and E.S. Phillips eds.

Berndt, R.M. 1974 *Australian Aboriginal religion*. Brill, Leiden.

Berndt, R.M. 1979a Aboriginal art in Western Australia, *Art and Australia*, Vol. 16, No. 4.

Berndt, R.M. 1979b Australien. In *Sonderdruck aus der Propyläen Kunstgeschichte*. Propyläen, Berlin.

Berndt, R.M. 1987 Panaramittee magic. Records of the South Australian Museum, Vol. 20.

Berndt, R.M. and C.H. Berndt 1942–1945 A preliminary report of field work in the Ooldea region, western South Australia, *Oceania Bound Offprint* (see *Oceania*, 1943, Vol. XIII, No. 4; Vol. XIV, No. 2; 1944, Vol. XIV, No. 4).

Berndt, R.M. and C.H. Berndt 1946 The eternal ones of the dream, *Oceania*, Vol. XVII, No. 1.

Berndt, R.M. and C.H. Berndt 1948 Sacred figures of ancestral beings of Arnhem Land, *Oceania*, Vol. XVIII, No. 4.

Berndt, R.M. and C.H. Berndt 1949 Secular figures of north-eastern Arnhem Land, *American Anthropologist*, Vol. 51, No. 2.

Berndt, R.M. and C.H. Berndt 1950 Aboriginal art in central-western Northern Territory, *Meanjin*, Vol. 9, No. 3.

Berndt, R.M. and C.H. Berndt 1954 *Arnhem Land: its history and its people*. Cheshire, Melbourne.

Berndt, R.M. and C.H. Berndt 1970 *Man, land and myth in North Australia: the Gunwinggu people*. Ure Smith, Sydney.

Berndt, R.M. and C.H. Berndt 1964/1977 *The world of the First Australians*. Ure Smith, Sydney.

Berndt, R.M. and C.H. Berndt 1974 *The First Australians.* Ure Smith, Sydney. (First ed., 1952.)

Berndt, R.M. and C.H. Berndt 1989 *The Speaking Land.* Penguin Australia, Ringwood.

Berndt, R.M. and E.S. Phillips eds 1973/1978 *The Australian Aboriginal Heritage. An introduction through the arts.* Australian Society for Education through the Arts in association with Ure Smith, Sydney.

Berndt, R.M. and J.E. Stanton 1980 *Australian Aboriginal art in the Anthropology Museum of the University of Western Australia.* University of Western Australia Press, Perth.

Black R. 1964 *Old and new Australian Aboriginal art.* Angus and Robertson, Sydney.

Brandl, E.J. 1973 *Australian Aboriginal paintings in western and central Arnhem Land.* Australian Institute of Aboriginal Studies, Canberra.

Brandl, E.J. 1973/1978 The art of the caves in Arnhem Land. In R.M. Berndt and E.S. Phillips eds.

Brandl, E.J. 1977 Human stick figures in rock art. In P.J. Ucko ed.

Brokensha, P. 1975 *The Pitjantjatjara and their crafts.* Aboriginal Arts Board, Australia Council, Sydney.

Bunug, *et al.* 1974 *Djugurba: tales from the spirit time.* Australian National University Press, Canberra.

Carrick, J. ed. 1975 *Art of the First Australians.* Aboriginal Arts Board, Australia Council, Sydney.

Carrington, F. 1888 The rivers of the Northern Territory of South Australia, *Proceedings of the Royal Geographical Society* (S.A.), Vol. 2.

Carroll, P.J. 1977 Mimi from western Arnhem Land. In P.J. Ucko ed.

Caruana, W. 1989 *Windows on the Dreaming: Aboriginal paintings in the Australian National Gallery.* Australian National Gallery, in association with Ellsyd Press, Canberra.

Chaloupka, G. 1977 Aspects of the chronology and schematisation of two prehistoric sites on the Arnhem Land plateau. In P.J. Ucko ed.

Chaseling, W. 1957 *Yulengor. Nomads of Arnhem Land.* Epworth Press, London.

Crawford, I.M. 1964 The engravings of Depuch Island, *Western Australian Museum, Special Publication,* Vol. 2.

Crawford, I.M. 1968 *The art of the Wandjina.* Oxford University Press, Melbourne.

Crawford, I.M. 1977 The relationship of Bradshaw and Wandjina art in north-west Kimberley. In P.J. Ucko ed.

Crawford, I.M. 1973/1978 Wandjina paintings. In R.M. Berndt and E.S. Phillips eds.

Davidson, D.S. 1937 A preliminary consideration of Australian Aboriginal decorative art, *American Philosophical Society,* Memoir X.

Dix, W.C. 1977 Facial representations in Pilbara rock engravings. In P.J. Ucko ed.

Edwards, R. 1968 Prehistoric rock engravings at Thomas reservoir, Cleland Hills, western central Australia, *Records of the South Australian Museum,* Vol. 15 (4).

Edwards, R. ed. 1975 *The preservation of Australia's Aboriginal heritage.* Australian Institute of Aboriginal Studies, Canberra.

Edwards, R. 1979 *Australian Aboriginal art: the art of the Alligator Rivers region, Northern Territory.* Australian Institute of Aboriginal Studies, Canberra.

Edwards, R. ed. 1978 *Aboriginal art in Australia.* Aboriginal Arts Board, Australia Council, Sydney.

Elkin, A.P. 1948 Grey's northern Kimberley cave-paintings refound, *Oceania,* Vol. XIX, No. 1.

Elkin, A.P., R.M. Berndt and C.H. Berndt 1950 *Art in Arnhem Land.* Cheshire, Melbourne.

Foelsche, P. 1882 Notes on the Aborigines of North Australia, *Transactions of the Royal Society of South Australia,* Vol. 5.

Glass, A. and D. Newberry trans. and ed. 1979 *Tjuma. Stories from the Western Desert* (illustrated by local Aboriginal artists). Aboriginal Arts Board, Australia Council, for the Warburton Community Inc., W.A.

Groger-Wurm, H.M. 1973 *Australian Aboriginal bark paintings and their mythological interpretation: eastern Arnhem Land.* Australian Institute of Aboriginal Studies, Canberra.

Groger-Wurm, H.M. 1973/1978 Bark painting. In R.M. Berndt and E.S. Phillips eds.

Groger-Wurm, H.M. 1977 Schematisation in Aboriginal bark paintings. In P.J. Ucko ed.

Hoff, J.A., 1977 Aboriginal carved and painted human figures in north-east Arnhem Land. In P.J. Ucko ed.

Holmes, S. leB. 1972 *Yirawala: artist and man.* Jacaranda Press, Brisbane.

Howitt, A.W. 1904 *The native tribes of South-East Australia.* Macmillan, London.

Isaacs, J. compl. 1980 *Australian Dreaming: 40,000 years of Aboriginal history.* Landsdowne Press, Sydney.

Jones, P. and P. Sutton 1986 *Art and Land: Aboriginal sculptures of the Lake Eyre Region.* South Australian Museum, in association with Wakefield Press, Adelaide.

Kupka, K. 1962 *Dawn of art.* Angus and Robertson, Sydney.

Lowe, P. with J. Pike 1990 *Jilji: life in the Great Sandy Desert.* Magabala Books, Broome.

Marawili, W. 1977 *Djet* (trans. and illustr. by Mrs Dundiwuy Wunungmurra). Nelson, Melbourne.

Maynard, L. 1977 Classification and terminology in Australian rock art. In P.J. Ucko ed.

McCaskill, D.J. 1977 Schematisation in rock art of the upper Gascoyne district, Western Australia. In P.J. Ucko ed.

McCarthy, F.D. 1956–1959 Rock engravings of the Sydney-Hawkesbury district, Pts. 1 and 2, *Records of the Australian Museum,* Vol. 24 (5 and 14).

McCarthy, F.D. 1957 *Australia's Aborigines: their life and culture.* Colorgravure Publications, Melbourne.

McCarthy, F.D. 1958a *Australian Aboriginal decorative art.* Australian Museum, Sydney.

McCarthy, F.D. 1958b *Australian Aboriginal rock art.* Australian Museum, Sydney.

McCarthy, F.D. 1962 *The rock engravings of Port Hedland, north & Western Australia.* Kroeber Anthropological Society Papers, 26, University of California, Berkeley.

McCarthy, F.D. 1964 The dancers of Aurukun, *Australian Natural History,* Vol. 14, No. 9.

McCarthy, F.D. 1964/1968 The art of the rock faces. In R.M. Berndt ed.

McCarthy, F.D. 1976 *The rock paintings of the Cobar pediplain in central-western New South Wales.* Australian Institute of Aboriginal Studies, Canberra.

McCarthy, F.D. 1977 Classification and terminology in Australian rock art. In P.J. Ucko ed.

Miller, M.D. and F. Rutter 1952 *Child artists of the Australian bush.* Australasian Publishing Co., Sydney.

Morphy, H. 1977 Schematisation to conventionalisation: a possible trend in Yirrkala bark paintings. In P.J. Ucko ed.

Morphy, H. 1978 *Manggalili art.* Faculty of Arts, Australian National University, Canberra.

Mountford, C.P. 1937a Aboriginal crayon drawings from the Warburton Ranges in Western Australia...*Records of the South Australian Museum,* Vol. 6, No. 1.

Mountford, C.P. 1937b Aboriginal crayon drawings... *Transactions of the Royal Society of South Australia,* Vol. 61.

Mountford, C.P. 1937c Aboriginal crayon drawings, II..., *Transactions of the Royal Society of South Australia,* Vol. 61.

Mountford, C.P. 1938a Aboriginal crayon drawings, III..., *Transactions of the Royal Society of South Australia,* Vol. 62, No. 2.

Mountford, C.P. 1938b Contrast in drawings made by an Australian Aborigine before and after initiation, *Records of the South Australian Museum,* Vol. 6, No. 2.

Mountford, C.P. 1939a Aboriginal crayon drawings, IV..., *Transactions of the Royal Society of South Australia,* Vol. 63.

Mountford, C.P. 1939b Aboriginal crayon drawings, Warburton Ranges, W.A., *Oceania,* Vol. X, No. 1.

Mountford, C.P. 1948 *The art of Albert Namatjira.* Bread and Cheese Club, Melbourne.

Mountford, C.P. 1956 *Art, myth and symbolism: records of the American-Australian scientific expedition to Arnhem Land,* I. Melbourne University Press, Melbourne.

Mountford, C.P. 1958 *The Tiwi, their art, myth and ceremony.* Phoenix House, London.

Mountford, C.P. 1962 The Aboriginal art of Australia. In *Oceania and Australia: the art of the South Seas* (A. Bühler ed. *et al.*). Methuen, London.

Mountford, C.P. 1965 *Ayers Rock: its people, their beliefs and their art.* Angus and Robertson, Sydney.

Mountford, C.P. 1968 *Winbaraku and the myth of Jarapiri.* Rigby, Adelaide.

Mountford, C.P. and R. Tonkinson 1969 Carved and engraved human figures from North Western Australia, *Anthropological Forum,* Vol. II, No. 3.

Mulvaney, D. J. 1975 *The prehistory of Australia*. Pelican Books, Australia.

Munn, N. D. 1973 *Walbiri iconography*. Cornell University Press, Ithaca.

Nangan, J. and H. Edwards 1976 *Joe Nangan's Dreaming: Aboriginal legends of the North-West*. Nelson, Melbourne.

Narritjan Maymuru 1978 *The Milky Way*. (With T. Egan.) Harcourt Brace Jovanovich Group, Sydney.

Norton, F. 1975 *Aboriginal art*. The Western Australian Art Gallery, Perth.

Petri, H. 1954 *Sterbende Welt in Nordwestaustralien*. Limbach, Braunschweig.

Robinson, R. 1956 *The feathered serpent*. Edwards and Shaw, Sydney.

Roughsey, D. 1973/1976 *The giant devil dingo*. Collins, Sydney.

Roughsey, D. 1975 *The rainbow serpent*. Collins, Sydney.

Roughsey, L. and G. Roughsey 1978 *The turkey and the emu*. (With T. Egan.) Harcourt Brace Jovanovich Group, Sydney.

Ryan, J. 1989 *Mythscapes: Aboriginal art of the Desert*. National Gallery of Victoria, Melbourne.

Smyth, R. Brough 1878 *The Aborigines of Victoria...*2 vols. Government Printer, Melbourne.

Spencer, B. 1914 *Native tribes of the Northern Territory of Australia*. Macmillan, London.

Spencer, B. 1928 *Wanderings in wild Australia*, 2 vols. Macmillan, London.

Stanton, J. E. 1989 *Painting the country: contemporary Aboriginal art from the Kimberley Region, Western Australia*. The University of Western Australian Press, Perth.

Strehlow, T. G. H. 1964/1968 The art of circle, line and square. In R.M. Berndt ed.

Sutton, P. (ed.) 1988 *Dreamings: the art of Aboriginal Australia*. Penguin Books, Ringwood, in association with The Asia Society Galleries, New York.

Thomson, D. F. 1949 *Economic structure of the ceremonial exchange cycle in Arnhem Land*. Macmillan, London.

Timaepatua, M. A. and R. Gumudul *et al.* 1977 *Kwork Kwork the green frog and other tales from the spirit time*. Australian National University Press, Canberra.

Tindale, N. B. 1936 Legend of the Wati Kutjara, Warburton Range, W.A., *Oceania*, Vol. VII, No. 2.

Tindale, N. B. 1959 Totemic beliefs in the Western Desert of Australia. Part 1. Women who became Pleiades, *Records of the South Australian Museum*, Vol. 13, No. 3.

Trezise, P. J. 1969 *Quinkan country*. Reed, Sydney.

Trezise, P. J. 1971 *Rock art of south-east Cape York*. Australian Institute of Aboriginal Studies, Canberra.

Trezise, P. J. 1973/1978 Aboriginal rock art of Cape York Peninsula. In R.M. Berndt and E.S. Phillips eds.

Trezise, P. J. 1977 Representations of crocodiles in Laura art. In P. J. Ucko ed.

Trezise, P. and D. Roughsey 1978 *The Quinkins*. Collins, Sydney.

Trezise, P. and R. Roughsey 1980 *Banana bird and the snake men*. Collins, Sydney.

Ucko, P. J. ed. 1977 *Form in indigenous art*. Australian Institute of Aboriginal Studies, Canberra.

Wallace, P. and N. Wallace 1977 *Killing me softly*. Nelson, Melbourne.

Warner, W. L. 1937/1958 *A black civilization*. Harper, New York.

Wells, A. E. 1971 *This their Dreaming*. University of Queensland Press, Brisbane.

Wilkins, G. .H 1928 *Undiscovered Australia*. Benn, London.

Wright, B. J. 1968 *Rock art of the Pilbara region, north-west Australia*. Australian Institute of Aboriginal Studies, Canberra.

Wright, B. J. 1973/1978 The art of the rock engravers. In R. M. Berndt and E.S. Phillips eds.

Wright, B. J. 1977 Schematisation in the rock engraving of north-western Australia. In P.J. Ucko ed.

Worms, E. A. 1954 Prehistoric petroglyphs of the Upper Yule river, north-western Australia, *Anthropos*, Vol. 49.

Worsnop, T. 1897 *The prehistoric arts, manufactures, work, weapons...of the Aborigines of Australia*. Government Printer, Adelaide.

# *Name Index*

# *Subject Index*